Mindanao
From Samai to Surallah

Ronald de Jong

Mindanao: From Samai to Surallah
Text and Photographs by Ronald de Jong

ThingsAsian Press
San Francisco, California, USA
www.thingsasianpress.com
Printed in Hong Kong

ISBN-10: 1-934159-66-2
ISBN-13: 978-1-934159-66-8

Crossing Mindanao, capturing moments, creating memories, captivating minds....

Contents

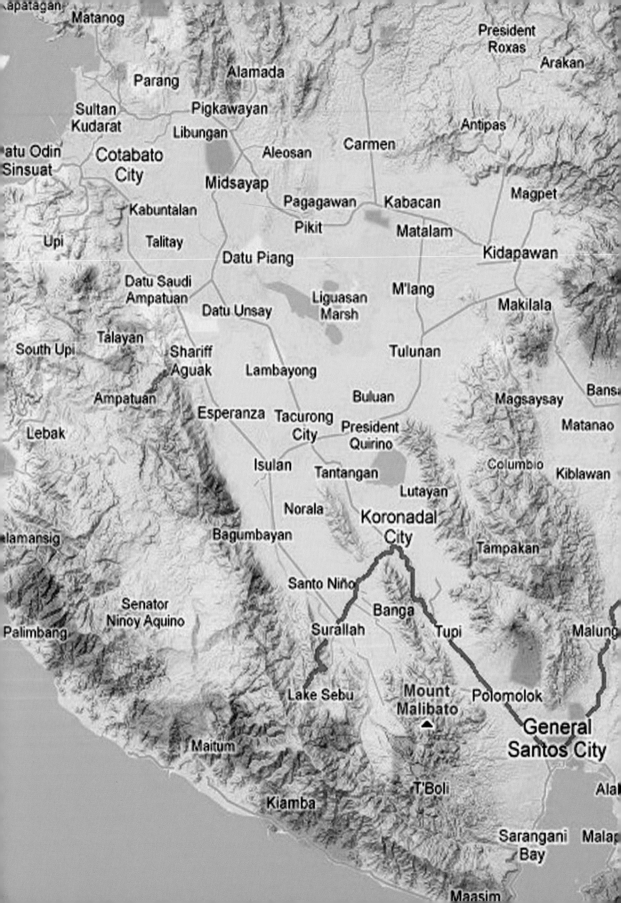

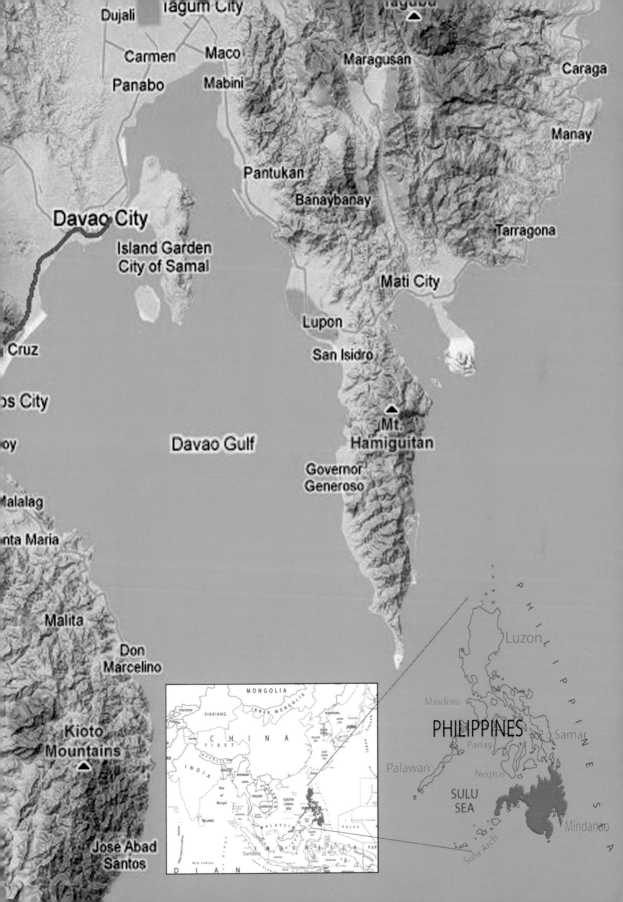

Foreword

I would like to thank the wonderful people of Mindanao for the inspiration that they gave to me for all the images and stories. A special thanks goes to my lovely wife Elena and my son Bryan, for their continuous patience and support during our travels throughout the region. I am grateful to my loving parents, who taught me to never give up and to pursue and fulfill my dreams.

Mindanao: from Samal to Surallah is a guide for those travelers who are not familiar with the southern Filipino culture. It is about surprising sights and experiences, the ins and outs and dos and don'ts of a fascinating place in the Philippines. It includes photographs of numerous destinations along a 200-mile stretch of the Maharlika Highway, featuring nature, culture, legends, festivals, adventure, local cuisine, everyday life, and various Philippine phenomena.

The book reflects the positive side of Mindanao; peace and stability are the aspiration and desire of most Mindanaoans. Regardless of their descent, religion, or political persuasion, they believe that tolerance, dignity, and mutual respect for their cultural and religious distinctiveness and for their individual differences are the universal powers that unite them in similar dreams of peace and prosperity.

There is much more to see, to do, and to discover than I could describe in this book, but I sincerely hope the words and photographs will inspire people to visit this part of an intriguing island.

Ronald de Jong

9

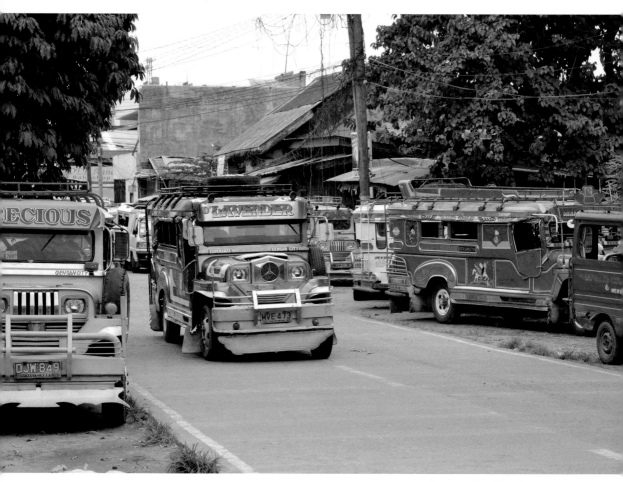

Koronadal City, Jeepneys

Mindanao: From Samai to Surallah

Introduction

The Philippines, an archipelago of 7,107 islands and islets, is the largest island group in the world, with three major island regions. Luzon is the largest, where the nation's capital of Manila is located. The Visayas are the most densely populated islands in the country. Mindanao is one of Asia's favorite tourist destinations, with its white sand beaches, islands, lagoons, mangrove swamps, mountains, valleys, rivers, lakes, waterfalls, rock formations, forests, springs, and marshlands.

Mindanao is home to a diverse group of people, who value peace and harmony above anything else. Catholics and Muslims live together in an intriguing blend of Christian and Islamic cultures. Many tribes such as the T'boli, B'laan, Yakan, Moro, Tausug, Maranao, Samal, and Badjao have also settled on the island. There is a wide variety of dialects spoken, both local to Mindanao as well as those from the Visayas and from Luzon. Mindanao is a melting pot of religions, customs, and traditions that all make an enthralling contribution to its image and charm. The island has amazing scenery, hospitable people, and a fair share of long-ingrained habits, practices, unusual peculiarities, and unique behavior.

Mindanao is probably not the most obvious choice for travelers, but it is off the beaten path and a low-cost destination for nature-loving voyagers. Traveling across this peninsula can be exhausting and confusing, but it is always affordable and it's a life-changing experience. It offers a chance to escape the tourist hubbub, to explore uncharted territory, and to see some of the most isolated areas in the Philippines.

Traversing this "Island of Smiles" is easy but the journey and the means of transportation have to be chosen with care. The southern part of the island is safe to travel, especially the areas in and around Davao City, Sarangani Bay, and the province of South Cotabato. If you remain in these three provinces, odds are you will have an incident-free and safe trip.

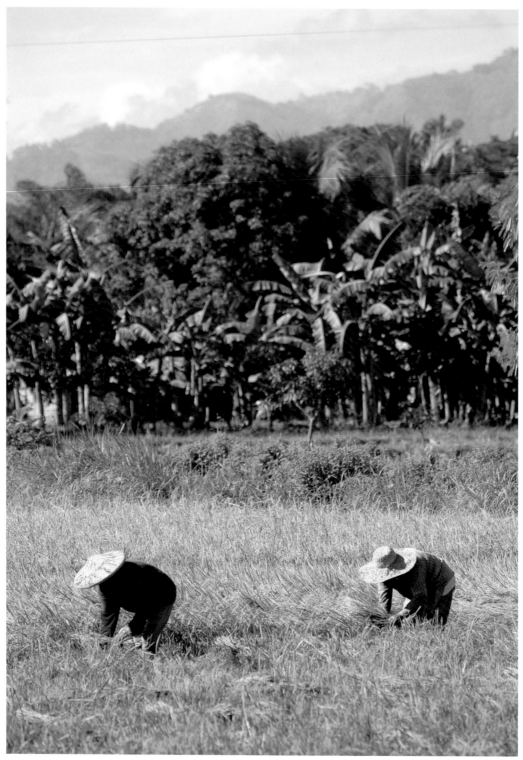

Koronadal Valley, Harvesting Rice

Mindanao: From Samai to Surallah

Unfortunately, travelers always run a small risk of having unpredictable difficulties or of becoming crime victims, just as they do in any other location on earth. Safety begins at home and it is important to choose any travel destination with wisdom and forethought. Mindanao has some conflict-ridden locations, but there are many places that are safe and secure.

Mindanaoans are among the friendliest and most hospitable people in the world, but travelers need to be well informed, accept good advice, and take some necessary precautions to ensure personal well-being. The Philippine Government and local authorities are doing everything reasonable to guarantee the safety of everyone. Still, it might take some time to get used to seeing military personnel and police officers maintaining peace and order by patrolling the streets and manning checkpoints on the roads. Get used to the fact that almost all public places use armed security guards to protect employees, customers, and property. Expect frequent security checks in hotels, restaurants, resorts, bus stations, and shopping malls.

Mindanao has a diverse mix of individual backgrounds, and the island has its own set of unwritten rules regarding social interaction and values. One of the best ways to understand the basic customs, traditions, and traits is to look at the way of life of the different communities. Many small pleasures can be found for less money than you might expect: enjoying authentic cuisine in local restaurants, having a drink in front of one of the many *sari-sari* stores (small local shops), and meeting local residents. Start your trip with a gentle heart, open eyes, and an open mind; be prepared to meet challenges and to encounter unfamiliar sounds, smells, and sights.

Some behavior and customs may be confusing or perhaps even offensive. At first glance it may seem difficult for you to fit in; so be patient and take plenty of time to adjust to this new environment. Mindanaoans readily accept foreigners, both from the East and the West. Making friends in the Philippines is amazingly easy, aided by the fact that the country is the third largest English-speaking nation in the world.

Local people are welcoming, polite, and easy to please. Always smile when greeting somebody because this will be accepted as a friendly nonverbal hello. An amicable pat on the back or even a raising of the eyebrows will be regarded as a token of understanding and friendship. Approach people with kindness and respect; be gracious, and say thank you (*salamat po*) when offered any kind of assistance.

13

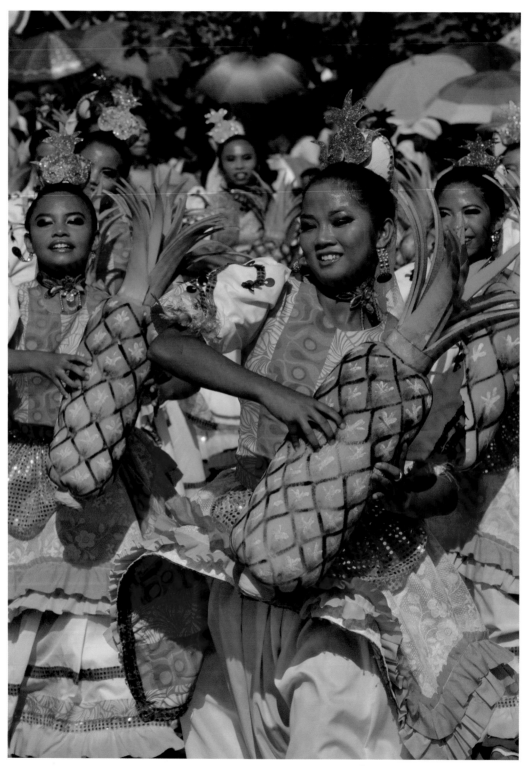

14

T'nalak Festival Street Parade

Mindanao: From Samai to Surallah

Hospitality is legendary and uncomplicated; visitors will always be greeted with a spontaneous smile that comes straight from the heart. Mindanaoans will do everything to make sure their guests feel comfortable; they will always offer something to eat and drink, even if your hosts are facing hardship at the time. This "open arms" welcome is special, and the cordiality works both ways. While Mindanaoans are known for the graciousness with which they show their generosity, they also know how to accept that same behavior from visitors.

For Mindanaoans any form of directness and frankness can be considered rude and unfriendly. Try to avoid any confrontation. Don't go straight to the point, be diplomatic, and never show negative emotions like anger or dismay in public. Losing your temper or raising your voice will guarantee that you will lose face. Be aware of your facial expressions, do not speak in a harsh tone, and do not curse, or people will surely feel embarrassed for you. The people in the Philippines tend to communicate through nonverbal cues most of the time, and Western body language and tone of voice often convey more to locals than the words that are being used. How you speak can be misinterpreted, completely changing the meaning of your words. Be modest in speech and don't be boastful in your behavior; humility, politeness, and consideration for others are much appreciated.

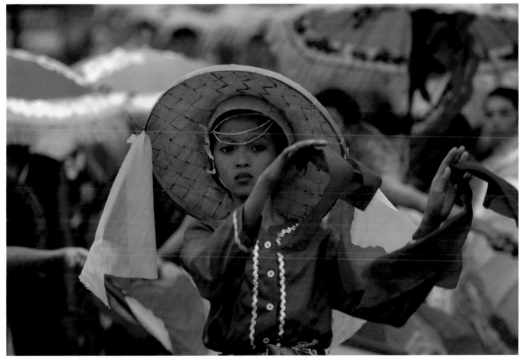

T'nalak Festival Street Parade

In some parts of Mindanao, especially in the countryside, foreigners are few and far between, so understand that locals might have a tendency toward long and curious stares or prolonged chat about your presence. Not only will you notice their gaze, you may hear the word *Kano* (*Americano*) many times; as a matter of fact, every person who doesn't have an Asian appearance is called Kano. It is normal to feel uncomfortable at this initially, but do not get annoyed or frustrated. It is not a sign of unfriendliness and there is no reason to feel different or strange in any way. People often stare without meaning to be offensive; they do it out of honest curiosity, admiration, and respect. A simple hello, just a nod and a smile, should be enough to break the ice.

In Mindanao there is always a place to stay that is right for any budget and personal level of comfort. There are many cheap hotels, boarding houses, and inns that provide basic accommodation, but these are usually dormitory-style with shared bathrooms and toilets and without air-conditioning. There are also hotels that offer more luxurious amenities.

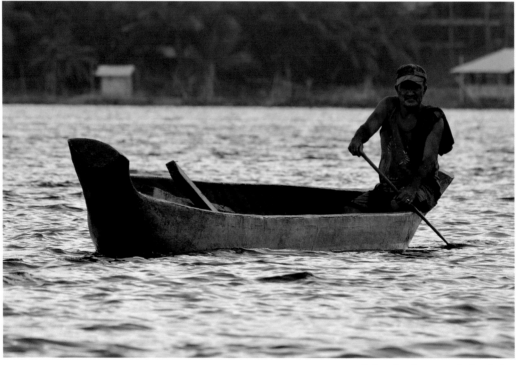

Man in Owong, Lake Sebu

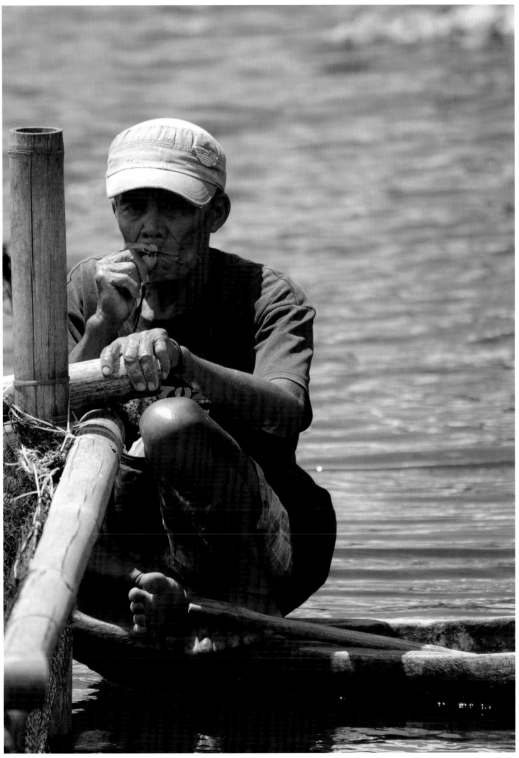

Lake Sebu, T'boli Fisherman

Try not to be so adventurous that you decide to sleep outdoors; there are creepy bugs and stinging insects out there, although most of them are harmless and only leave an annoying itch on the skin. It is best to take precautions in areas where malaria and dengue fever are rampant. Using insect repellent regularly is a must and getting a malaria vaccine before travel is advisable. As in many Southeast Asian countries, drinking bottled water (rather than water from a faucet) is mandatory.

When you are on the road and nature calls, do not be disappointed when you find not a square of toilet paper in sight. In most public bathrooms toilet paper is replaced with a bucket of water and a ladle. Local people use water instead of toilet paper to clean themselves; it is thought to be more hygienic and is part of the local culture, so for safety's sake, carry a pack of tissues when you go out. (It's not a bad idea to carry an ample personal supply of bath tissue with you on your trip, in case of an emergency.)

It's also useful to carry a cell phone when traveling; it is convenient and reassuring to have easy access to information, to contact loved ones at any time, or to book a hotel for the night without having to search for a local pay phone. It will provide a smoother overall travel experience and peace of mind. Mobile phone coverage is very good in Mindanao; check with your own provider before leaving for the Philippines and make sure that your phone has been activated for international roaming.

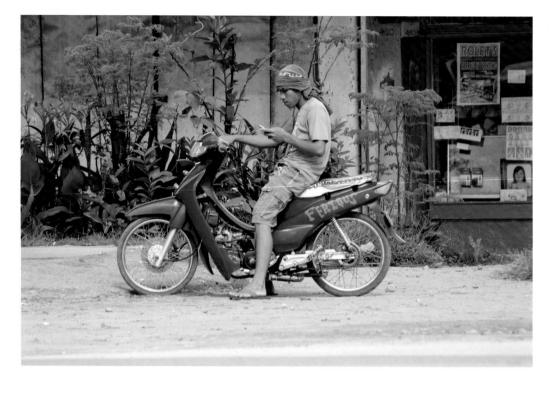

Mobile Phones

Mindanao has sufficient mobile phone base stations with good coverage, and loading up your phone with minutes will be no problem at all. Just look for the sign *Load Na Dito*, a phrase that screams from banners on almost every sari-sari store and other outlets in town. There are also signs that advertise various telephone companies, trying to convince potential customers to load up prepaid cell phones at that particular spot. These loading stations sell mobile minutes or e-minutes as easily as vendors do street food; there is no shortage of clientele because plenty of users carry their phones with them at all times.

With about 71 million cell phone owners sending more than an estimated 200 million text messages a day (more frequently than the annual average of any other country in the world), it is not hard to understand why the Philippines is generally known as the text capital of the wireless world. To send their personal bits and bytes, Filipinos from all walks of life and of every age use old phones, new phones, smartphones, iPhones, and iPods at work, at the beach, in schools; on buses, tricycles, and jeepneys; when they shop, drink, drive, walk, talk, meet, eat, watch TV, and—in some cases—when they sleep.

The sound of ringtones is quite common on the streets, and in churches, government buildings, restaurants, shopping malls, and hotel lobbies. Phones seem to be a virtual lifeline; to avoid any missed calls, people carry handsets in belly, hip, and shoulder holsters, in belt and neck pouches, in pockets, bags, purses, and mini carriers. However, most people prefer to hold their dearest accessory in their bare hands, so it is easy to reach and a reply can be given straightaway. Many use their cellular phones almost exclusively for texting, which is usually cheaper than making a voice call and reduces the monthly phone bill. Text messaging is hardwired into the Filipino way of life, an inexpensive and preferred way to keep in touch with family and friends at home and abroad.

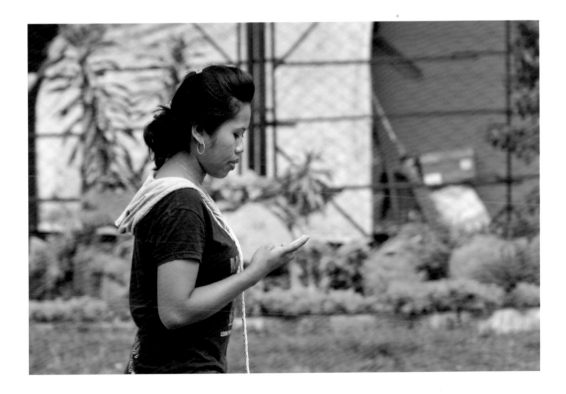

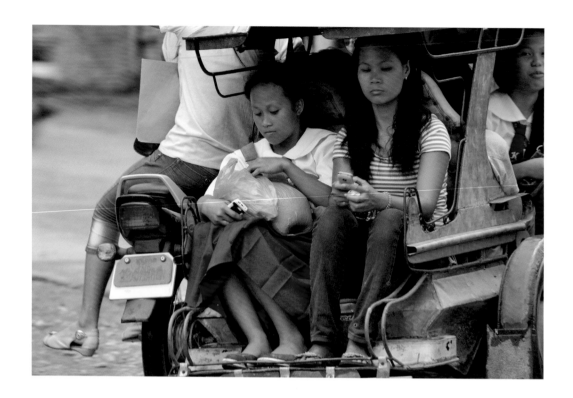

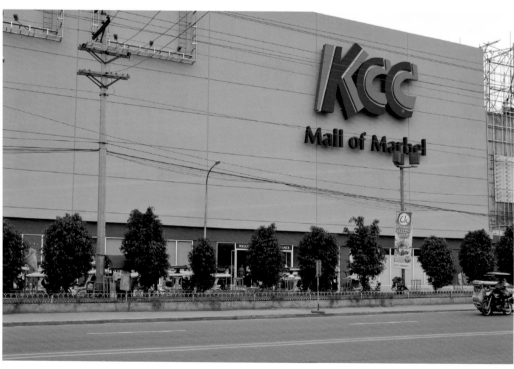

Koronadal City, KCC Mall of Marbel

Mindanao: From Samai to Surallah

Filipinos have raised texting to an art form; they are able to create a complete message with twenty-six characters, including the necessary punctuation, with only ten tiny buttons in a very short time. Typing very skillfully, with rapid-fire key punches using both left and right thumbs, without looking at the display and keyboard, people often walk and text at the same time with heads bowed, paying no attention to their surroundings, no matter how crowded they may be. The vocabulary used is a mixture of English and Tagalog, with a rare form of abbreviated spelling and creative grammar. Using the same texting slang creates a sense of belonging within a certain group and binds individuals together, regardless of their social and financial status.

For Filipinos a cell phone is much more than a simple communication device; it serves as an electronic billfold, letting people conduct their business on the go, paying bills and purchasing goods. This is a great convenience for many because shopping is a national passion and pastime.

Shopping

The main cities in Mindanao are a haven of shopping malls and commercial establishments, including dining facilities and specialty stores. Cheaper goods and food can be bought in smaller stores and from stalls on the streets, where haggling is common and not bargaining means getting ripped off. The average street vendor will expect some bargaining and will state prices higher than what will be paid in the end. Shopping malls and other stores, however, maintain fixed prices.

South Cotabato and Sarangani are often designated as great places for any shopping extravaganza; these provinces are a shopaholic's heaven, with vast and sprawling one-stop shopping centers housing department stores, a wide range of shops, fast-food chains, and a large selection of recreational facilities. The city of General Santos in Sarangani has some of the largest shopping centers; even though these malls are not as huge and luxurious as the malls in major cities, they have much to offer.

KCC Mall, which has more than thirty different shops, is one of the main shopping centers in this city. SM General Santos City, located at the corner of Santiago Boulevard and San Miguel Street, also provides great shopping and entertainment. Robinsons Place Gensan is the largest mall, with more than 150 shops. The Grand Gaisano Mall of Gensan and the smaller Grand Gaisano Mall of Marbel can accommodate every taste, pocket, and style. About an hour's drive from General Santos City, the three major shopping malls in Koro-

nadal City—KCC Mall of Marbel, the Grand Gaisano Mall of Marbel, and the Ace Center-point Mall—allow their customers the convenience of buying almost everything they want under one roof.

Shopping, more frequently called "malling," is deeply seated in the Mindanao way of life and malls are always full of shoppers. These modern marvels are excellent hangouts for people of all ages and backgrounds who want to splurge time and money to make their shopping experience a day out. Shopping malls are supposed to be places where one goes to buy goods; people stroll through their shining hallways, peeping through the many glass windows and buying the things they like or need. But here in the provinces "mall hopping" is a lot more than shopping; the air-conditioned centers are perfect places to get away from the oppressive heat. People spend time in them not just to shop, but to go to the movies, dine, play video games, or just roam around with family and friends. Many escape their poor living conditions by wandering and watching the world go by, or by going window-shopping, glancing at the goods they cannot afford today but perhaps may buy when times are better.

Teenagers, also known as "mall rats," ramble about the malls after school with their friends, spending three or more hours there every day because these places are large, clean, and safe. The food courts have inexpensive eating choices, and armed security guards provide safety and protection for their customers. And perhaps the biggest draw? Every mall is a great place to find somebody to flirt with.

When mall customers spend a certain amount of money, they are given raffle tickets with the chance to win a large sum of prize money and other gifts at the end of a promotional period. The lottery drawing always attracts a large audience of contestants, all of them eager to win the main prize. Usually local artists perform and show off their musical chops during the drawing, and a singing contest is held for upcoming talent, making these kinds of competitions very much in vogue among the general public.

Another crowd-pulling event is the seasonal bargain sale, organized a couple of times a year. Even though most people visit a mall to relax and cool off, the heat is on when sales begin. Filipinos are acclaimed for their etiquette, yet the temptation of a bargain can trigger unforeseen behavior.

Regardless of social class, some of them go straight back to their foraging roots, surrendering to the "call of the mall," which turns bargain hunting into a sport. Men, women, and

children sort through heaps and racks of outdated styles and rummage through boxes and baskets that are filled to the brim with discounted goods, hoping to scoop up treasures before anyone else beats them to it and yet never losing their tempers; they scrounge through neatly stashed piles of clothing under the watchful eye of attentive lady clerks who will refold the scattered apparel again and again.

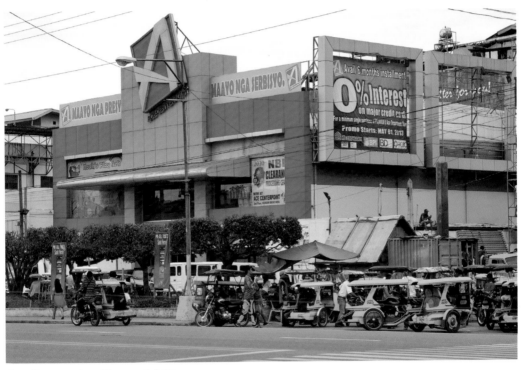

Ace Centerpoint, Koronadal City

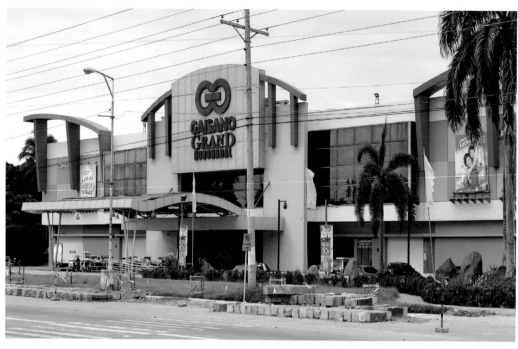

Gaisano Grand, Koronadal City

The clerks, all pretty in their own individual fashion yet proudly wearing their company uniform of high-heeled shoes, short skirts, and the same-style full-on makeup, are renowned for their personal approach and helpful attitude. They greet customers with a smile, follow their clientele at a discreet distance, and will assist immediately when asked.

As soon as the day has come to an end, tired mall customers and employees have to find their rides home. As they leave, pandemonium awaits. The warm humidity in the air folds over their bodies like a damp blanket, and the whiff of burning charcoal, diesel, and rubber is everywhere, along with the sounds of barking dogs, people yelling to each other, the tin whistles of parking attendants, and vehicles blowing their horns.

Numerous tricycles (three-wheeled motorcycles) form an orderly line in front of the mall and drivers approach potential commuters, each boasting about his driving capabilities and claiming that his three-wheeled motorcycle taxi is the best in town. Whether or not the bike is free of rust, or equipped with side mirrors or a complete and functional exhaust pipe, seems of no importance at all. For the tricycle operators and the noisy crowd of street vendors who hawk newspapers, comics, DVDs, and sunglasses, the presence of the malls with their continuing flow of shoppers ensures a regular source of income.

Even with their small number and size, the shopping malls in Sarangani and South Cotabato can compete with their bigger and more modern counterparts in the cosmopolitan cities, providing venues for shopping, relaxation, and other social activities. Nevertheless, it is undisputed that the good-natured people in this southern part of Mindanao are the ones who make a real difference. The uncrowned sales queens of courtesy, bargain hunters, die-hard shopping addicts, junior cleaners, Argus-eyed guards, loitering teenagers, fervent window-shoppers, wannabe lovers, pushy peddlers, determined drivers: all of them are an inseparable part of this shopping adventure that is best described as the Midland Mall Mania.

But these commercial centers also have their fair share of miscreants, beggars, and others who are more than happy to take unfair advantage of unwary travelers. Most of them are children who hang around the malls and parking lots; they can be quite a nuisance as they relentlessly beg for a few pesos. Do not give money to them; it will only lead to a confrontation with even more children. If they continue to follow or harass you, seek assistance from the store staff or security guards.

The street vendors on the city sidewalks and in the countryside can also be overwhelming with all sorts of unwanted attention; some can be quite persistent and very intrusive, with nearly all of them trying to make some kind of income by flogging counterfeit and pirated goods, overpriced wares, and products of inferior quality. Purchasing luxury items from street vendors is strongly discouraged. Always buy big-ticket purchases from reputable stores instead.

And be sure to go to a bank to exchange foreign currency; they generally provide fairly standardized and decent rates. Money changers can also be found at department stores, supermarkets, and hotels, but the rates are often highly unfavorable. Avoid anyone who wants to exchange money on the street.

ATMs are widely available in cities throughout the island, but may not be present in smaller villages or in remote areas. It is preferable to use ATMs during the day, when there are a lot of people around. Flashing money or carrying wads of bills in your pocket turns you into a sitting duck.

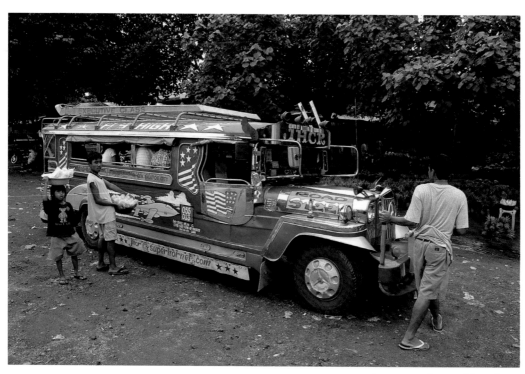

Street vendors selling fruit

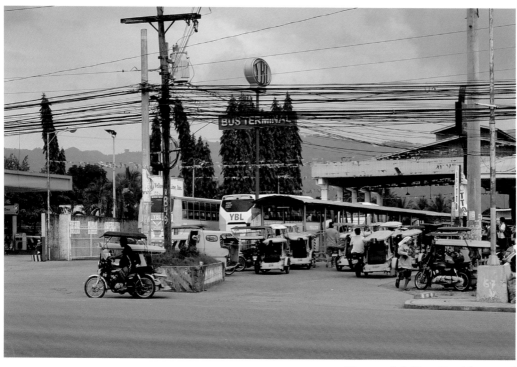

Koronadal City, Bus Terminal

Mindanao: From Samai to Surallah

Travel Tips

To explore the island countryside and mingle with local residents, the brightly painted jeepneys, multicabs, or minivans are great forms of low-cost public transportation. It is also easy to hop on a bus; the price of a ticket depends on the desired comfort level and the distance that will be traveled, but the standard of comfort on public vehicles can be lower than what you might be accustomed to. The poorly maintained, overcrowded, cheaper buses, with their broken seats and windows, are the ones on which you should be the most careful, but it is important to practice awareness with any form of public transportation. While buses provide an opportunity to travel long distances in a short time, remember that getting a seat on a bus or a plane can be difficult on Christmas, Easter, and other national holidays, when everyone in the Philippines hits the road.

The air-conditioned buses are reasonably priced and comfortable, while the older, unair-conditioned buses and jeepneys are used by locals and travelers who are hardy and resilient enough to experience a real taste of Filipino life. Taxis are generally available within the major cities but are usually not used for travel across the various provinces and mountainous regions. Confirm that the driver will turn on the meter before getting inside any taxi; if he doesn't want to do so or tells you it is broken, you can be sure he will cheat you on the fare. Some drivers can even be abusive. When taking taxis, it's wise to let the hotel staff call one; otherwise, take one from a taxi stand rather than hailing one in the street.

Travel by tricycle, jeepney, or any other local transport mode can be done for prices that range from five to twenty pesos. For riding short distances, a tricycle is the most common means of conveyance; they are a dime a dozen in cities and villages and almost outnumber cars on the road. Always agree on a price for the trip before getting in, ask the driver if he knows how to reach your destination, and do not pay for the ride until you arrive at the place where you want to be.

Road conditions can differ significantly from those you may encounter in your home country. Traffic rules are rarely enforced and traffic conditions in cities are often chaotic and crowded. Bus and jeepney drivers routinely ignore lane markers and stoplights; they sometimes drive recklessly and much too fast.

When leaving the highway it is easy to get lost and it can be hard to find a street or house, since there are many unnamed roads and the streets are not laid out in a grid alignment. In most places there are no street signs or house numbers and the addresses often are

only the name of the *barangay* (neighborhood) or the main street. Most people are willing to help, but for many it is difficult to say no and their "yes" may merely mean "perhaps." When they are asked for guidance, they may indicate the direction that has to be followed by pointing out with chin, lips, or head. Pointing with an outstretched index finger is only used to beckon dogs and is a rude and offensive gesture when flashed at another person.

As a rule it is best to avoid using any single finger as a gesture. Open-handed gestures, with all fingers kept together, are usually a safe approach. Extending your arm, hand facing toward the ground and moving the fingers back and forth—like making a fanning motion—is an acceptable way of calling someone or saying goodbye. Moving the head down once is also known as a beckoning gesture, but sometimes can mean "I don't know."

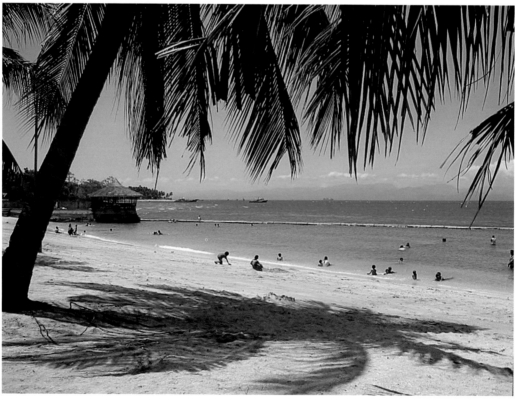

Beach Front, Sarangani Bay

Mindanao is widely known for its white sand beaches and crystal-clear waters; many local and foreign tourists visit the coastal areas all year round. Regrettably, opportunistic criminals also go to these alluring seafronts, searching for valuables that lie unattended. When tourists go for a swim, in the blink of an eye, their property can be gone, leaving them to bear the burden of their own carelessness and ignorance. Thefts at beaches have been a great problem for day-trippers for as long as anyone can remember, so do not leave possessions without proper supervision and stick to the main beaches that are well guarded where plenty of people enjoy the sea, the sand, and the sun.

The cities of Davao, General Santos, and Koronadal offer some of the most convenient hotels and resorts. For a short stay or an overnight stopover some budget hotels and pension houses in the area provide an economical alternative to the major hotels. The last thing you want to worry about is hotel security so pay close attention to location; make sure that your hotel is situated in a residential neighborhood and that there are security guards on the premises.

The door locks in the smaller hotels and pension houses in the region are mostly of inferior quality so use the extra bolt, if there is one, and keep the key in the lock. Never leave valuables out in plain sight and do not leave the room unlocked, even if you are just stepping out for a short while. At no time should you open the door to an unexpected knock, and under no circumstances should you allow a stranger to enter, even if they look and act helpful.

Mindanao has many festivals held in every town, attracting hundreds of passionate participants and even more enthusiastic spectators. Large crowds also attract pickpockets and thieves, who work alone, in pairs, and in groups. Crooks and unscrupulous scroungers can come in all shapes and sizes: children, men, women, and everyone in between. It could be someone "accidentally" bumping into you on the street, in a busy shopping mall, or on a jeepney. It only takes a couple of seconds for a bandit to strike, a few minutes for you to realize what's happened, and hours or days to deal with the consequences. While looking around or taking photographs, stay attentive to the people nearby. Staying safe and sound is largely a matter of using common sense and being alert.

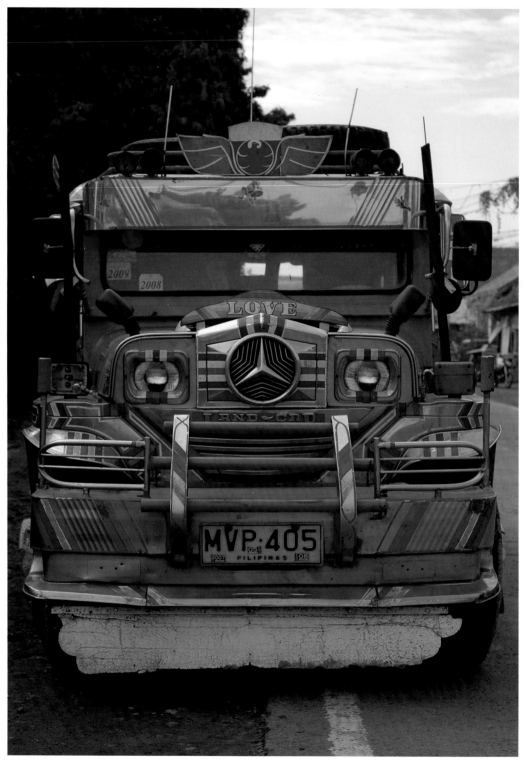

Jeepney

Mindanao: From Samai to Surallah

The Maharlika Highway

The greatest way to explore Mindanao is by car or motorbike, and the best road to drive is the mother of all highways in the Philippines, the Maharlika Highway. (*Maharlika* means "noble.") Better known as the Pan-Philippine Highway, this expressway extends for approximately 2180 miles, a network of long roads, bridges, and ferry services. It begins in Laoag City on the northern island of Luzon, goes through the Visayan islands of Samar and Leyte, and then further to the city of Zamboanga in Mindanao.

The Davao–General Santos–Koronadal National Highway is just a short part of this network, connecting the provinces of Davao and Sarangani to South Cotabato, Sultan Kudarat, and other parts of Mindanao. Over the years, this mostly four-lane main road has undergone many improvements and realignments, changing its path and overall length while moving its endpoint further into the hinterlands.

The highway is one of the smoothest road networks in the Philippines. Long and straight, it is a scenic journey through the unbelievable natural settings that make this region in Mindanao one of the best and most exciting ecotourism destinations in Southeast Asia.

Even those who only have time to pull off the road for a moment or so will still have the experience of a lifetime; this main artery has many points of interest along the way. The journey is just as important as the destination and it is worth it to get off the asphalt and take time to visit some of these sites.

Passing through this toll-free portion of the Pan-Philippine Highway will take you down small-town roads, city streets, mountain passes, rice fields, and plantations. You will also face road hazards that will keep your speed down and blood pressure up. Jeepney drivers and motorcyclists pass other vehicles both on the right and the left, taxis cut off other drivers without warning, overloaded trucks create clogged traffic, stray dogs mate in the middle of the road, and wandering *carabao* (water buffalo) and tricycle drivers suddenly stop or turn. Dump trucks run on crude oil that exudes more black smoke than a burning stack of rubber tires; horse carts and bicycle riders slowly move down the highway; *palay* or harvested rice is left on the road to dry; vehicles speed down the wrong side of the road while their drivers steer with one hand and use their mobile phone with the other; and pedestrians decide to cross the highway without warning.

Some parts of the highway feature narrow curves, without center lines or guardrail. It's important to watch out for sudden loose-gravel breaks where lanes are under repair, and the frequent traffic signs, sometimes placed in the center of the road, exhorting you to Slow Down, a phrase that is appropriate for the overall pace of the local highways. Construction sites are guarded by what seem to be apathetic road workers in makeshift shacks, waving barely noticeable green and red flags to make traffic move on or stop, sometimes making drivers wonder if the flagmen know the correct meaning of the two colors. The most common culprits are speeding and overpacked private buses and jeepneys; the words Keep Distance, painted on the back of these vehicles, are a constant reminder not to come too close.

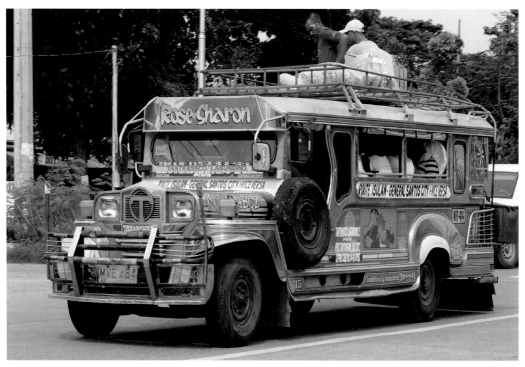

Jeepney

The Different Forms of Public Transportation

The jeepney was originally made from leftover US military jeeps and in time became both a symbol of the Philippines and one of the country's favorite means of transportation. In Mindanao most jeepneys are festively decorated and are often named after biblical characters or females. Every single jeepney is personalized; none is exactly the same as another. These undisputed kings of the road are as famous for their imaginative illustrations and bright colors as they are notorious for their horn-blowing drivers.

Because the fare is very inexpensive, jeepneys are much in demand; their seats are often filled with people and their belongings, seated face-to-face and knee-to-knee, with personal space minimized to almost nothing. As the vehicles travel, more and more people are added to a space that's already crowded, but Mindanaoans are very flexible and creative. They still get on board, eager to start their journey, hanging from bumpers or sitting on the top of the jeepney.

Standing at the side of the road and hailing a jeepney with a raised hand is the way to stop it and catch a ride. Once in motion, the vehicle can be stopped by knocking or tapping a coin on the ceiling. The various destinations are written on the sides and windshields; jeepneys do not take passengers to the exact spot where they want to go unless that place is along their daily route. If it isn't, you'll have to transfer to a tricycle or another form of transportation.

In places with few jeepneys, the tricycle is popular; this three-wheeled workhorse carries people and cargo and can easily reach the interior roads, narrow alleys, and rural areas. A good example of Filipino ingenuity, tricycles are constructed from stainless steel and chrome, and are often decorated with various mirrors and banners. They are the most convenient, economical, and common way of getting around, ferrying travelers just about anywhere. Although they have a seating capacity of five or six people, they can cram in many more than that. Passengers sit on the bench of the sidecar, on the floor, behind the driver, or on the luggage rack; hang on to the rear or sides of the sidecar; cling to the back; or even sit on the roof.

In addition to transferring people from one place to another, many tricycles are adapted to haul pigs, sheep, goats, and other livestock. A single-wheeled metal frame that partially or completely encloses the animal is attached to the motorcycle: a contraption that's also used to carry gas tanks, charcoal, recyclable junk, or crates of beer and soft drinks.

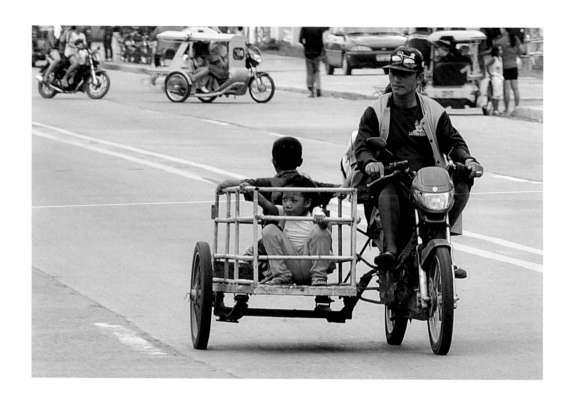

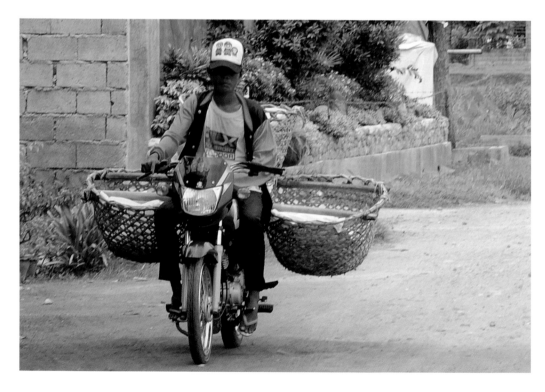

Mindanao: From Samai to Surallah

This flat sidecar is also the ideal cruising apparatus for a low-budget outing with the whole family or a trip to the shopping mall. It comes in many different forms and lengths and serves people in almost any kind of weather, terrain, road, or traffic conditions. It is also used to transport fish, furniture, appliances, and hardware—and is sometimes even used as an ambulance.

Wheeled transportation touches everybody, in all aspects of their daily lives, providing the community with access to friends, family, goods, services, recreation, and work, while giving a legion of venturesome and ambitious Filipinos a chance to earn some income. Being on the road costs money, and that is not available for everyone. But the rank and file in this country are well known for creativity; sometimes it seems they can make anything out of nothing. Whether it's for the transportation of human beings, animals, or freight, there is always a practical solution. For many it is not important how their vehicle looks; all that matters is that it works. If it moves, it will be transformed into an elaborately decorated conveyance.

The weirdest looking two-, three-, and four-wheeled contraptions can be seen in every corner of the cities and provinces. These come in a plethora of colors, shapes, and sizes, and can be well made or poorly constructed, motorized or man powered, factory built or homemade, cheap or high priced. Fabricated from new and secondhand materials, spare parts, and accessories from various brands; safe or unsafe; for commercial or private use, all of them are original with no restrictions of weight, width, or height.

Itinerant merchants who pull or push two-wheeled carts and hawkers with bicycles who sell all kinds of goods are a common sight on the streets. Street peddlers make daily life less expensive and much easier; they play an important role in keeping the local economy in motion. Most of them take their mobile shops to spots where they work every day, or they ply a regular daily route.

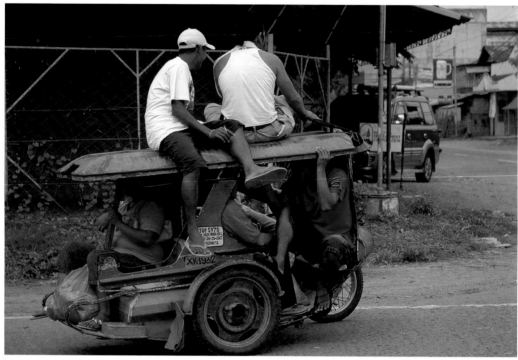

Tricycle

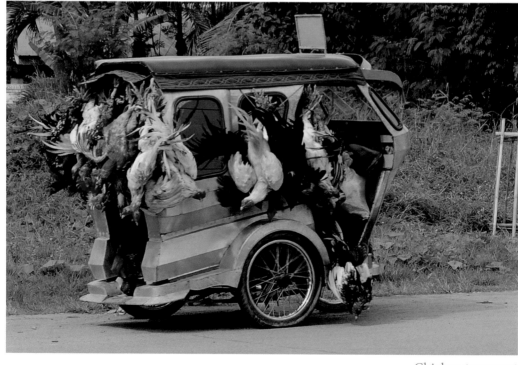

Chicken transport

Mindanao: From Samai to Surallah

A familiar sight around town is the vegetable vendor, going from place to place and house to house on a pedal-powered store. A majority of bicycle vendors sell food that is prepared on the spot, supplying hungry bellies with ice cream, fish balls, popcorn, vegetables, bread, and much more. These tireless food vendors, in perpetual motion on their small, eco-friendly carriers, know how to bring big smiles to many faces. Their wandering meals on wheels are fitted with an overhead umbrella or a canopy made out of plastic, canvas, rags, or even cardboard, providing some shelter from the sun, but giving little protection when it is raining or stormy.

Every movable mini-mart is converted and adapted to the kind of product that is being sold and is fitted with the appropriate essentials. Metal, wooden, plastic, or Styrofoam boxes and bamboo baskets for storage are mounted in various ways. All small-scale street entrepreneurs have a different way of announcing their presence, continually repeating the same sound as they move along: whistles, loudspeakers, cowbells, jingling bells, and bicycle horns all let potential customers know they are approaching. When such jingling and jangling, clanging or honking gadgets are not available, vendors call out what they have for sale.

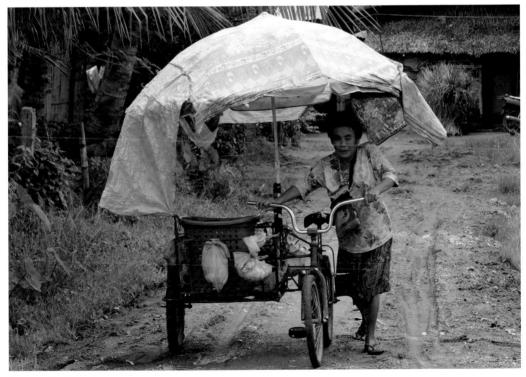

Vegetable Vendor

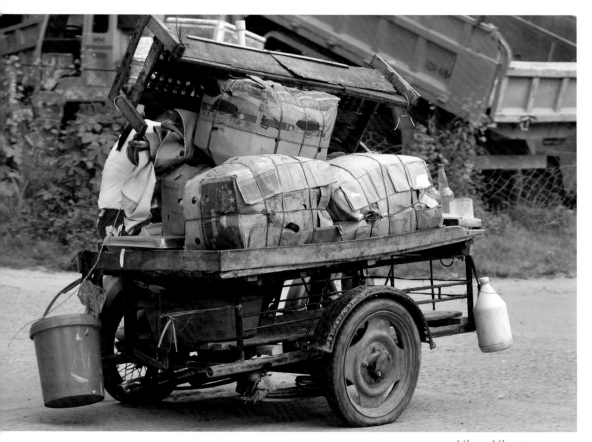

Ukay-Ukay transport

Mindanao: From Samai to Surallah

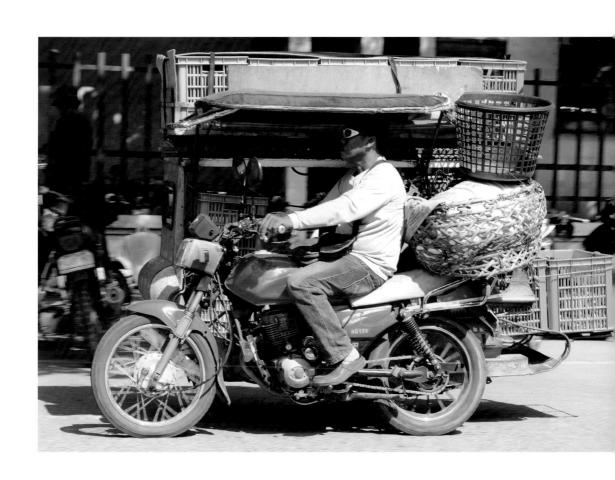

Introduction

Samal, Paradise Island Resort

Samal Beach

Mindanao: From Samai to Surallah

Samal Island

A good starting point for a journey through the southern part of Mindanao is the island of Samal, located at the heart of the Davao Gulf. Samal was once known as the island of Pu and was reputedly inhabited by giants named *dinagats,* who were over seventeen feet tall and were believed to be born from the union of gods and humans. These huge and violent barbarians were in the habit of sailing to the coastal villages, stealing food and abducting women. The tribal people living on the mainland were afraid to go to defend themselves against the dinagats, but after some time they decided to retaliate by sending a small raft to the island of Pu, decorated with colorful tassels, flowers, and lots of poisoned food. The offerings were eaten by the giants, who died and were buried in the cave cemeteries of Ligid Island.

Later the island of Pu was renamed after the Isamals, a tribe that originated from Borneo, Sulawesi, and the Moluccas; they were the first inhabitants of the island and probably one of the first Muslim groups in the country. One of the most scattered tribes in the Philippines, Samal people can be found in the Sulu Archipelago, the Zamboanga Peninsula, and the coastal regions of Mindanao. This nomadic people have distinctive rituals, dances, and songs. They are known for their decorative wood carving called *ukil,* and for making dyed mats from pandan leaves.

Samal Island is also called the Island Garden City, with its beautiful seashore enriched with mangroves, swamps, and coconut trees. It has many unspoiled natural attractions: caves, rock formations, and well-protected wildlife and native plants. There are some private beaches and about twenty-five commercial resorts along the coastline.

The waters surrounding Samal Island provide excellent diving spots that boast an abundance of marine life and coral reefs. Jet skiing and windsurfing are also popular.

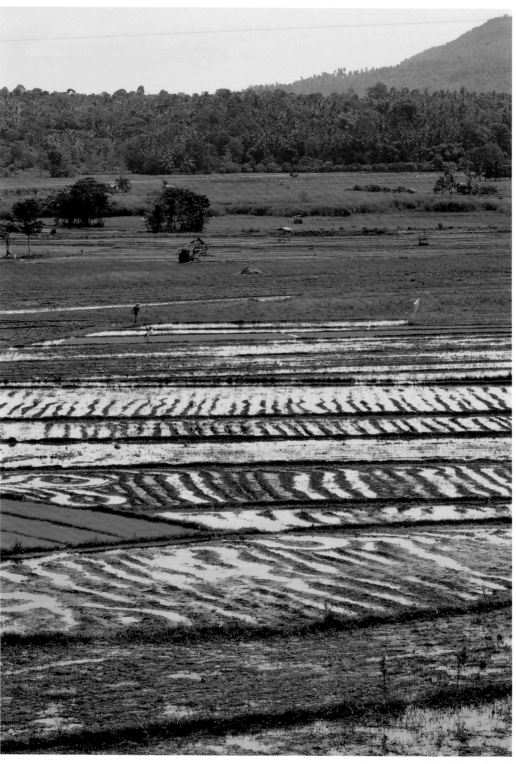

Samal, Aumbay Rice fields

Mindanao: From Samai to Surallah

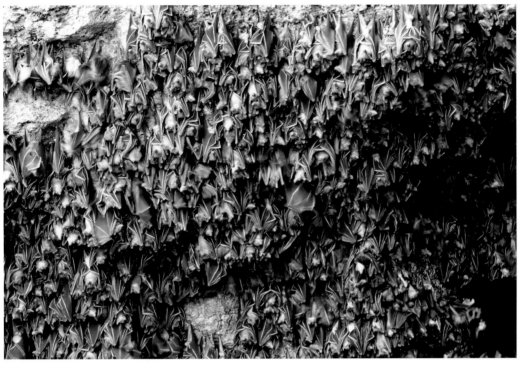

Samal, Fruit Bats *Kwaknits*

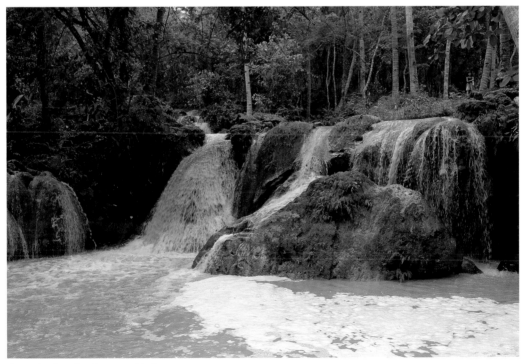

Samal Island, Hagimit Falls

Samal Island

Samal offers a wide range of outdoor activities. For trekkers and nature enthusiasts seeking higher ground, climbing Mount Putting Bato, the highest peak on the island that towers 1,362 feet above sea level, is a great adventure.

The island is also a splendid place for mountain bikers, with the Hagimit Falls serving as a spectacular destination. These falls have natural swimming pools and dramatic rock formations with a great variety of vegetation growing along the river banks.

Extreme challenges can be found by exploring the many caves, each a natural masterpiece with an exciting trail of mystery and magic. The seventy small caves on Samal Island are known for being among the world's largest habitats of fruit bats, known locally as *kwaknits,* providing a place where five major bat colonies cluster in groups for warmth and security. Thousands of these bats play a key role in the production of durian fruit every season and in maintaining the important balance in the island's ecosystem; their droppings, guano, are the best natural and organic fertilizer known to humankind.

Even though this flying, nocturnal mammal is historically one of the most feared creatures in the world, locals believe that eating the bat will cure coughs and asthma. They burn off the fur, skin the bat, and remove the stomach, glands, and legs. The remaining meat is chopped into small pieces and sautéed in oil, garlic, vinegar, tomatoes, pepper, and bay leaves. The dish, *paniki,* is said to taste like duck.

The bats can also be smoked, braised in coconut milk, or simmered. Although many people consider these fruit bats a delicacy, hunting and eating them ought to be stopped because their population is decreasing.

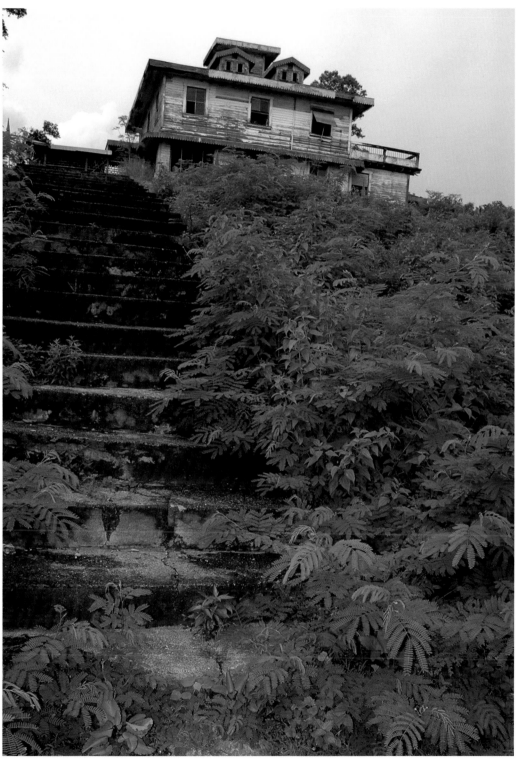

Headquarters of the *Filipino Crusaders World Army*

Samal Island

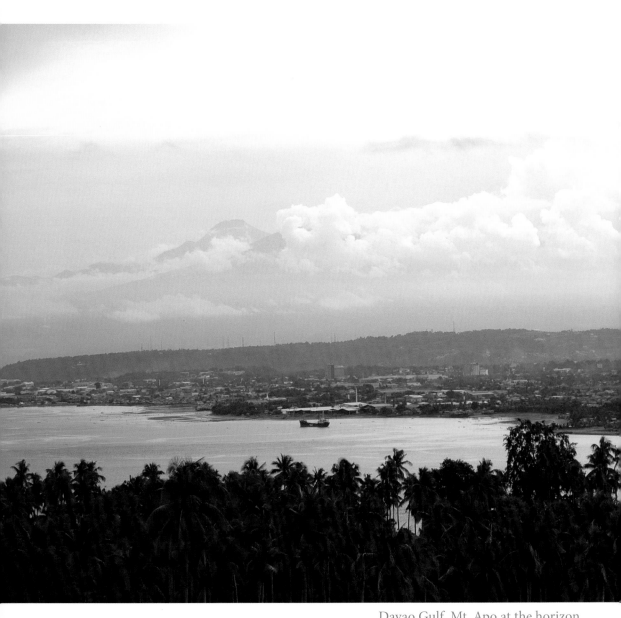

Davao Gulf, Mt. Apo at the horizon

Mindanao: From Samai to Surallah

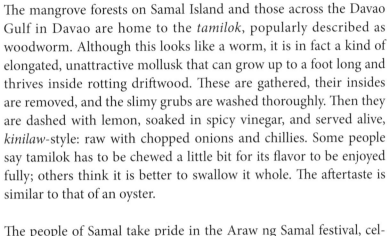

The mangrove forests on Samal Island and those across the Davao Gulf in Davao are home to the *tamilok*, popularly described as woodworm. Although this looks like a worm, it is in fact a kind of elongated, unattractive mollusk that can grow up to a foot long and thrives inside rotting driftwood. These are gathered, their insides are removed, and the slimy grubs are washed thoroughly. Then they are dashed with lemon, soaked in spicy vinegar, and served alive, *kinilaw*-style: raw with chopped onions and chillies. Some people say tamilok has to be chewed a little bit for its flavor to be enjoyed fully; others think it is better to swallow it whole. The aftertaste is similar to that of an oyster.

The people of Samal take pride in the Araw ng Samal festival, celebrated in the first week of March with water sport competitions, horse fights, a sand castle contest, and cultural shows. During this celebration, local fishermen compete in showing their skills and speed, paddling their *bangka* (pump boats) in the Bigiw Regatta. Other festivals are the Caracoles Festival (April 28–29), the Kabasan Festival (May 28), the White Nights Festival (June 18), and the Pangapog Festival (the first week of August).

A man-made attraction of Samal is a place named the White House, a historic two-level vantage point. The veranda on the upper floor provides a sensational view of the Davao Gulf and of Davao City's coastline.

The house once was the headquarters of the Filipino Crusaders World Army. It was inhabited by a man named General Hilario Moncado, born in 1898 and the founder of the religious sect known as the Mongkadistas.

Members of this sect ate their food uncooked and avoided all fish or meat. Tobacco, drugs, and alcohol were forbidden. Many of the adult men had long hair and flowing beards, thought to "shadow" the face of God. To his followers, General Moncado was regarded as a teacher, a prophet, and the source of the group's spiritual strength. He was believed to have the power to heal.

49

Pearl Farm Resort, Samal

Resort Recommendations

A popular place to stay is the Pearl Farm Beach Resort, once a cultivation farm for south sea pearls and now one of the most comfortable retreats on Samal Island, located on a secluded beachfront that is lined with mangroves and rocks. The resort can be reached from Pearl Farm Beach Resort's Davao Marina by boat in about forty-five minutes; there are four trips daily. A golf cart will carry guests from the parking area in about three minutes to the main area of the resort.

Guests can stay in cottages that are built on stilts submerged in the sea, in native Samal tribe-style, and are decorated with the tribe's customary pink and yellow colors. More accommodations are set on higher elevations with great views of the sea. Right in front of the resort, on a smaller island, there are a number of luxury villas that are located next to white sand beaches.

The resort has an aqua sports center that rents out jet skis, speedboats, kayaks, and outrigger boats for visitors who seek marine adventures. There is also a tennis court, a game room, a spa, and two swimming pools. The Parola Bar offers a magnificent 360-degree view of the island and the sea. At the Maranao Restaurant, there's an open-air stir-fry section where a wide variety of seafood can be chosen and handed over to the chef for frying. (The stir-fried prawns and crab is a dish that comes highly recommended.)

The Paradise Island Resort is located in Caliclic, Babak, and boasts a shoreline with nearly half a mile of powdery white sand beach, the longest on the island. Guests stay in air-conditioned cottages with thatched roofs and traditional *amakan* woven bamboo walls, all with private verandas.

Activities include jet skiing, scuba diving, badminton, and volleyball. The swimming area is manned by lifeguards and has a "safety net" to ward off jellyfish and floating rubbish. A fleet of ten colorful bangka transport guests to and from the resort in less than ten minutes.

The 138-acre Secdea Beach Resort is located at San Isidro, Babak. Near the white sandy beaches are luxurious accommodations and amenities such as floating cabanas that are built over the water on stilts, a multisport pavilion, buffet hall, fishing area, tennis court, wall-climbing sites, clubhouse, and the Infinity Restaurant, which serves exquisite Filipino dishes. The child-friendly swimming pool, fitted with a mini-bar for adults, gives a magnificent view of the sea and the island's landscape. Visitors can stroll over a wooden bridge and follow the trail along the shoreline to view the mangrove trees and the variety of animals that live there.

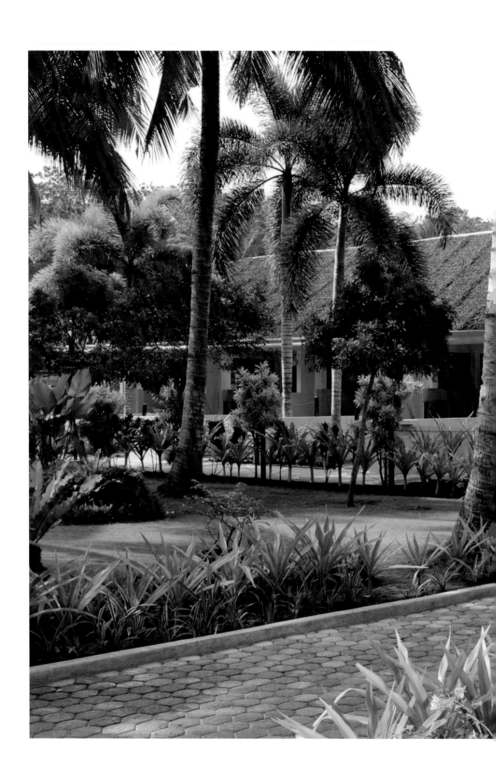

Mindanao: From Samai to Surallah

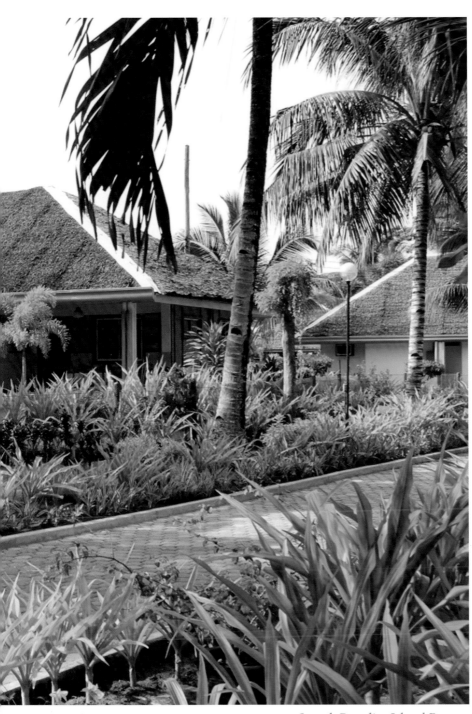

Samal, Paradise Island Resort

Samal Island

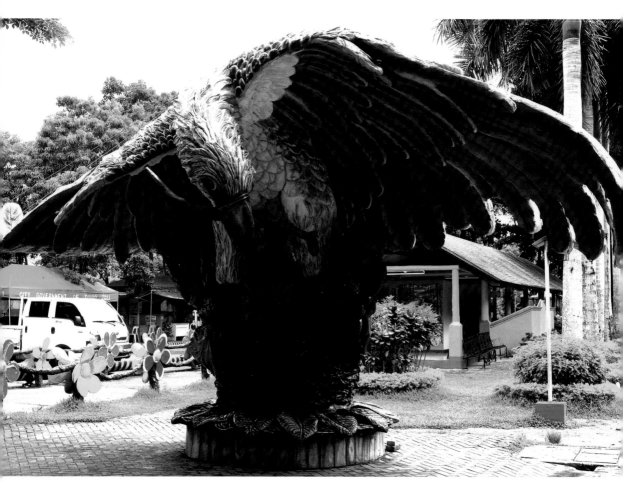

Davao, People's Park

Mindanao: From Samai to Surallah

Davao City

Davao is often called "the window to Mindanao" and is easy to reach from Samal Island. Roll-on roll-off, or *roro*, ferries transport cars and motorbikes in regularly scheduled twenty-minute crossings of the Samal Strait. (Bangka make the same trip in fifteen minutes and also can be privately chartered to go to Talikud Island and to explore the coastline of Samal.)

Davao's name comes from the word *Baba-Daba*, which finds its origin in the images of fire-breathing mythical figures used in rituals that were carried out before the beginning of a tribal war. Despite differences in traditions and backgrounds, the *Dabawenyos* (as the local residents call themselves) have always lived together in harmony. The various religions in this region coexist within a peaceful and kind community; mosques stand alongside Chinese and Buddhist temples and Christian churches.

The diversity of Davao's population translates into an exciting culinary adventure. Most restaurants cater to every gastronomic desire, including a wide range of halal food. Many choices of seafood dishes can be found in the restaurants and cantinas that are located along the coast and in the city's center.

Tuna is served in many ways, but the dishes that should not be missed are definitely *sinugbang panga* (grilled tuna jaw) or *tiyan* (grilled tuna belly), eaten with a spicy dipping sauce that is a mixture of vinegar, soy sauce, sugar, chopped onions, garlic, and chillies.

Davao is among the top ten dive destinations in the country; the coral reefs swarm with equatorial sea life and are unmatched scuba diving spots. It's also an ideal place for windsurfing and snorkeling.

For history buffs, the four main attractions are the San Pedro Cathedral, one of the oldest churches in Mindanao; the Saint Mary of Perpetual Rosary shrine; the Davao Museum (or *Museo Dabawenyo),* with its collection of southern Mindanao antiques, art, and handicrafts; and the shrine of the Infant of Prague.

The People's Park, found in the center of Davao City, is a ten-acre cultural theme park featuring man-made waterfalls, ponds, fountains, and a stretch of rainforest. At the heart of the park, a large statue of the Philippine eagle stands as a tribute to the national bird, and various sculptures scattered throughout the park represent the Lumads of Davao, illustrating the local life of this indigenous tribe.

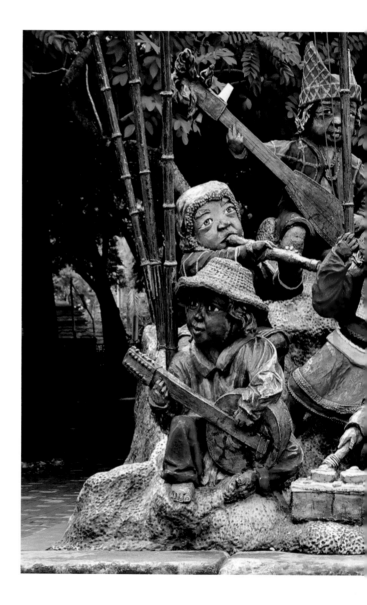

The people of Davao celebrate their festivals throughout the year, but the most famous of all is the Kadayawan Sa Dabaw festival. Observed every third week of August, this is a week-long celebration of the harvest of fruit and orchids, as well as a thanksgiving to the bounty of nature. The Araw ng Davao, a celebration of the founding of Davao, is another vivid and well-attended fiesta, held on March 16.

Mount Apo, on the borders of Davao, North Cotabato, and Bukidnon, at 9,692 feet, is the highest peak in the Philippines. (*Apo* means "grandfather of all mountains.") Its slopes are covered with tropical forests, rivers, streams, waterfalls, and exotic flora and fauna. A dormant volcano, it is a sanctuary for rare birds such as flycatchers, doves, sun birds, racket-tailed parrots, fairy-bluebirds, flowerpeckers, and the "monkey-eating eagle" or Philippine eagle. This bird of prey, with a wingspan of six and a half feet, is one of the rarest, largest, and most powerful birds in the world and has become the national symbol of the Philippines.

Because of Davao's proximity to Mount Apo, it is one of the most famous Philippine mountaineering destinations. Before ascending, all climbers must first undergo the traditional *pamaas*—a ritual to appease the mountain god, Apo Sandawa—which is performed by elders from the Bagobo tribe. Mount Apo is the Bagobo ancestral domain and their sacred place of worship.

Davao, People's Park

The Bagobo Tribe

The mountainous region between the upper Pulangi and Davao Rivers is also the home-land of the upland Bagobo tribe. The coastal Bagobo once lived in the hills south and east of Mount Apo, where according to legend, their supreme god and common ancestor Apo Sandawa ruled over them. The Bagobo tribe traces its origin back to the people who brought Hinduism to Mindanao. (The name of the tribe pays tribute to this, with *bago* meaning "new" and *obo* meaning "growth.") Throughout the centuries, a strong social structure has enabled these native groups to blend well with the indigenous population while still retaining their own customs, beliefs, and values.

The Bagobo were originally a nomadic tribe, traveling from one place to another by hack-ing their way through the virgin forests. They finally settled in this region, which had large stretches of grassland with tall trees and a vast area for hunting. The Bagobo used bows and arrows both to hunt wild boar, deer, or monkeys as well as for fishing in the pure waters flowing from the slopes of Mount Apo.

The first Bagobo settlers cultivated the land with various crops, but always abandoned the farmland after harvest time to search for a better place. The inhabitants in these early settlements feared the *anitos*, spirits which included deceased ancestors, and nature spirits or *diwatas*, who could grant their desires if offered sacrifices.

Their religion is a collection of innumerable *gimokods* or spirits, who must be shown re-spect, while the Bagobo believe in a supreme being, *Eugpamolak Manobo* or *Manama*, who is the great creator who inhabits the sky world, as well as a deity, a supernatural immortal being, who brings sickness and death.

The knowledge of spirits and ancient legends resides in old tribal women, better known as *mabalian*, who often tell the story of Tuwaang, a brave and strong warrior with supernatural powers. One of the stories they tell is a myth that recalls the fight between Tuwaang and a giant from the land of Pinanggayungan. A maiden of the Buhong Sky who was fleeing from the giant of Pangumanon encountered Tuwaang when he was riding on lightning across the sky. As Tuwaang and the giant fought for the maiden, the giant used his magi-cal powers and threw a flaming bar at Tuwaang. He was able to escape this ordeal by using his own magical ability, calling for the wind to fan the fire and engulf the giant in his own flames.

58

The mabalian practice ceremonies, including healing, and their reliance on ancestral rituals and herbal medicine have widely gained acceptance as part of the island's culture. The mabalian are also skilled weavers of abaca cloth, woven from plant fiber, dyed in earth tones, and then heavily embroidered with beads and elaborate stitch work. They are known for their inlaid metal betel boxes that are finished with bells, and for baskets that are trimmed with multicolored beads, fiber, and horsehair.

The never-ending jingle of the tiny brass bells that have been woven into clothing has become a Bagobo symbol, and the heavily ornamented Bagobo are thought to be the most colorful people of the Philippines. It is said that the spirit Baipandi taught the weavers the arts of embroidery and beadwork, the tie-dyeing technique of ikat, and the designs that are woven into the fabric.

Some Bagobo people have abandoned their tribal roots to embrace modern life, but most of the tribe remain proud of their heritage, tradition, and cultural identity. They still wear their colorful costumes, play their music on gongs and *kulintang* (an instrument similar to the Indonesian *gamelan*), dance ancestral dances, and sing solemn chants during their harvest rituals.

59

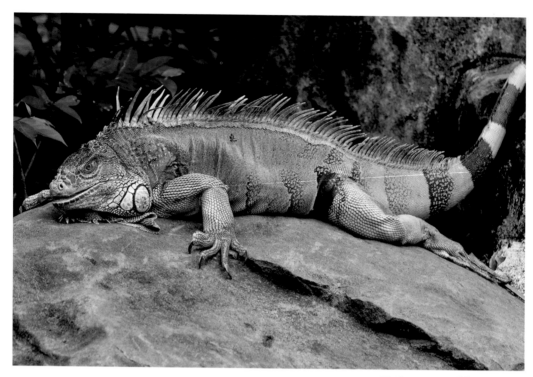

Philippine Sailfin Dragon

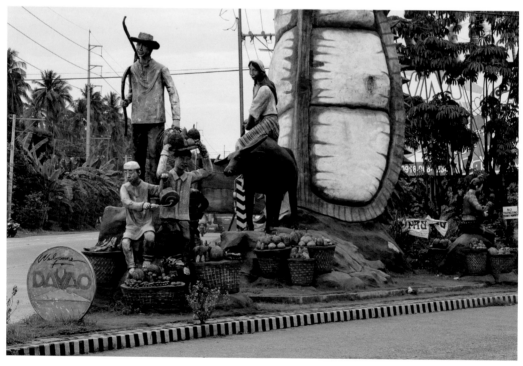

Toril Sculpture

Mindanao: From Samai to Surallah

Surallah

As your southbound journey continues, you can make the 125-mile trip to Surallah in as little as six hours, but that's one heck of a drive and you will miss a lot. There are plenty of places for staying overnight in all different levels of comfort along the route and many places to visit with a lot to do.

For thrill seekers there is the Davao wild-water experience; rafting on the Davao River with its varying degrees of rough water is pure excitement. The spelunking sites in the Marilog District also deserve a visit. And when going off the highway near Barangay or Buhangin, a fifteen-minute ride will take you to the Crocodile Park in Ma-a for a confrontation with one of humankind's most feared creatures, the man-eating crocodile or *buwaya*. Aside from these giant predators, there are many other animals to see: monkeys, snakes, dragon lizards, and birds such as parrots, doves, falcons, hawks, ostriches, and eagles. For those who dare, the Riverwalk Grill Restaurant next to the Crocodile Park serves braised crocodile paws, crocodile steak, fresh crocodile pasta, and many other culinary treats that are made from crocodile. The white meat of the sharp-toothed reptile is a bit hard to chew but has a unique taste, comparable to the flavor of whitefish, with a texture that is somewhat similar to pork.

A special dessert can be grabbed right across the park at Sweet Spot Artisan Ice Creams—crocodile ice cream, made from milk and the eggs of the crocodile.

In addition to the crocodiles, another reptile will surely grab your attention: a Philippine sailfin dragon that is over five feet long, much of that length in its tail.

After leaving the city of Davao it is only a forty-five-minute drive to Toril, a small village with seaside charm. Near the Gaisano shopping mall, a cluster of sculptures depicts tribal

people celebrating the new harvest. A large durian is at the center of the piece, surrounded by fish and fruit vendors, a *kudyapi* (traditional two-stringed lute) player, and a woman riding a carabao.

Santa Cruz is the oldest municipality in Davao del Sur, a province along the shores of southeastern Mindanao that is known for its interesting rock formations. A quaint coastal town, Santa Cruz has excellent seafood restaurants, most of them located along the shoreline, overlooking the sea. They provide great opportunities for a rest stop in a beautiful setting and to discover local dishes made with freshly caught grilled fish.

At the outskirts of Santa Cruz, roadside vendors sell decorative wooden handicrafts and other local products.

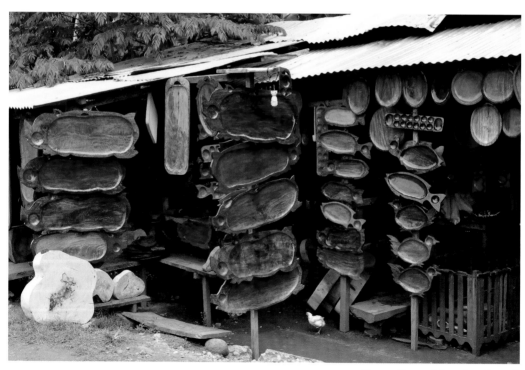

Santa Cruz, Handicraft stall

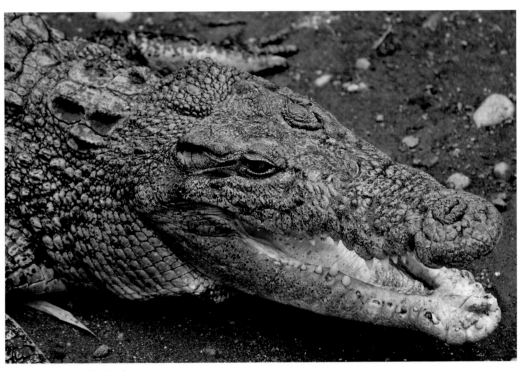

Davao, Crocodie Park

Crocodie Steak

Surallah

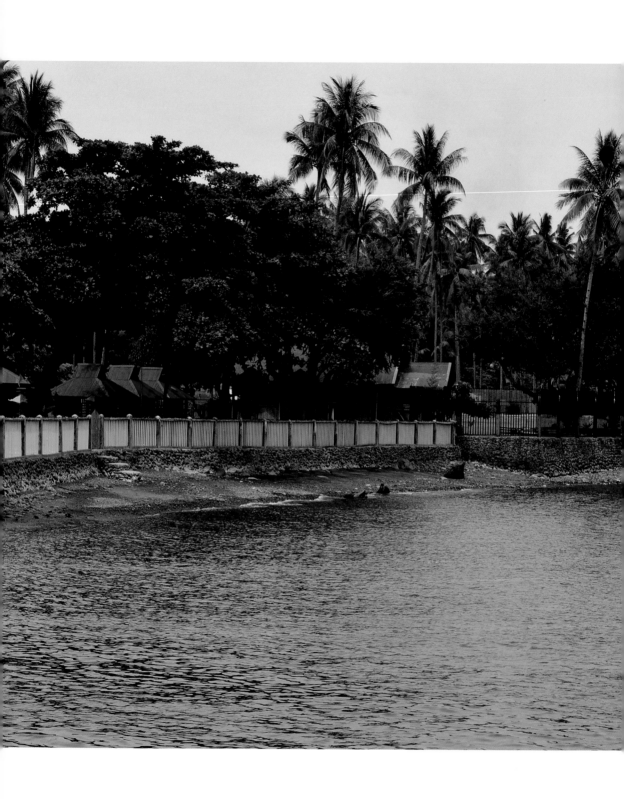

Mindanao: From Samai to Surallah

Santa Cruz, Coastline

Resort Recommendations

Close to the town of Toril, less than thirteen miles away, at the foot of Mount Talomo is the Eden Nature Park, a mountain resort that is full of huge pine trees and a great variety of blossoming flowers. An area with replicas of traditional houses shows how people lived centuries ago; Lola's Garden (*lola* means "grandmother") offers a lovely view of the park; and the Mayumi wishing well is a picturesque spot with colorful *gumamela* flowers floating on the water's surface. Activities here include rope gliding or sliding down the 656-foot Skyrider zip line.

65

About half a mile from the coast a small tropical resort can be found on the pastoral Passig Islet, located at Sitio Bato in Santa Cruz. Once a coast guard base, the two-and-a-half-acre island is now the Aqua-Eco Park Resort, which can be reached by bangka. Small but comfortable traditional nipa cottages that are shaped like mushrooms are placed around the islet, some of them right next to the beach.

Malungon, Cliff Hanger

Mindanao: From Samai to Surallah

Digos and Malungon

After driving 37 miles, you will reach Digos, the capital of Davao del Sur and a city built on seven hills. Digos is located halfway between Davao and General Santos City on the eastern shores of the Davao Gulf and has beaches, island resorts, and many rivers that flow into the gulf. The city's name comes from the word *pagdigos,* meaning "to take a bath."

In the city center, restaurants that serve fresh seafood are open twenty-four hours a day. Digos also has the second-longest zip line in the Philippines. With a ride that soars 262 feet above the trees for a length of 2,690 feet, this spine-tingling attraction at Camp Sabros draws thousands of thrill seekers.

The mangrove forest and its surrounding habitat are the ecological basis for the survival of the region's marine life. The branches of mangroves serve as a nesting ground for coastal and wading birds, and many animals find sanctuary in the roots of these trees. Additional places to visit are the Napan Falls in the barangay of Goma; the Lumayan spring; the two-tiered Bacoco spring; Marawer's hot and cold deepwater wells; Mahilak Falls, a forested area with clear water; and Dulangan Falls with its five tiers of cascading water.

When you arrive in Sarangani Province on your way to the town of Malungon, rolling hills and mountains dictate careful driving at low speed. Driving this spiraling road, with its tight curves, steep inclines, and narrow drops, is an exhilarating adventure, with a sensational viewpoint at every bend, turn, and slope. At the road's highest point, 755 feet above sea level, a terraced restaurant suitably named Cliffhanger grants spectacular views of Mount Apo, Mount Matutum, Sarangani Bay, and the Davao Gulf all at the same time.

Malungon's S'lang Festival features the town's rich variety of highland products along with the cultural heritage and traditions of the B'laan and Taga-Kaulo tribes, the region's

original inhabitants. (*S'lang* is a B'laan word that means "barter," and the festival is held to commemorate and preserve the practice of bartering. While exchanging goods rather than money still takes place, nowadays most festival-goers pay for their purchases with currency.) Among the activities are horse fighting, a parade, street dancing, and tribal games such as *sambunot*, a wrestling competition. The three-day event is celebrated during the founding anniversary of Malungon, in the month of July.

Malungon's natural attractions are the Datal Bila Water World, located within the Mount Matutum Nature Park, and the Nanima Watershed, a reforested area that is a main source of drinking water, just at the foot of the Kalon-Barak Skyline. The watershed is home to the Philippine tarsier, a sacred animal for the B'laan and Taga-Kaulo tribes. This night-loving creature is one of the country's most recognizable animals and easily found in sanctuaries of its natural habitat. No larger than an adult man's hand, it is one of the smallest primates in the world.

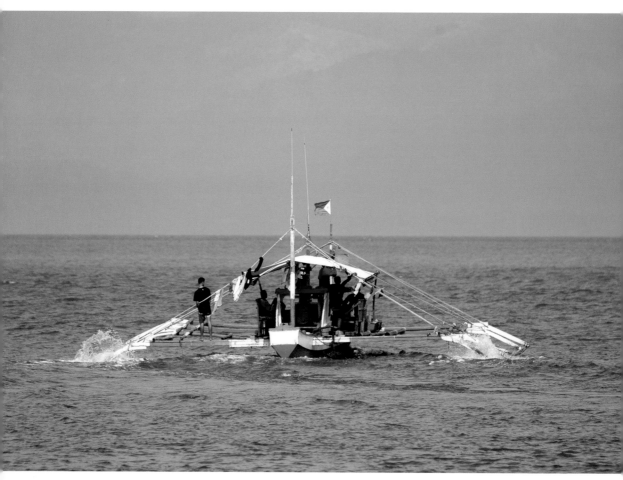

Sarangani Bay, Banca, outrigger boat

Mindanao: From Samai to Surallah

The Province of Sarangani

Not far from Malungon is the coastal province of Sarangani, located on the southernmost tip of the island. The name *Sarangani* comes from the mythical Saranganing, a brave sailor and son of the Sangil family who lived on the island of Celebes. His voyages often brought him to trade goods with the people of the Maguindanao tribe who lived in the Sultanate of Buayan (now General Santos City). Saranganing was well known and respected by the Maguindanao, and after his death the bay was given his name.

The Sarangani Bay Festival is the biggest beach and sporting event in Mindanao, a two-day festival held at Gumasa Beach on the third weekend of May. One of its highlights is a three-hour swimming relay race that is regarded as the longest sea-swimming race in Asia. The marathon runs from one end of the bay to the other, from Tinoto Beach in Maasim to Gumasa Beach in Glan.

A large number of local tourists come to Sarangani Bay because its beaches are some of the few undiscovered places that have escaped the clutches of mass tourism. In the months of June and July, large squid come in by the hundreds to lay eggs on the staghorn corals, which are home to a wide variety of fish and other sea creatures. The warm, clear water in the bay is a refuge for as many as twenty-four hundred species of sea life, including yellowfin tuna, whales, sea turtles, reef fish, dugongs, dolphins, and large congregations of shrimpfish, manta rays, eagle rays, barracuda, marlin, and mackerel.

The Abyss, Maasim Reef, and Sumbang Point give sanctuary to a large population of whitetip sharks, butterfly fish, and cabbage corals. Diving at the enormous Tinoto Reef Wall in Maasim provides an incredible underwater experience at depths of forty to sixty feet. Along the walls of the reef big sponges, gorgonians, rainbow runners, and corals can be seen.

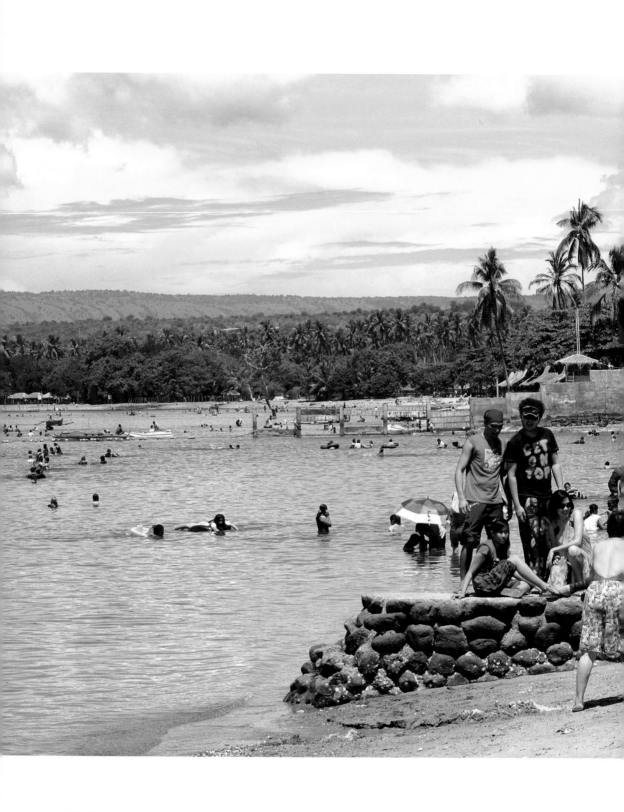

Mindanao: From Samai to Surallah

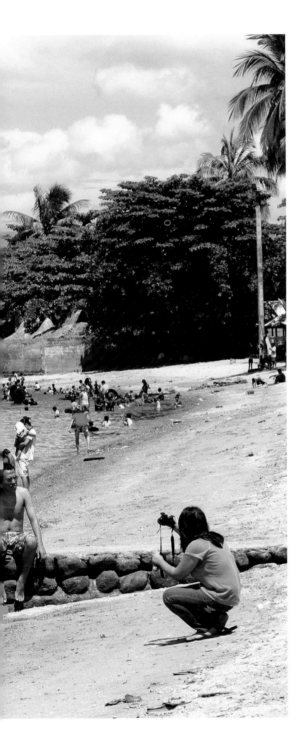

Resort Recommendations

Among the resorts in the Sarangani Bay area that provide affordable accommodations, the Tropicana, London Beach, T'boli, Rajah, and Maharlika resorts are seaside sanctuaries for romantic retreats and the ultimate hideaway for beach lovers. The best times for swimming are early in the morning and late in the afternoon when the low tide transitions to high tide. Sarangani Bay may not be as luxurious as the usual tourist spots in the Philippines, but its low prices and kind people make it a superb aquatic playground.

Located at the southwest corner of Sarangani Bay, at the edge of the Tinoto Reef, the Lemlunay Resort serves as a perfect base for scuba diving. *Lemlunay* means "paradise" in the native dialect of the T'boli and B'laan tribes.

One of the best beaches in Sarangani can be found in the town of Kiamba, about an hour from General Santos City. Tuka Beach is often described as one of the most wonderful beaches in the Philippines. The Tuka Marine Park Sanctuary is accessible only by sea. It has three white sand beaches and four coves. Only one of the beaches is open to visitors, with a few cottages and a beach house available for overnight stays.

Sarangani Bay, Tropicana Beach Resort

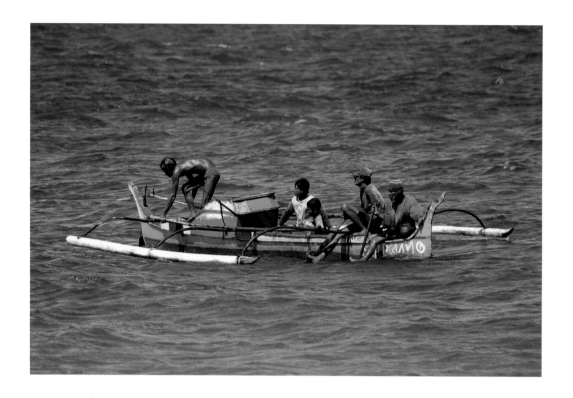

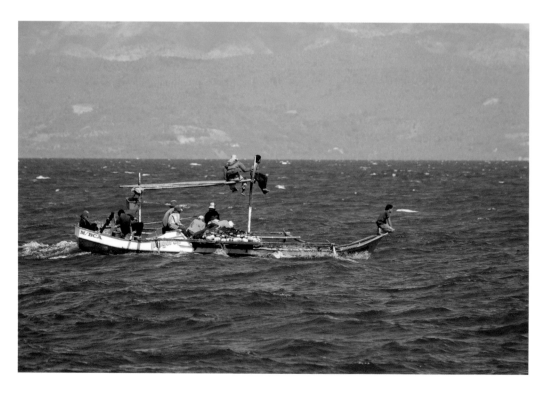

Mindanao: From Samai to Surallah

The Badjao Sea People

Communities of fisher folk live on the shore of the bay, and depend heavily on it, since fishing has been their main source of income for centuries. The majority of these local fishermen still cast their nets upon the water to catch small schools of fish, putting to sea in bangka. These traditional wooden canoes are sleek and long, with two bamboo outriggers for stability, and a small engine. Over centuries, the bangka has developed into a primary mode of water transport and is used for hauling people and small-scale cargo, as well as for fishing. These boats are generally owned and operated by the Badjao, a tribe of seafaring people originating from the Samal tribe. They are known as sea gypsies because they move with the wind and the tide on their small houseboats called *vintas*. They can be found in many coastal settlements on the waters along the shores of southern Mindanao. (*Badjao* or *Bajau* means "man of the seas.")

Legend tells that these boat dwellers came from the shores of Johore in Indonesia. Princess Ayesha of Johore was betrothed to a Sulu sultan but she wanted to marry the Sultan of Brunei. One day, as a large fleet of war boats escorted the princess to Sulu, the fleet was intercepted by the man she truly loved, the Sultan of Brunei, who kidnapped her and set sail back to his domain.

The escorting fleet could not return without the princess, so they continued to sail the seas, mooring only at uninhabited islands. Some of them turned to piracy and searched for fortune and glory. Others became fishermen, since the Sulu Sea had an abundance of fish to sustain their livelihood, and they traded most of their daily catch with other tribes that lived along the shores and beaches.

Although the Badjao still prefer to live in houseboats, they have also built stilt houses near their fishing sites, as temporary domiciles during times when they need to repair their sea-dwelling homes. Still, these sea wanderers are born on the water, live on their boats, and say they will settle on land only when they die and are buried in a cemetery. The Badjao regard themselves to be a nonaggressive tribal community. Conflict with other tribes is often dealt with by fleeing to other places on the sea. Other tribes traditionally looked down on these fisher folk, calling them *palao* or *lumaan* (godforsaken).

Over the centuries, the water has altered the attitude and appearance of these Bedouin of the sea. The rough environment and nautical way of life have shaped their physical features, with their bronze- colored hair and dark brown skin clearly distinguishing them from other tribes.

Although they have been strongly influenced by Islam, the Badjao practice a form of ancestor worship; the spirits of deceased forefathers are asked for favors during frequent cemetery visits. They offer cigarettes and food, and a fragrant tonic is sprinkled on the corners of the graves. The spirits are still part of the family and their surviving descendants continue to provide them with comforts that will keep them happy. Offerings are also made to the god of the sea, the *omboh dilaut*, and mediums are called upon to remove spirits who cause illness during times of epidemics.

Although the Badjao people have fished the open seas for over a thousand years, overfishing by other groups who use everything from dynamite to high-tech fishing trawlers, and soaring costs for fuel and repairs are eroding their traditional way of life. In their small bangka they continue to roam the waters, fighting the current to follow schools of fish, hunting for the bounty of the ocean, trying to make a living while seeking refuge in the vastness of the deep blue sea.

The Badjao have never had easy lives, but they have learned that although times can be tough on the water, it is worse on land where, as sea gypsies, they are shunned by almost everyone. For centuries this resilient tribal group firmly pushed away modernity with both hands, but tossed by modern winds, the way of life bequeathed to them by their ancestors has vanished in most parts of Mindanao. The Badjao are the most marginalized ethnic group and one of the poorest tribes in the Philippines, forced to beg for food in the streets of General Santos City and other nearby towns.

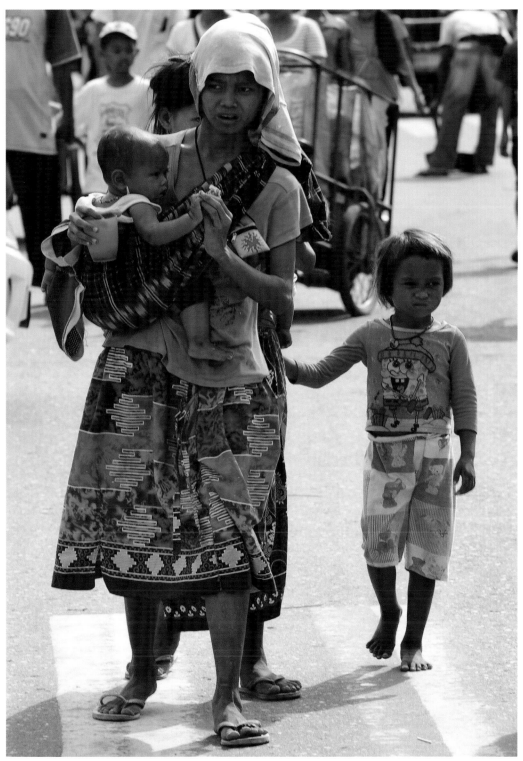

Badjao Children

The Province of Sarangani

General Santos City, Queen Tuna Park

Mindanao: From Samai to Surallah

General Santos City

General Santos City is a dynamic place tucked away in the mouth of Sarangani Bay, one of the most populated cities in the country and a fusion of diverse groups coming from all over the Philippines. Despite its high population, it's also an area with splendid scenery, charming lakes, natural springs, palm-fringed white sand beaches, and historical sites.

The city is also known as *Dadiangas,* a word from the Bl'aan tribe used for a tree which has thorns on its trunk and stems—although only a few dadiangas trees can now be found in the General Santos Park and surrounding farms in the rural barangays. The city was later renamed to pay tribute to Paulino Santos, a general who led the first group of settlers from Luzon into Mindanao.

The tuna (or *bariles*) fishing industry is strongly present in General Santos City. Every day the city processes the largest tuna catches in the country. The processed tuna immediately goes from the harbor to the airport and is sent to markets around the globe.

Since General Santos City is the tuna capital of Asia, it's no wonder that many restaurants and smaller eateries (called *carinderias* or *turo-turo*) offer tuna as their main dish, with the word *tuna* prominently displayed on big billboards. It can be ordered fried, grilled, in a soup, or even raw; although grilled tuna is a best seller, one of the most popular appetizers is probably *kinilaw na tuna*, a raw fish salad that is similar to ceviche and usually consumed as *pulutan*, or finger food.

But there is no fish on the table without a harbor; the Makar Wharf is the main international public port of the city and one of the best open dockyards in the Philippines. The busy anchorage lies at the head of Sarangani Bay, stretching along the bay from Tampuan to Sumpang Point. Makar Wharf connects General Santos City to foreign as well as domestic shipping routes and is equipped with up-to-date facilities.

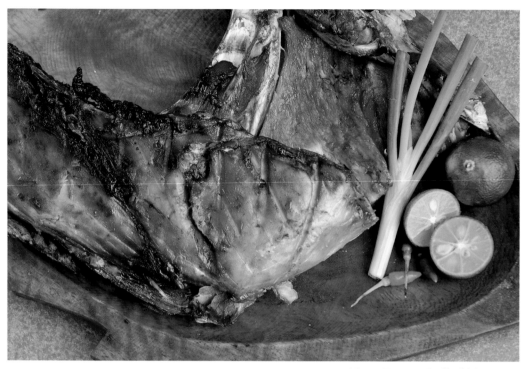

Tuna Panga, Grilled Tuna Jaw

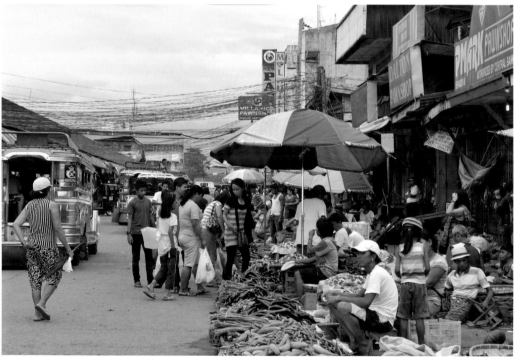

General Santos City Street Market

Mindanao: From Samai to Surallah

Not far from the Makar Wharf is the Fisher Port Complex, where, from first light till late in the evening, fisherman carry huge, fresh tuna on their shoulders. Large tuna, which can weigh over three hundred pounds, are caught in nets from the big trawlers and pump boats and brought to the local fish auction and markets.

Every September the Gensan Tuna Festival, one of the biggest and most anticipated festivals in the region, is celebrated throughout the city. It is both the anniversary of the city's charter and an homage to the fishing industry that drives and supports the local economy. The centerpiece of this fiesta are the culinary activities that create the dishes made from freshly caught sashimi-grade tuna. Other highlights are the street-dancing contest, beauty pageants, and a float competition in which giant replicas of tuna and other sea creatures appear.

General Santos City's annual Fluvial Procession takes place on the water during the Gensan Tuna Festival. This aquatic parade is in honor of the Feast of the Santo Niño, on the third Sunday in January, and consists of devotees in the thousands on sea vessels of all shapes, designs, and sizes. The flotilla can be best observed from the beach in the Queen Tuna Park, in downtown General Santos.

This park has a promenade with colorful lights and landscaped gardens. It is an attractive spot for a family outing, skimboarding, windsurfing, and beach volleyball, as well as many open-air events that take place there year-round.

General Santos City has outstanding diving sites; some of these locations are scattered all over the province of Sarangani, but are always within a short traveling distance from the city. The bay teems with marine life and the water is pleasantly warm, creating a memorable underwater experience for beginners as well as for experienced scuba divers. A wonderful attraction for diving and snorkeling enthusiasts are the colonial Spanish shipwrecks from the sixteenth through the eighteenth centuries that can be found near the coast, a site that can be dived again and again with a different experience each time. The region also offers some of the finest deep-sea fishing with an extensive variety of big game fish close to shore.

For adventurers in search of land-based activities, the city features waterfalls, caves, and rock formations. Standing on top of Nopol Hills, one of the highest vantage points in the city, offers an indescribable view of Sarangani Bay and the coastline of white beaches that face the serene waters of the Celebes Sea.

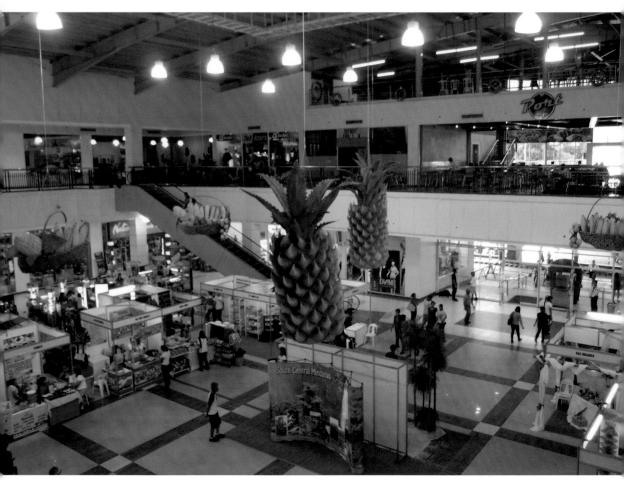

General Santos City Gaisano Mall

Mindanao: From Samai to Surallah

People who want to explore destinations that are off the beaten track will head for the Kalaja Karsts Area. This sprawling natural reserve is graced with wildflowers, waterfalls, and underground caves, including the Kalaja Cave, which is home to scores of bats and sparrows. The karst formations are millions of years old; their name comes from *kalaha,* meaning "frying pot." Hiking trips can begin from the campground of Bunga Springs, right in the heart of the Kalaja Karsts Area, surrounded by rugged mountains and cliffs.

The Kalaja area has historical sites to explore; many hidden bunkers are a somber reminder of the presence of the Japanese army during the Second World War. A field hospital for wounded soldiers was created in one of the ten caves that the imperial forces used for their water supply. Rumors abound that the invaders may have left treasures in the caverns when they retreated from the area.

Not far from the Kalaja Cave lies the Malakong Gorge, a spot with smooth limestone walls for mountaineering, trekking, and trail running.

The Maitum's white-water tubing is a hair-raising adventure that's not for the fainthearted. Instead of rafts, a rubber tube or *salbabida,* made of recycled truck tires, is used to traverse the wild waters of the Pangi River. Racing down this turbulent waterway is a thirty-minute adrenaline rush, as adventurers whirl through the rapids and enjoy the marvelous sights along the way.

In the center of General Santos City, tricycles and tricycads (tricycles that can carry up to eight people) are the primary mode of transportation. Thousands of these motorized, boxed-in three-wheelers drive along the major thoroughfares. Many of them ignore other drivers, switch to the opposite lanes to get out of traffic jams, make left turns from the far-right lane, never use turn signals, suddenly stop in the middle of the road, and breeze through red lights. Although they can be risky, these vehicles are the most common and convenient way to get around the city, for both residents and visitors.

General Santos is a midsize city but it has a wide range of convenient hotels with good services and comfortable rooms. Many accommodations that cater to all budgets can be found near the city's shopping malls.

General Santos City is unquestionably a place for great shopping, with local markets selling goods at bargain prices and commercial centers that offer a wide choice of merchandise. Only a couple of footsteps away from the city's public market, along Cagampang Street, shops sell native clothing, such as *malong* (the traditional tube skirts), and T'nalak weaving. Handicrafts made by local Maranaw and T'boli craftsmen are prized souvenirs.

For all kinds of sports activities, festivals, partying, shopping, or just relaxing, General Santos City is a fine destination for the entire family, who can be certain that the weather is not going to spoil anybody's fun. Mindanao is situated outside the typhoon belt, and has a generally mild, subtropical climate throughout the year. Rainfall is spread evenly and it often rains for two or three hours in the afternoon. The best time for water sports is during the dry season from January until June, while November and December bring a cooler climate to the city.

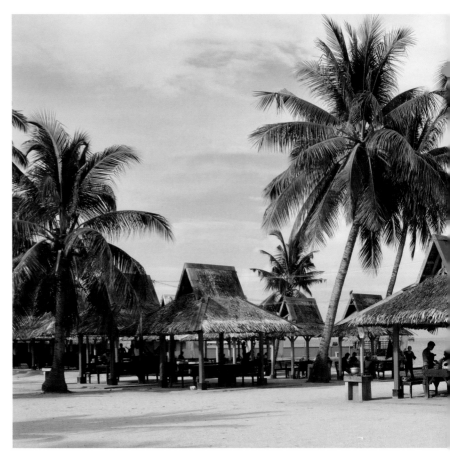

Mindanao: From Samai to Surallah

The General Santos airport handles direct flights to almost all key cities in the Philippines and is about a twenty-five-minute drive away by taxi or jeepney from the city center. There are four national carriers operating within the Philippines and all have good safety records. Be aware that on most domestic flights the airlines have a maximum baggage allowance ranging from 22 to 33 pounds. Since there may be an excess baggage fee, it might be a good idea to send any large backpacks or suitcases as cargo, which is much cheaper. Makar Wharf, the main port of General Santos, is home to many shipping lines for passenger and cargo traffic.

Ferries from this port bring passengers to Cebu and Manila in the most basic fashion for just a few hundred pesos. If a boat or ferry seems to be overcrowded or overloaded, or if the weather conditions are uncertain, do not step on board, as the safety of some of these ferries cannot be guaranteed.

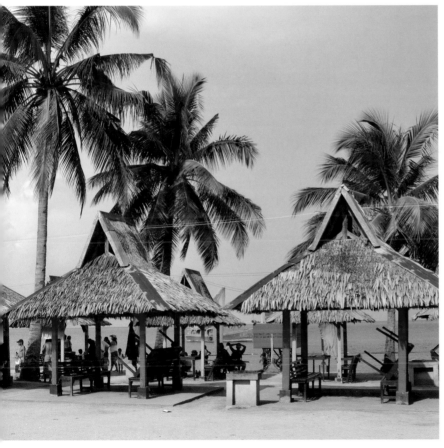

General Santos City, London Beach

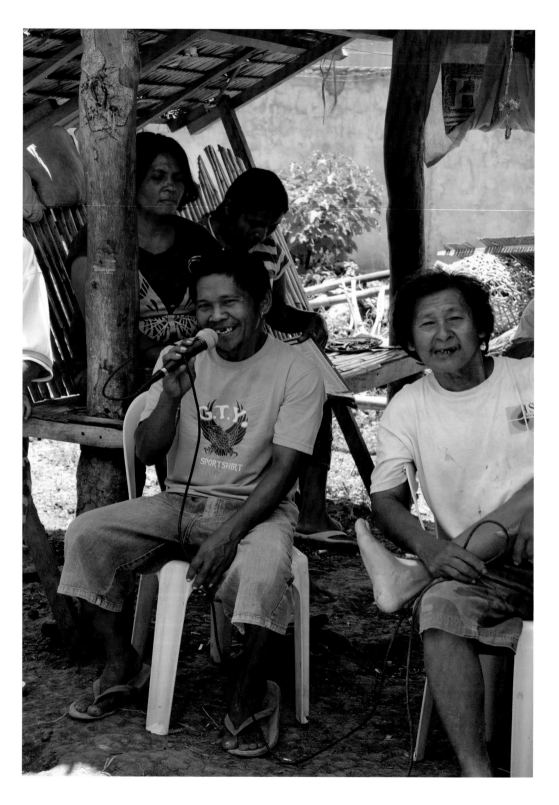

Mindanao: From Samai to Surallah

Karaoke

General Santos is a city with an average pace during the daytime, but it has a different speed after sundown when the place comes to life. For partying or hanging out with friends, the bustling Al Fresco strip with first-class restaurants, fashionable bars, and cozy coffee shops is worth a visit, while in the beach area, there's always some kind of festivity going on. The Philippines is often described as the most musical country in Asia, so plan to start singing the night away at one of the downtown karaoke bars.

Karaoke is part of daily life in the Philippines, a national tradition and pastime. A Filipino named Roberto Del Rosario is believed to be the inventor of a sing-along system that in time became known as karaoke, a Japanese term derived from *kara* (empty) and *ōkesutora* (orchestra).

For more than three decades karaoke has been a real treat in the Philippines. Nowadays, people can also sing their favorite songs using videoke: video karaoke (KTV). In this system, lyrics are displayed on a television screen while a cursor directs the singer in following the tune and singing along with a music recording without any vocals.

87

Mindanaoans are very sociable with a strong preference for group activities over individual ones. Karaoke participants take their turns in performing, supported by other players; it does not matter if their singing is good or bad. Singing and listening can create a shared identity between singers and spectators, giving a feeling of mutual support and understanding. A superb interactive form of creative entertainment, it is the way that Filipinos develop camaraderie and strengthen family ties.

Karaoke is a means of inexpensive family fun. Stylish and cheap portable karaoke systems are widely available and many homes are turned into small theaters during anniversaries or major occasions. A party is never complete unless there's karaoke singing to bring excitement and pleasure into the night and perhaps the early hours of the next day.

Karaoke singing has become big business as people realize that it's a profitable form of lounge, nightclub, and home entertainment. Karaoke machines in all shapes, colors, and sizes, most of them with oversized loudspeakers, are placed in the most unimaginable locations: garages, sidewalks, restaurants, shopping malls, and even on beaches. It is common in bars, cafes, and stores. If there is electricity, music, a microphone, and a Filipino, there will be karaoke. Many establishments hold karaoke nights and contests where people

can show off their ear-busting vocal talents, in harmony or out of tune, but always searching for their best performance. It is a way to unwind from stress and to release emotions, and it's also lots of fun.

Karaoke is everywhere in Mindanao—there's no getting away from it. If you don't like to sing, you can always provide enthusiastic applause as those around you become temporary superstars.

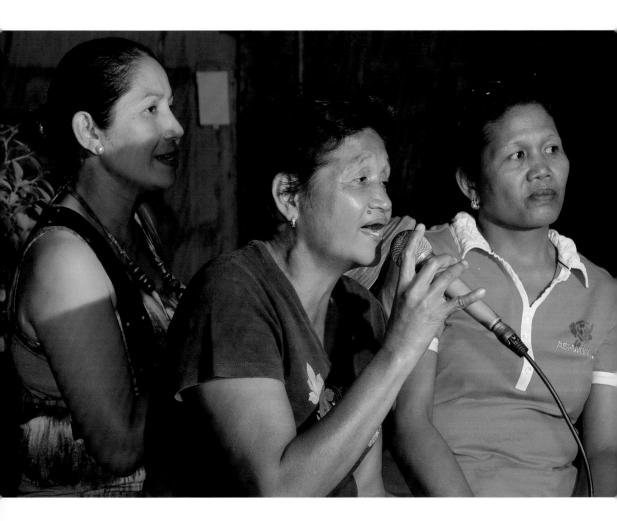

Mindanao: From Samai to Surallah

General Santos City

Pasalubong and Balikbayan

For Filipinos everywhere, *pasalubong* is a familiar word for a well-respected custom. (Freely translated, this means "a gift to family and friends when coming home.") To strengthen ties with loved ones, bringing back a pasalubong for those who have remained at home has become one of the most widely practiced and most distinctive Filipino traditions. It is a sign of appreciation and thoughtfulness; it highlights the relief of being back safe and in good health after spending some time away from home, and illustrates the happiness travelers feel when reuniting with next of kin. This "homecoming gift" is an established practice but never a mandatory gesture. However, failing to return with pasalubong can sometimes be felt as a great disappointment, because giving and sharing is considered a practice that strengthens the bond with relatives and warms the family spirit.

Mindanao: From Samai to Surallah

Filipino migrant workers and tourists can be seen at airports around the globe, hauling large suitcases, bags, and boxes stuffed with presents, canned goods, knickknacks, toys, and other items, as much as they can carry and their budget will permit. On many occasions they push the luggage allowance over the limit, frequently sparking heated debates with customs officers and port officials. They often end up paying overweight surcharges or repacking the contents of suitcases and carry-ons into pockets and plastic shopping bags. The result is an overloaded carry-on luggage compartment, leaving latecomers to discover that there is no room left in the overhead bins.

An ostensibly easier way of transporting these gifts is in a corrugated container, better known as the *balikbayan* box. These low-cost boxes are often used as check-in luggage when traveling, but they can also be sent as freight by air or sea and delivered directly to the doorstep of the recipient. When shipped by sea, a balikbayan box has no weight limit, so some of these packages are stuffed beyond belief. A typical box can weigh more than a hundred pounds.

General Santos City Airport Ramp

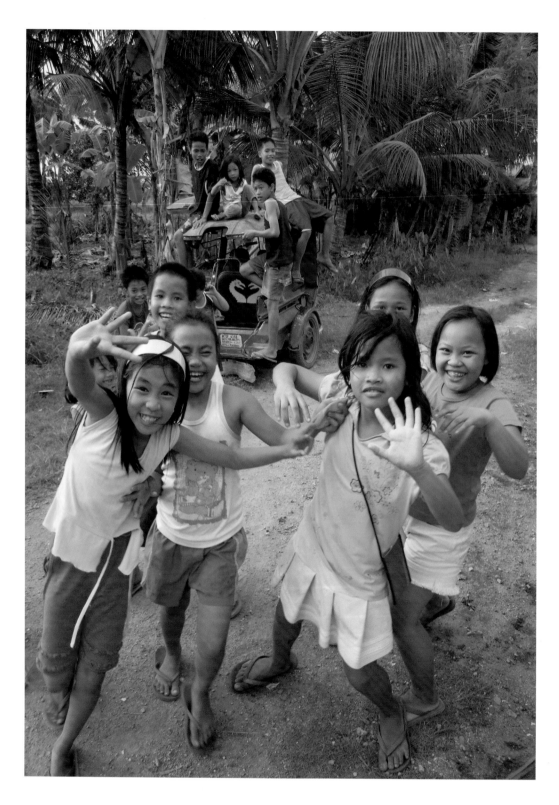

Mindanao: From Samai to Surallah

General Santos City

It seems as though the skill of packing a balikbayan box is handed down from one generation to another, and is very much like putting an enormous jigsaw puzzle together. After this tedious and time-consuming effort is completed, the box has to be tightly secured and wrapped with great care, lots of patience, and plenty of brown or transparent packing tape. Sealing the box in such a way ensures that the precious items inside will reach their destination unopened, unpilfered, and undamaged.

The next step is to put the names of sender and receiver, clearly visible and preferably in huge letters, on all six sides, to prevent the package getting lost during transport and probably to impress the neighbors of the beneficiary as well. Still, the tortuous task of pleasing people back home and sharing the fruits of overseas labor isn't over yet. After the packing and labeling is complete, the thorough search for a reliable and accredited forwarder is begun—after all, not just anyone can be chosen to perform the backbreaking ritual of collecting and transporting that only-in-the-Philippines cardboard icon of goodness.

Advertisements and reviews must be read carefully, lots of phone calls and serious deliberations must be made, and a reasonable amount of information and advice from friends and coworkers must be taken into account before selecting that one-and-only privileged cargo company. Then comes the unavoidable wait, six to ten nail-biting weeks, until the freight arrives at its destination.

Fortunately, for those who do not want to go through all the rigmarole of shopping, stuffing, taping, and shipping, online alternatives await. Even boxes that are prepacked with a large variety of goodies and gadgets can be ordered on the Internet. With just a few mouse clicks, gifts can be chosen, bought, and sent to kith and kin in the Philippines. In the last decade these one-stop Internet stores have sprouted up across the web and have become a regular feature among the Filipino community worldwide. Thanks to modern technology, people can cybershop for freebies and discount deals to stock their balikbayan box quickly, easily, and comfortably.

The Province of South Cotabato

Your next destination is South Cotabato, a beautiful region that lies between majestic mountains in the south of Mindanao. The name means "stone fort," from the Malay words *kota batu* or the Maguindanao phrase *kuta wato*. Cotabato was once the largest province in Mindanao, until it was divided into the separate provinces of North and South Cotabato.

South Cotabato is one of the most accessible areas in Mindanao, with hidden scenic places and enchanting attractions, both natural and man-made. This land of flowers and fruit has been planted with groves of rambutan and durian, as well as orchids and other tropical blooms. Its forests are among the most species-rich ecosystems on earth, supplying local communities with lumber, food, drinks, spices, and medicine. The landscape of the province is varied with fertile plains, rice fields, and farmland; its climate and geography provide shelter for wildlife and vegetation that are as diverse as its people.

In South Cotabato live six major tribes: the Kalagan, Ubo, Manobo, B'laan, Maguindanao Muslims, and the T'boli. Within this diversity, the indigenous, the Islamic, and the Christian traditions blend wonderfully into one single southern spirit. Through the years these tribes have managed to resist being changed by centuries of colonization, retaining their own ways of life.

Driving on the main roads in this province requires a high degree of attention. Most of the highways are two-lane roads, with many being expanded to four lanes. The usual traffic hazards apply, along with the many cows and goats grazing nearby that seem to think the grass must be greener and more succulent on the other side of the road. Vision is often obscured by thick clouds of smoke that drifts across the highway when villagers burn their household trash close to the road. And because there are many highway inspection checkpoints, watch out for motorists who pull over without warning. They join a long line of parked vehicles that will remain immobile until they know the checkpoint has been lifted.

Polomolok Landmark

Mindanao: From Samai to Surallah

Polomolok

Polomolok is the first town you will reach after leaving General Santos City. (The name *Polomolok* comes from the B'laan term *flomlok*, which means "hunting grounds.") Just before you enter the city, a large sculpture of a green pineapple, supported by four pillars, will announce you have reached the pineapple country of South Cotabato. Under the shadows of Mount Matutum lies the world's biggest pineapple plantation, almost three thousand acres, owned and operated by Dole Philippines. The endless green-and-red-hued pineapple fields stretch across the interior landscape of the region as far as the eye can see and exude the scent of ripe pineapples and *kalachuchi,* or plumeria, flowers.

The pineapples from Polomolok have a sweet and tangy taste; they are both eaten locally and processed to produce juice and sliced pineapple for export. On both sides of the highway, stands sell this juicy golden goodness in small packages.

The Pinyahan Festival of Polomolok is the anniversary of the founding of the Barangay Cannery Site, and is celebrated in the last week of August. The festival also honors the pineapple, or *pinya,* that has become the city's main source of income. Among the many events of this weeklong festivity are the sky lantern and fireworks display, a street-dance competition, and the Parada at Lumba Karabaw, which is a parade and a race with water buffalo.

Before the parade and the race begin, contestants wash and brush their water buffalo's hide until it is shiny and sleek, so spectators can enjoy the sight of the proud owners and their hulking, carefully groomed animals parading through the streets. The farmers then race bareback on their galloping water buffalos, hitting them with sticks to urge them toward the finish line. Often a buffalo decides to run in the opposite direction or a jockey falls off while his buffalo decides to continue the race on its own, making this event both exciting and amusing.

Mindanao: From Samai to Surallah

Polomolok, Dole Pineapple plantation

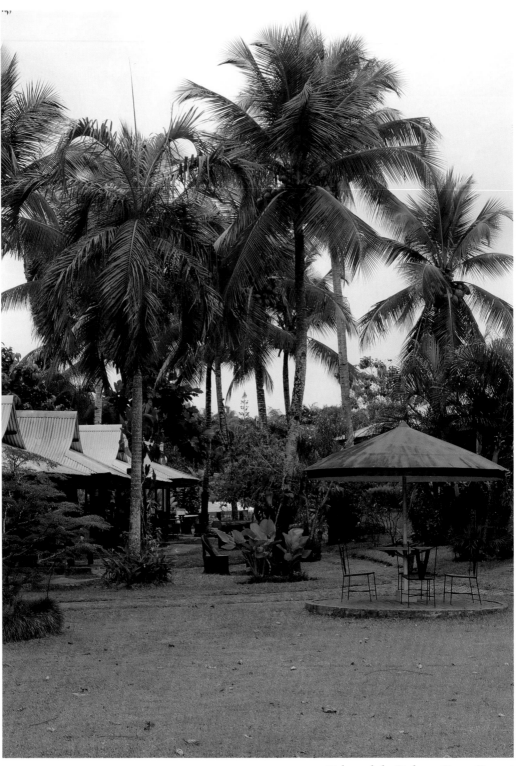

Polomolok, Dolores Farm Resort

Mindanao: From Samai to Surallah

Polomolok, Trappistine Monastery

A tranquil place in Polomolok is the Trappistine Monastery of Our Lady of Matutum, located at the foot of Mount Matutum, in Landan. It is a place of worship and meditation that breathes an atmosphere of silence, far from the noise and distractions of daily life. This isolated place is an expression of pure faith and peace, the first of its kind in the Philippines. The red-roofed monastery stands majestically in the landscape; its simple and intimate chapel is a center of devotion and prayer. The Cistercian nuns are also called Trappistine; their daily work consists of living a life of solitude, praying in perpetual silence, and supporting themselves by selling religious items, cookies, and postcards. Visiting the Trappistine Monastery is a moving experience, giving all who go there a sense of homecoming, regardless of religion or background. It's a transcendent place for people seeking reflection and spiritual refreshment, and is visited by many pilgrims and benefactors coming from every corner of the earth.

The Monthong Ponds at the Dolores Farm Resort are a nursery for *bangus* (milkfish) and tilapia. Visitors can bait the hook themselves if they want to, and their fresh catch will be served, along with other Filipino dishes, in the Chanee Restaurant. Crispy tilapia fish fingers are served with a dipping sauce that adds flavor to the fish. A few of the best dishes are the delectable fried garlic chicken and *tinolang manok*, a soup-based dish that is cooked with chicken, wedges of green papaya, leaves of the *siling labuyo* or wild chilli, ginger, and onions.

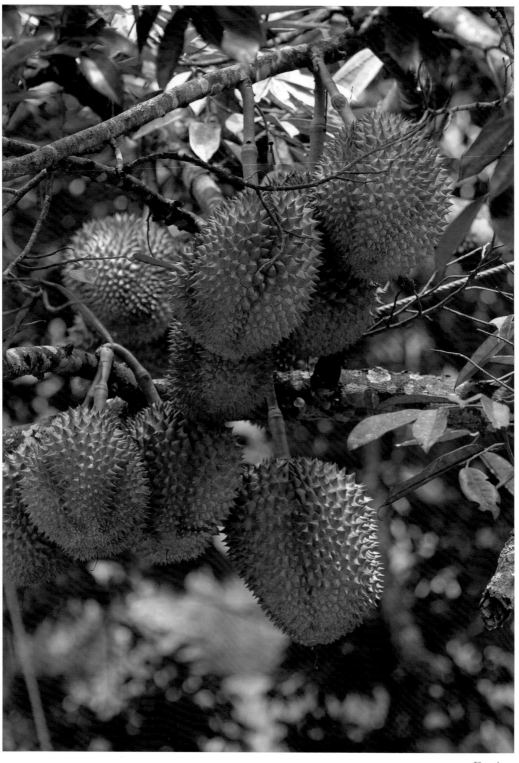

Durian

Mindanao: From Samai to Surallah

Polomolok, Durian Garden

Durian Garden Pool

Durian Pie

The warm, sunny days provide an excuse to take a dip at the Kanyao Swimming Pool and Water Park, while a visit to the mini-zoo is fun and educational for kids of all ages. Get up close to the feathered and furry animals, look at all of the different shapes, sizes, and colors, and try to figure out exactly who's watching whom. However, be aware that the animals are housed in small bare cages that can't compare to their natural habitat or meet the standards of a modern zoo.

Polomolok is famous for its durian, a large, spiky fruit endemic to the woods of Mindanao. Durian is widely acknowledged as the world's smelliest fruit. The pungent scent is unlike anything you've smelled before and it raises many different reactions, from extreme disgust to the utmost in appreciation. True durian lovers say the fruit smells like hell but tastes like heaven. This lowland fruit not only has a reputation for its odor and taste, but also for its large size and massive thorn-covered husk. When ripe, the fruit is golden brown and yellow, with a creamy, sweet flavor; its seeds can be eaten raw, roasted, or canned. Durian is very nutritious, full of protein, minerals, and fat.

The best way to taste this "king of fruits" is on a visit to the Durian Garden, located alongside the highway. This is one of the South's main agritourism destinations. It has an excellent restaurant with a casual atmosphere that serves the best durian desserts: homemade durian pie and durian ice cream, with mango, jackfruit, and ube ice cream for variety's sake. Nearby orchards grow rambutan, pomelo, and jackfruit as well as durian.

Polomolok is also a place where the world's most expensive and unusual coffee comes from, *kafe balos*, or coffee alamid, which originates from the droppings of a palm civet. This nocturnal, catlike mammal, named *balos* by the B'laan villagers, eats only the ripest and sweetest coffee beans. Its droppings that contain the beans are gathered before first light and are processed to become the source of delicious and aromatic coffee.

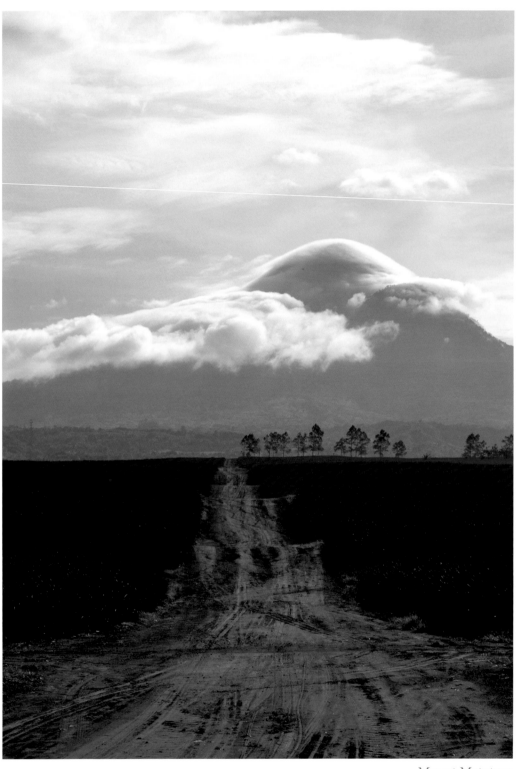

Mount Matutum

Mindanao: From Samai to Surallah

Mount Matutum

Mount Matutum is undoubtedly the province's most imposing landmark, dominating the landscape from General Santos to Koronadal City. A steep, dormant volcano, its irregular shape was formed by volcanic upheaval during periods of activity in the past. (Its last eruption was in 1911; the name *Matutum* in the local dialect means "burned out.") It has a well-preserved 150-foot-wide crater at the volcano's summit that is near three gorges. Towering 7,500 feet above sea level, Mount Matutum is one of the prime climbing destinations in the area, an incomparable challenge for mountaineers.

The forested slopes and steps are covered with huge ferns and trees and are host to a diverse number of plants and animals, including the Philippine eagle. Dense forests and waterfalls abound at the foot of this mountain, while many creeks flow from the hillsides. The area is filled with birds, monkeys, deer, and wild boar.

Mount Matutum is one of the greenest outdoor destinations in South Cotabato, a place that commands a great respect for nature and the environment. Every climber and hiker is required to plant a tree while climbing the mountain, a personal contribution to nature that is named after the B'laan term *amyak maleh,* which means "climb and plant." This activity is highlighted in the weeklong celebration Linggo ng Mount Matutum, an annual festival held by the residents of the town of Tupi.

The hike to the summit is not an easy one; the steep slopes present muddy and rocky approaches. There are three different trails. The Lemblesong trail is the oldest, featuring ravines and waterfalls, and takes more than a day to traverse due to thick overgrowth along the way; the Glandang trail is the shortest, with a six-to-eight hour journey; and the Ulolandan trail takes about three days to reach its end.

The outlook from the viewing deck at the top of the volcano, the highest point in South Cotabato, is worth the climb, offering an extraordinary panorama of Polomolok, Koronadal City, and General Santos City. At the bottom of the mountain, less than four miles west of the volcano, two hot springs, Akjmoan and Linan, provide amazing spectacles, with geysers spouting endless towers of hot water. The B'laan tribe believe that the minerals in the sulphuric water have healing powers.

At Barangay Landan, you should allow about two hours to explore the Salkak Cave, a 755-foot- long cavern that is full of chambers and underground rivers. An open shaft aboveground sheds some daylight into parts of the dark, damp cave.

The B'laan Tribe

The Bilaan or B'laan is a tribal community of southern Mindanao. (The name stems from the words *bla* and *an*, meaning "opponent people." The tribe is known by many other names as well: Bla-an, Bira-an, Baraan, Vilanes, Bilanes, Tagalagad, Tagakogon, and Buluan.) The B'laan in South Cotabato were outstanding hunters and food gatherers; they hunted wild animals and reaped grains, root crops, fruits, and herbs in the once vast open space of grassland known as Kolon Datal, which is now Koronadal City.

The tribe is known for their fine arts and handicrafts: brass ornaments, traditional beadwork, costumes woven from the stalks of a bananalike plant called *abaca* that are decorated with embroidery, buttons, and heavy brass belts with tiny bells. These belts are worn by the women of the B'laan, making their approach heard even from a far distance. Sequinlike capiz shells called *takmon* are used to give a distinct design and color to their clothing and, for every woman, the intricately beaded wooden comb, the *swat san salah*, is a must.

The B'laan have their own form of weaving, using abaca fiber. Before making any pattern or design or weaving their classic patterns, they hold ancient ceremonies in which divine guidance is sought. Only the weavers know about these rituals and it is believed that the designs are imparted to them in dreams through the *l'nilong* or fairies, who are the guardians of nature. Tribal handicrafts and attire are priceless possessions that are offered as dowries for weddings; they are also used as payment for crimes committed against a person or clan, or for settling disputes among warring clans.

Maharlika Highway, Bahay Kubo roadside work site

The Bahay Kubo

After you leave Mount Matatum, its hot springs, and its caves, your journey continues on a straight section of the Maharlika Highway. At this point it's possible to see for miles ahead into the distance, giving the impression this road will never end. Just about halfway between Polomolok and Tupi, various family-owned roadside work sites are situated along the highway where bamboo furniture, doors, and other items made of wood are manufactured and sold straight from the carpenter's workshop. It is here that local craftsmen produce the *bahay kubo*, one of the most familiar icons of the Philippines. The name of this primitive nipa palm hut is based on the Spanish word *cubo*, meaning "cube," probably because of its rectangular appearance, and *bahay*, which is the Filipino word for "house." Traditionally, the bahay kubo has always been made of organic materials, a good example of an environmentally sustainable, simple structure that has been around for a very long time.

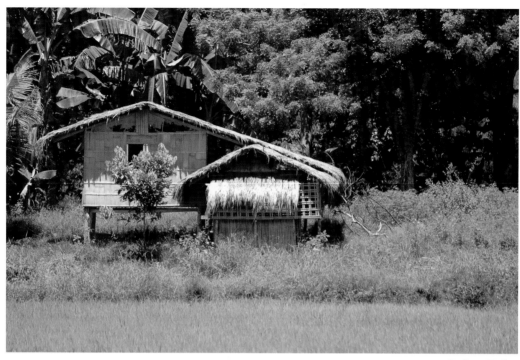

Bahay Kubo

The construction is completely based on local needs and conditions, fabricated with the ever- dependable bamboo or *kawayan* and bound together by thin strings of bamboo, with dried coconut leaves or cogon grass also used as building materials. Walls are made of nipa leaves or bamboo slats and the floor is made of finely split resilient bamboo. The structure is raised three to six feet above the ground, supported by thick bamboo poles. Depending on the area where it is constructed, this elevated structure will protect its inhabitants against wild animals, snakes, torrential rains, and floods.

A bahay kubo is built for comfort in tropical weather, be it heat or rain. There are awning-like windows on all sides, which keep the interior well ventilated; these can be sealed off from the elements by a series of sliding panels. The steep-sloping, high-pitched roof sheds rain and provides sufficient room for warm air to escape, while a cooling airflow enters through the porous bamboo walls and floor. The top of the house is high with open gables to allow ventilation; it is fitted with wide overhanging leaves that provide shade from the hot sun and keep out the rain. Some huts have an open back porch or *batalan*, where water jars are kept; a *silong* (the area below the house) is used for most household chores, for food storage, and as a place to keep chickens and small livestock; and a *silid* or alcove is where bedding is stored for the day.

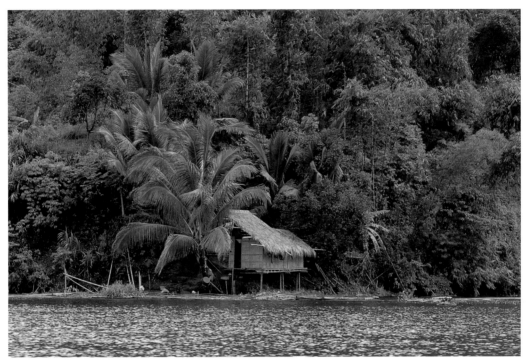

Lake Sebu, Bahay Kubo on stilts

A distinct feature of the bahay kubo is a kind of stairway or *hagdan* that can easily be disconnected at night and placed on the patio. Because the house is constructed with natural materials which are very inexpensive or freely available, it can quickly be rebuilt or repaired, using simple tools, if it has been damaged or destroyed by fire or a natural disaster. Corresponding to the Filipino concept of shared space and limited privacy, a bahay kubo usually has no partitions for separate rooms. It is designed for family living and all household activities, like dining, recreation, and sleeping, to take place in one single, open, and multipurpose room called a *bulwagan*. This also serves as an area for storage and livestock pens, or as a workspace, with sometimes a separate area for the kitchen.

Even so, inhabitants still have enough privacy to raise children and take care of the family, the sick, and the elderly. Filipinos are known for their close family ties and do not want to be separated from one another; even if the children marry, they and their families often stay in their childhood home, or they might build their own bahay kubo next to the homes of their relatives.

It is customary that there should always be someone present in the house at all times. Returning to an empty house is not done; therefore it is out of the question to lock the front entrance of the house. Life in a bahay kubo is not restricted by the walls of the house; it includes the lives of neighbors and friends, who often are accepted as relatives. Solid communal ties bring them together to help others if a new house has to be constructed or to transport an existing house, if its inhabitants want to move it to another spot.

A move is done by putting bamboo poles lengthwise and crosswise under the house, forming a strong frame that lifts the stilts from the ground. The entire structure is then carried to its new destination. Each man carries a portion of the bahay kubo's weight and each becomes a hero to the other carriers because he lightens the burden for them all. This event is a social and festive one; after the house arrives at its new site, the family who lives in it shows their appreciation by hosting a modest fiesta for all the volunteers who helped them. This collective activity is known as *bayanihan,* meaning unity and harmony within the community. (*Bayan* means "community," "nation," or "town" and stands for a shared spirit that makes an apparently impossible endeavor possible through the strength of cooperation and solidarity.) Bayanihan is an old Filipino tradition: working together for the common good and giving each other unsolicited assistance out of a sense of closeness and camaraderie, often during difficult times, without expectation of recognition or personal gain.

Mindanao: From Samai to Surallah

In many places the bahay kubo has been replaced by modern structures, but some of the nipa huts can still be found clustered in barrios, scattered around the rural areas. In coastal areas nipa cottages are built on stilts in the water, and on lakes floating bahay kubos are used as shelters for fishermen.

They are still very much in demand as recreational buildings in private gardens, holiday resorts, and children's playgrounds. The shape and size has changed throughout the years; what remains is the desire for a collective space with a Filipino style and feeling, one that embraces and preserves the comforts of local tradition. The modern bahay kubo is used for family gatherings or to relax with neighbors and friends, sharing moments of community while discussing family matters or local gossip. It has passed the tests of time and nature because it is totally adapted to its environment and is built to withstand the country's hot, humid, and rainy climate.

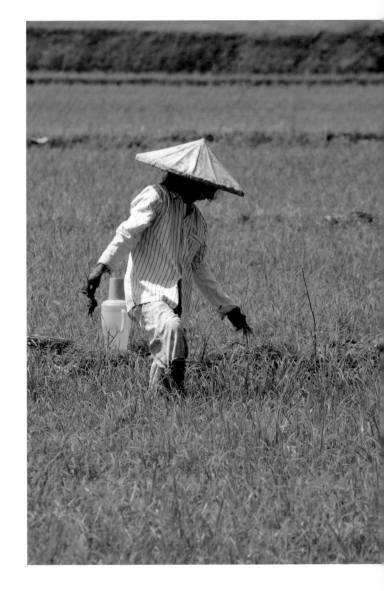

The bahay kubo is not only an indigenous house; it is an architectural and monumental masterpiece, a national icon, and a symbol of togetherness. This time-honored abode serves as a testament to the simple and resilient Filipino spirit. It embodies the character of the provincial landscape, reflecting the Filipino identity as well as the heart and soul of rural living.

Mount Matutum

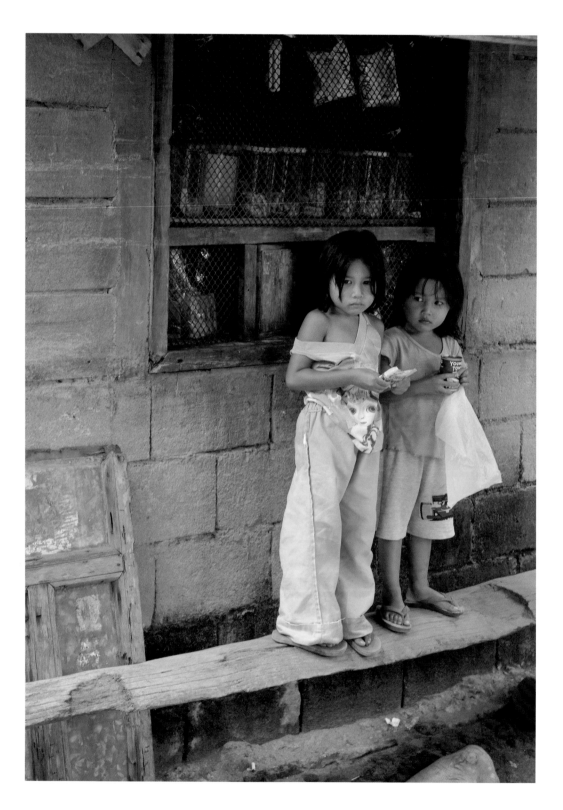

Mindanao: From Samai to Surallah

The Sari-Sari Store

Only a few feet from the road, a handful of sari-sari stores offer their merchandise to travelers. A sari-sari store, or *tindahan*, is a small unit in the vast Philippine cultural and economic landscape, found throughout every city, in many villages, each neighborhood, at almost every corner of any street, in residential areas, and even in the poorest of squatter communities. It is the oldest and smallest kind of store in the country; it's believed that the first stores date back more than five hundred years. A piece of the past, it is still present today and it will undoubtedly be there in the future.

Sari-sari stores are often privately owned and family operated in small-scale bamboo huts, inside the shopkeeper's house, or (semi-) detached in front of or next to the proprietor's house. Frequently a large signboard will draw the customer's attention, bearing the first and last name, or initials, of the owner, with variations like "2 Sisters" store, "4 Marias" store, and "3 Brothers" store. As a rule, along with the store name, the name and logo of a cigarette brand, soft drink manufacturer, or beer brewer also is featured.

Sari-sari means "various kinds," referring to the goods that are available in a wide range of sorts and sizes: candy, detergent, soap, toothpaste, canned goods, coffee, soft drinks, ice-cold beer, and instant *canton* noodles. Cigarettes can be bought individually, shampoo is available in miniature sachets, and many other things are sold in single-use packets (*tingi*). The store owner repacks food staples into smaller packages, with necessities like rice, salt, pepper, and sugar for sale in tiny plastic bags. Cooking oil, soy sauce, vinegar, and even gasoline are measured in cups and then poured into a bottle or glass that the shopper has brought from home. Now and then soft drinks are sold in a plastic bag, because some customers cannot afford the deposit for the bottle or do not want to return later to get their down payment back. Open seven days a week and at an average of fourteen hours a day, these shops allow everyone to purchase the goods they need, at an affordable price and at any convenient time, with an exception, of course, for the afternoon siesta.

In remote areas, the nearest shopping mall, market, or grocery store can be far away, so the sari-sari store cuts down on transportation expenses. Since many sari-sari stores are located in areas with underprivileged populations, they are invaluable for people who earn just enough to feed themselves through the day, providing them with portions designed for one meal at a time. They allow the poor to budget their pesos and generally will provide some credit (*pautang*) to villagers who have limited financial means.

115

The storekeeper must cope with clientele who cannot or will not pay their bills, although because of the closeness of the community, merchants know where to go to make good on bad debts. If they don't, they'll lose their businesses because of unpaid bills—unfortunately this happens occasionally.

Sari-sari stores, mainly in the provinces, display their merchandise in a big open framework covered with chicken wire and iron bars, with an opening for passing goods and money. Small items such as candy and individual cigarettes are placed in plastic jars, so a customer can point to what's wanted. Wooden tables and benches are set up in front of the shop for customers; this hangout (*tambayan*) provides shelter from the hot sun or from rainfall. It is a place where friends and neighbors meet each other and catch up on the local gossip (*chismis*) whenever they like. It is the prime hub of social activity in small communities, a place to meet for a cigarette after a hard day's work, or to enjoy cold beer, soft drinks, coffee, or a locally produced liquor called *tuba*, which is fermented palm sap.

Throughout the day, street vendors gather around the store to sell brooms (*walis*), household goods, roasted nuts, and homemade street food. Mothers come with small children to do some shopping and listen to the latest rumors. Their kids, screaming and laughing, play games on and under the tables. Jeepneys and tricycles stop in front of the shop to let their passengers in and out or to unload their transported goods, making the shop an activity center. Some stores have small TV sets and customers can view a basketball game or boxing match by peeking inside.

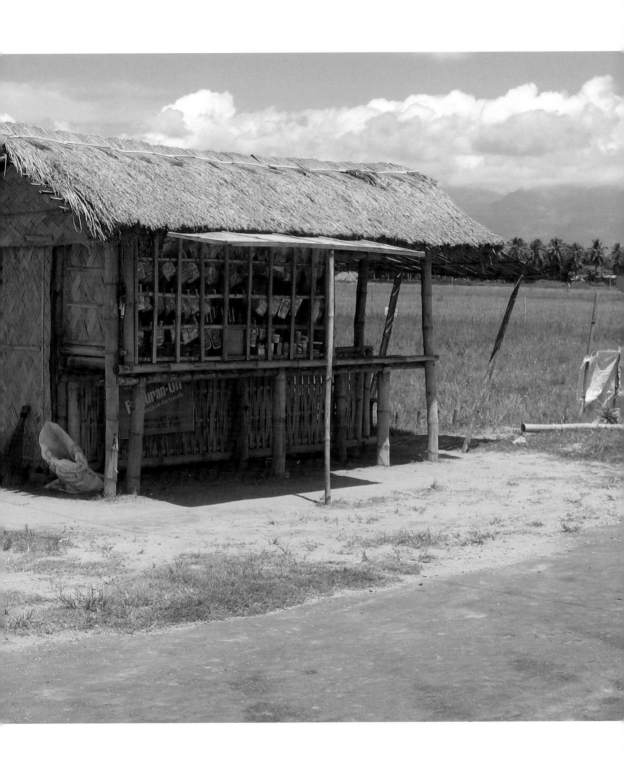

Mount Matutum

When the results of the weekly lottery (*loteriya*) are announced, the tambayan is crowded with men and women watching the show, hoping and praying that their numbers will hit the jackpot and their dreams will come true that evening.

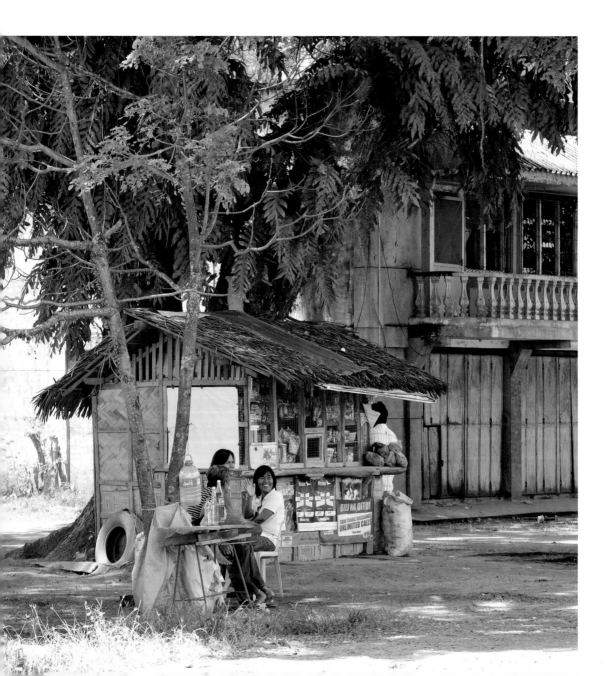

A sari-sari store is the primary place to mingle with local residents, to make friends, and to learn and understand more about Filipino people and their way of life. The store isn't just a mainstream outlet, a small mom-and-pop shop, or a shopper's convenience. It is much more than a home-based marketplace. It is a neighborhood institution, a vital life-line deeply grounded in the community, and a welcome source of credit in hard times for impoverished residents.

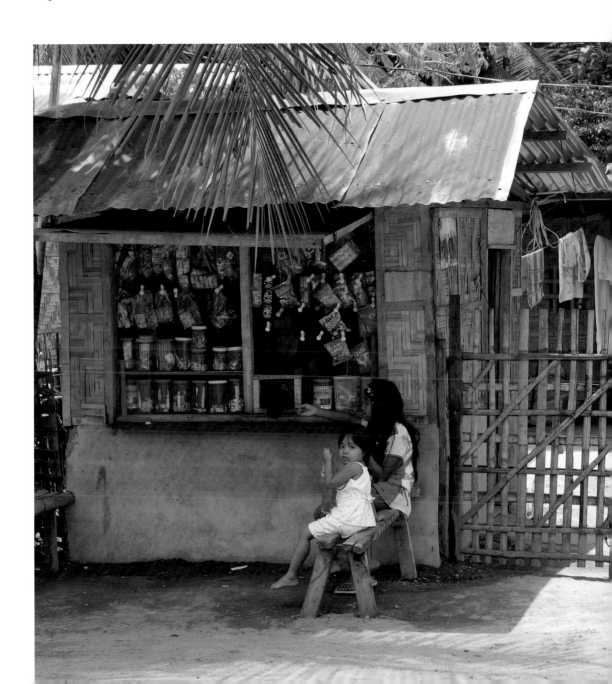

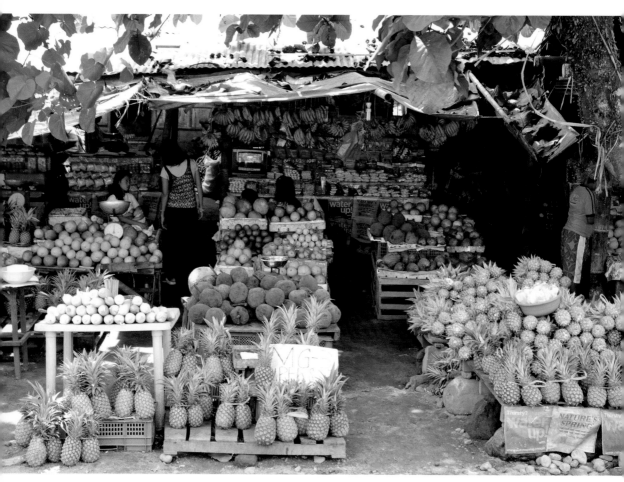

Tupi Fruit Stall

Mindanao: From Samai to Surallah

Tupi

Your next stop is the town of Tupi, named after the B'laan word *tufi*, meaning "vine" or "grape." (Local tribe members used to chew tufi fruit because of its refreshing taste.) The town is known as the fruit, flower, and vegetable bin of the South. The sweetest and juiciest fruits available in Mindanao can be tasted at the fruit stands that are strategically located along the National Highway. These stalls give residents the means to sell fresh fruit grown in their hometown at a very low price. The peddlers wave their hands at motorists and other travelers, holding the merchandise they are so eager to sell.

At Kablon Farms, travelers can purchase passion fruit jelly, guava jelly, and *macapuno* (coconut) and papaya jams, as well as chili powder, spiced vinegar, spicy dark chocolate, dried *camias* (bilimbi fruit) in coconut sugar, bottles of pickled asparagus, and fruit concentrates made from passion fruit, *guyabano* (soursop), *calamansi* (lemon), and *dalandan* oranges. All of the food is organically grown on the two-hundred-acre farm in Barangay Kablon and is prepared without any artificial preservatives. There is also a Kablon Farm Store located along Alunan Avenue in Koronadal City.

The Blooming Petals Plantation is a peaceful floral paradise, filled with roses, chrysanthemums, and many varieties of exquisite orchids. One of the largest orchids, which is also the most beautiful and colorful, is the *waling-waling*, found only on the island of Mindanao and often called "the queen of Philippine orchids." (*Waling-waling* means the graceful movement of a butterfly in flight.)

The eleven-day Agten Tufi Festival, held at the end of August, showcases the local culture and the town's abundant bounty of fruit, flowers, and vegetables. *Agten Tufi* is a B'laan term which means bountiful or beautiful Tupi.

Koronadal City, Statue of Paulino Santos

Mindanao: From Samai to Surallah

Koronadal City

Your journey is nearly complete when you reach the city of Koronadal, the main gateway to other key points in southern and central Mindanao. Just before you pass a bend in the road, an arch spanning the highway welcomes motorists. When you enter the city, the statue of General Paulino Santos is eye-catching, standing nobly in the middle of the traffic roundabout, facing the highway and looking toward the city that bears his name. At this intersection, a constant flow of vehicles during rush hours, frequent violations of motoring regulations, and the general lack of respect for fellow travelers brings a whole new meaning to the word *traffic*. It's often a pandemonium of honking horns and flashing headlights, as drivers try to squeeze their way through the madness.

The City of Koronadal, called Marbel by the local residents, is the capital city of South Cotabato Province, a bubbling hodgepodge of contrasting cultures, influences, dialects, and traditions. Many different people with different beliefs, dreams, hopes, and yearnings live harmoniously in this place. In every respect, they understand the art of getting along, creating a living mosaic of tolerant individuals. A community that is willing to greet and accept people from all backgrounds, religions, and origins with a smile and a welcoming spirit, Koronadal City is a modern, multicultural city with an abundance of local color.

Few tall buildings can be seen in this energetic city that is always bustling with lots of action. The mix of many small businesses and street vendors on the sidewalks, bicycles, tricycles, jeepneys, pedestrians, kids playing, and other traffic creates an organized chaos. Children of the Badjao tribe are often found in the streets around shopping malls and restaurants, begging for money or food while holding their younger siblings in their arms, sometimes watched over by their parents.

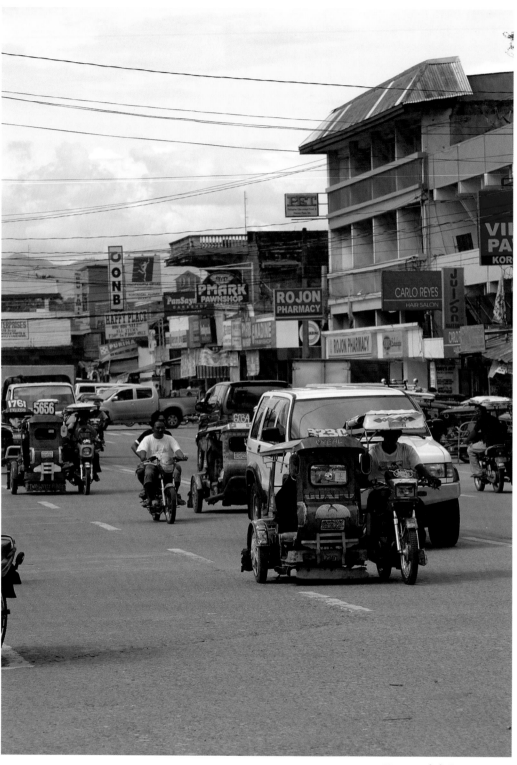

Koronadal City Proper

Mindanao: From Samai to Surallah

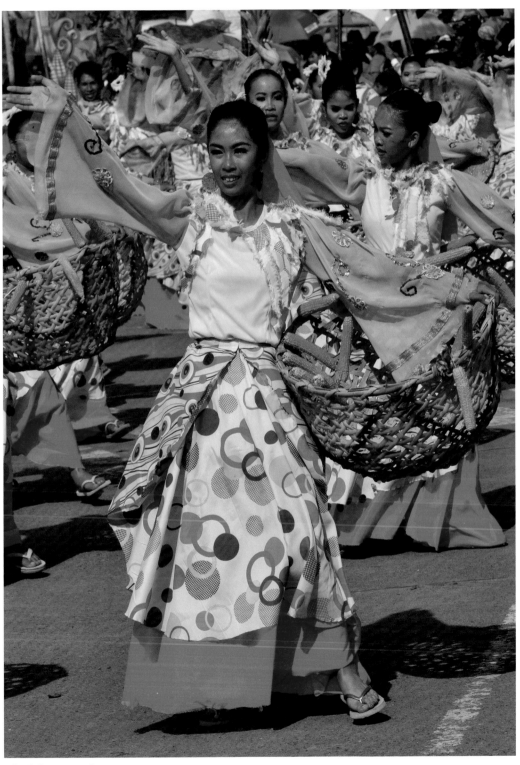

T'nalak Festival

Koronadal City

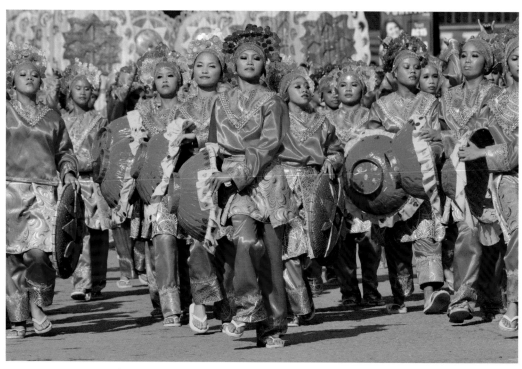

T'nalak Festival

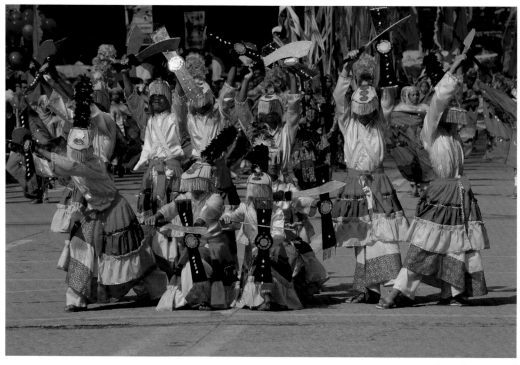

T'nalak Festival

Mindanao: From Samai to Surallah

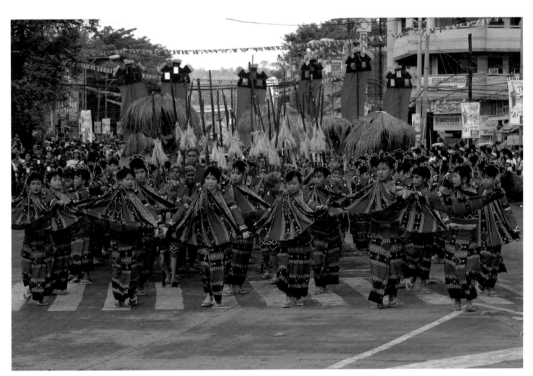

T'nalak Festival

Nearby waterfalls in Saravia and San Jose and the El Gawel wildlife sanctuary are great for family excursions. In the surrounding forests, monkeys roam around the area, crossing paths and interacting with people. If given a chance, these little primates will sit on your shoulders and climb around your back and head. Another natural attraction located about three miles from Koronadal City is the Mambukal Hot Springs. Heated deep within the earth, these medicinal, sulphuric waters are known for their mineral content and legendary healing powers. This untouched and unspoiled site has yet to be discovered by tourists and travelers and the simplicity of its wellspring is inviting. Other unexplored sites are the Cadidang Cave, a hidden cavern in the Roxas mountain range with three chambers that are connected by small, dark tunnels; the huge rock formations in Barangay Cacub; and the South Cotabato Wildlife and Nature Preserve.

Koronadal is a kaleidoscopic city that reflects influences of both East and West—no wonder so many different ethnic groups call it their home. The city's diversity is revealed each year in the T'nalak Festival, the Kawayan Festival, and the Hinugyaw Festival.

The T'nalak Festival is one of the most exciting celebrations in South Cotabato. The festival is named after a cloth created and woven by the women of the province's T'boli tribe; T'nalak is an indigenous term for a predominant way of weaving abaca cloth. This fabric is chosen as the festival icon, symbolizing the strength and unity of the various tribes living in the province. The weeklong T'nalak Festival is held in mid-July during the founding anniversary of the province of South Cotabato, and is a visual experience not to be missed. The unifying power of this celebration and the irrepressibly festive spirit of the participants and spectators can be felt everywhere in the area.

Activities organized for the T'nalak festivities include shows, an agri-trade fair, bazaars, and visits to various tourist attractions in the province. Concerts by local and national performers and a fireworks display keep the public entertained as well. The celebration kicks off with the Dayana Civic Parade, which is highlighted by floats and a dance competition. Dancers from around the province, dressed in native costumes of B'laan, T'boli, and other tribal groups in Mindanao, perform on the streets of the city. These competitions show the distinctive customs and brilliantly colored costumes of the diverse minorities in the area and are the highlight of the festival.

128

Another example of unity is the Kalimudan Festival, held in Sultan Kudarat, about eighteen miles from Koronadal City. (*Kalimudan* is a Maguindanaoan word meaning "informal gathering.") This ancestral revelry brings together almost every major tribe on the island, including the Manobo, Tiruray, and T'boli, to commemorate the founding of Sultan Kudarat. The festival also celebrates the splendor of Mindanao art and the social, ancestral, and historical legacy of the indigenous tribes, with street dancing, sports competitions, and the exchanging of gifts.

These festivals are of great importance in the social life of rural Filipinos. Family, friends, and neighbors will visit each other to enjoy an abundance of food, and a good fair will bring good luck for the rest of the year. Fiestas are usually smaller in scale than festivals; every barangay holds an annual feast in remembrance of a local historical event or to honor its patron saint. The Babak Fiesta, Peñaplata Fiesta, Musikahan, Araw ng Santa Cruz, and Mango Fiesta are all essential components of provincial living. The main features of the festivities are generally a carnival, a village fair, and a beauty pageant, which is an inseparable piece of almost every event in Mindanao. Local girls show off their charm, good looks, and talent, embodying the sparkling spirit of their hometown and fiesta.

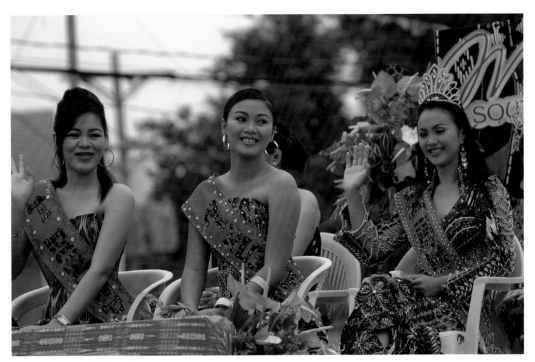
Mutya ng South Cotabato

The most prestigious beauty pageant in Mindanao is the Mutya ng South Cotabato, held during the T'nalak Festival. It's an event with international allure in which ambitious candidates from South Cotabato and other provinces passionately try to impress the judges in hopes of being one of the main contestants. The fairest of all will be crowned as the queen of the festival and will take her rightful place on the throne of a parading float.

Economical eating-out options in Koronadal are plentiful. People from different backgrounds eat different food, but food plays a major role in bringing these diverse groups together. The city has multifold restaurants and *carinderias* that serve Filipino food in an infinite range of choices and variety, catering to all tastes.

A good example of the local cuisine is Pat's Carinderia, located on Emilio Aguinaldo Street, opposite the South Cotabato Provincial Hospital. The family-run, side-street eatery serves the best Filipino dish in town, *nilaga*, a delicious meat and vegetable stew. This small and simple outlet, where food is still chosen in the very Filipino *turo-turo* style of pointing at the desired dish, has what people value the most: cheap and enticing meals. It's casual, clean, and unpretentious with wooden tables and plastic chairs, but it's an excellent spot for people who love to eat delicious, home-cooked specialties.

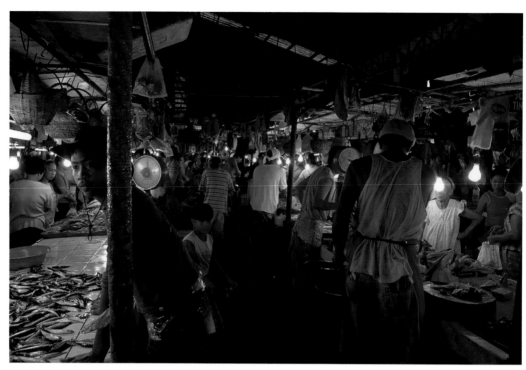

Koronadal City, Wet Market

Patti's Grill & Seafood Restaurant next to Gensan Drive has an excellent ambiance with live music; their menu holds a wide selection of choices, at affordable prices.

The SaBalai Bistro, located near the city center, is a steak and pasta house, but it also serves spicy East Asian delicacies such as tandoori and kabobs (Indian-style, yet adapted for the Filipino palate), as well as dishes from the Mediterranean. It features a number of Filipino best sellers, such as *bulalo* (a stew made from beef shanks and marrow bones), *pancit canton* (stir-fried noodles with shrimp and vegetables), and *lomi* (thick, fresh egg noodles served in thick starchy gravy with crispy shrimp and vegetables). SaBalai is not a halal restaurant, but no pork is found in any of their recipes.

Even though the city has a variety of deeply rooted culinary customs, Koronadal could not escape the Western fast-food companies that have found their way into the city.

Pancit Canton

Soup Bulalo

Koronadal City

Koronadal City, BJ's Lechon House

Jollibee, better known as the McDonald's of the Philippines, can be found at General Pau-lino Santos Drive, right near the Rotunda; it's one of the main American-style fast-food restaurants. Serving Filipino-influenced dishes, sweetened spaghetti, burgers, chicken, and French fries, Jollibee is a popular, all-ages destination. Right across from Jollibee, conve-niently located in the KCC Mall of Marbel, Chow King offers a fusion of Asian food and Western fast-food service at an affordable price: *siopao* (steamed buns), pancit, noodle soups, dim sum, braised beef, and rice with toppings. Some of the house specialties are *longaniza almuchow* (Chinese chicken sausage), *chaofan* (a spicy beef, chicken, and rice dish), and elaborate, multicoursed meals called *lauriat*. Different variants of the familiar rice porridge, congee, along with *halo-halo* (a fruit dessert with shaved ice, jello, sweet beans, and evaporated milk), and a variety of desserts are served.

This same mall is also home to Greenwich Pizza, an over-the-counter pizza and pasta store, serving rice meals along with Italian-style and American-inspired dishes. The pizza, with its combination of crispy crust, sauce, cheese, and a great choice in toppings, strikes a chord with nearly everyone.

For those who like sugary-sweet things, Dunkin' Donuts, not far from the KCC Mall, in front of the old City Hall, is Koronadal's top stop for donuts, coffee, bagels, brownies, and other treats. Trisha's Burger House, a casual cafeteria along Rafael Alunan Avenue, is the right choice for a quiet break, with a helpful staff serving burgers, spaghetti, and lasagna. The Ace Centerpoint Mall, situated on Osmena Street, just beside the old Koronadal City Hall and right in the heart of downtown, is home to Mang Inasal ("Mr. Barbecue"), a fast-food diner for meat and fish lovers. Its specialty, Mang Inasal's Chicken, is skewered chicken legs grilled on charcoal, served with a marinade made from local spices and herbs, and rice wrapped in banana leaves. With their traditional style of food preparation and cooking, Mang Inasal is a reflection of the true Filipino food culture in which guests are encouraged to eat with their fingers (*kinamot*).

Genuine Filipino food remains the number one choice for the people of Koronadal, but they have easily accepted the influences from American, Chinese, Italian, Vietnamese, Malay, French, and other cultures. They have embraced these dishes as part of their own cuisine, but of course with added Filipino touches.

133

Chicken Inasal

Koronadal City

Fried Tilapia

Sweet, Sour, and Salty, but Not That Spicy

Filipino cuisine is an exotic blend of many different cultural influences from both sides of the Pacific and reflects the multiethnic history of this tropical archipelago. Over time this mixture of indigenous and colonial cuisines created the unique native dishes that are filled with a diverse richness of flavors, colors, and traditions. Although the type and taste of food is different in every region, it can generally be described as sweet (*tamis*), sour (*asim*), and salty (*alat),* but not that spicy (*maanghang*). Garlic, onions, vinegar, soy sauce, lemon juice, and tomatoes are the most common ingredients. The use of extremely hot spices is limited compared to that of neighboring countries, with chilli (*siling labuyo*) primarily applied as flavoring for a number of dipping sauces, while cooking pepper (*siling mahaba*) is used in soups and stews. Everyday cooking methods are braising (*adobo*), stir- or deep-frying (*prito*), grilling (*inihaw*), and boiling (*nilaga*).

Mindanao: From Samai to Surallah

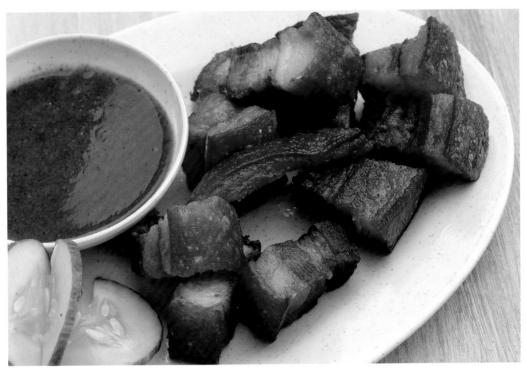

Lechon Kawali

La Paz Batchoy

Koronadal City

Adobo, a salty, savory stew, is often regarded as the unofficial national dish of the Philippines. (The name is Spanish in origin; *adobar* means "to stew.") The recipe is as simple as it is delicious: small pieces of braised meat, fish, or vegetables are simmered in a marinade of vinegar, soy sauce, bay leaves, crushed garlic, black peppercorns, and several other spices, and usually served over steamed rice. The addition of vinegar gives adobo its specific tangy taste; vinegar is also one of the main preservatives used in the Filipino kitchen.

Cooking *Sinigang*-style is another way of preservation, but without using vinegar. A clear, slightly sour soup, sinigang derives its sharp, biting taste from tamarind and gets its pungency from fruits such as calamansi, guava, cucumber, and green mango. This popular dish can also be made with fish, shrimp, chicken, or pork.

Pork is the main ingredient in many Filipino recipes, followed by poultry, beef, and sometimes water buffalo (carabao) meat. In Islamic areas in Mindanao, pork and pork by-products are forbidden (*haram*), so beef is commonly used.

Prito or *pinirito* is used for dishes like *pritong manok* (fried chicken), *lumpiang prito* (fried vegetable rolls), *calamares prito* (deep-fried squid rings), and *pritong isda* (pan-fried fish).

Pritong Manok, deep-fried garlic chicken

Mindanao: From Samai to Surallah

All of these dishes can be eaten with the fingers and served as a side dish, appetizer, or main course.

Just about anything, from pork and poultry to fish and vegetables, can be grilled—usually over charcoal, which sears the food quickly and gives it a smoky flavor and crisp exterior.

Inasal means cooking over fire, be it charcoal, wood, or gas. The meat is marinated in concoctions like red *achuete* (annatto seeds), which imparts a reddish hue. Inasal is quite different from other grilled food because there is no sweetness in the seasoning; even its dipping sauce is a sour mixture of vinegar, garlic, chillies, and shallots.

Nilaga is a hearty and filling soup with pork or beef, potatoes, bok choy (or *pechay*) and cabbage in a broth flavored with onion, fish sauce stock, and black peppercorns. This one-pot meal is usually served as the main entree with steamed rice and a dipping sauce of the ever-present *patis* (fish sauce), which tastes salty and slightly sweet.

Patis is made from salted, fermented fish and is a natural flavoring and salt substitute. When mixed with calamansi juice it is a favorite dipping sauce for all kinds of seafood, chicken, and pork. A number of meals are customarily served with dipping sauces (*saw-sawan*) on the side. (*Sawsawan* means "to dip.") The most common of these sauces is vinegar mixed with crushed garlic or chillies, known as *sukang maanghang*. Other widely used sauces are *toyo-mansi*, a combination of soy sauce and calamansi, and *bagoong-mansi*, a mixture of shrimp paste and calamansi.

Smoked fish, better known by the name *tinapa*, is a popular delicacy garnished with tomatoes, onion, and garlic-flavored vinegar for the dipping sauce. The fish most often used for tinapa are herring and sardines (called by the locals *tinapa tamban*), but *galunggong* (short-finned scad) and *bangus* (milkfish) are used as well. Sun-drying and salting fish (*tuyo* or *daing*) are other methods of preservation. After being cured by smoke, salt, or sun, the strong-smelling fish are used both as a primary ingredient in a dish or as a flavoring agent.

Tuyo can be found anywhere in the country and is still a source of livelihood on most of the islands; it's known as "poor man's food" because of its low price. For many Filipinos the most common meal is undoubtedly *tuysilog*, a combination of fried tuyo, fried rice (*sin-angag*), and *itlog* (fried egg), which can be eaten for breakfast, lunch, supper, or *merienda* (snack).

Lomi

Paella Pilipino

Mindanao: From Samai to Surallah

Tinolang Manok

Nilaga

Koronadal City

Koronadal City, Del Rio Resort

Mindanao: From Samai to Surallah

Resort Recommendations

Great family fun can be found at the multifaceted Paraiso Verde Resort & Water Park on the outskirts of Koronadal City, an oasis of recreation and relaxation. This family-oriented retreat, the largest recreational water park in the region, offers a wave pool, a Raging River, a Kid's Paradise, and a lap pool. The Cinco Niñas restaurant located inside the resort serves a collection of mouthwatering specialties, like the tempting crispy *pata* (deep-fried pig's trotters or knuckles served with a soy-vinegar sauce) or *sisig* (chopped pig's face, ears, and pork liver).

Located at the boundary of Koronadal City, the Del Rio Splash Resort is an all-inclusive family vacation getaway where both children and adults can enjoy their stay. It is a prime spot in South Cotabato, with a swimming pool with slides for adults and children; pool cottages; and a restaurant that serves a wide variety of seafood and exquisite Filipino and Chinese dishes.

Pork Sisig

Carpenter Hill, The Farm

Mindanao: From Samai to Surallah

Carpenter Hill, The Farm: Japanese Garden

Barangay Carpenter Hill, just outside Koronadal along the Maharlika Highway, is the location of the Farm, a sprawling Japanese-inspired hideaway. The hotel has different styles of accommodation, a garden resort convention center, a pond filled with multicolored fish, a park, and an aviary. The Farm restaurant serves an enticing variety of fresh fruit, vegetables, and fish and meat dishes with the rich flavors of Asia—must-tries are sweet and spicy *hipon* (shrimp) and *kani* (crab) salad. The Sushi Bar presents a diverse selection of food and drinks and the Koi Hut is the main breakfast area. The Aviary Bar and Cafe is surrounded by cages of colorful birds; and the Goat House, now a spot for parties and other gatherings, was used in the past as a barn for the farm's goatherd. The Farm is a perfect holiday spot for families. Its natural setting of flowers, shrubs, and lush green trees makes it well insulated from the noise and bustle of city living, yet it is easily accessible by road.

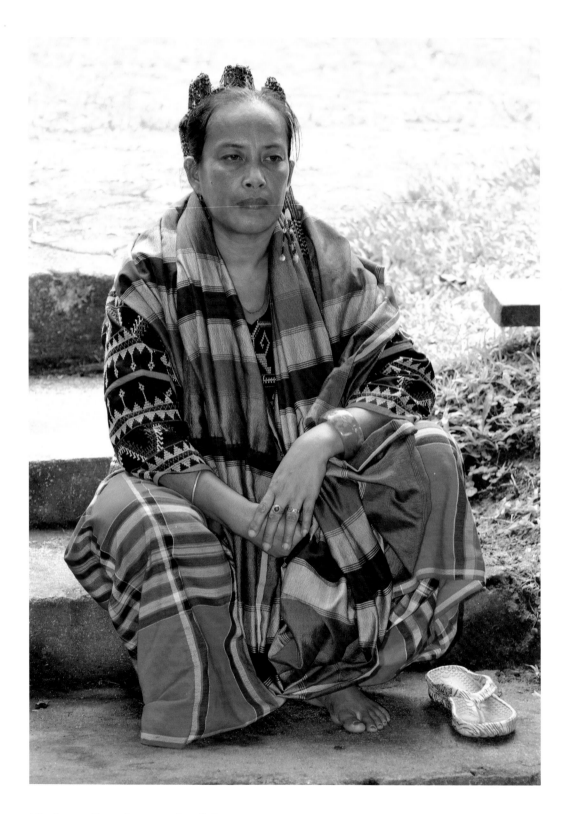

Mindanao: From Samai to Surallah

Tsinelas

Almost everyone you see wears slippers called *tsinelas*, which are affordable, lightweight, functional, comfortable, and convenient slip-on footwear. The design, one that dates back to ancient Egypt, is very basic: open, low-cut, backless, and held in place by a Y-formed strap. The strap is connected at three points to a thin, flexible sole that is often spongy, absorbing the weight of the wearer's feet. Nearly every person in the Philippines owns at least two pairs of tsinelas, which are known around the world as flip-flops, thongs, zories, or slippers.

Tsinelas in the past were traditionally made from abaca fiber and hemp, but today's models can be plastic, foam, leather, suede, corduroy, or even recycled rubber. They come in many shapes, styles, sizes, patterns, and colors and are present in every Filipino household, prosperous or poor, urban or provincial. They are worn almost everywhere, at the beach, when shopping, playing a basketball game, on the streets, in church, and at school. Because of their low cost, they are widely used as everyday working gear and are perfect footwear for hot weather, since their open construction allows the feet to breathe. Quite a few parts of the country are flooded during the rainy season and dirt roads can have rain-filled potholes, so wearing these casual slippers is quite practical. They are easy to remove before entering a house, can be tucked away in a pocket or bag, are washable, and dry quickly.

The word *tsinelas* is taken from the Spanish term *chinela,* meaning "slipper" or "sandal." Over time they have gone from a necessity to a hot commodity and a stylish statement. Fashionistas jazz them up with beads, LED lights, fragrances, and ribbons, adding more colors and prints by using special paint to give their footwear a personal touch. Tsinelas are also a tool used by parents to drum some discipline into their children, a correctional practice known as *pamamalo,* or spanking a kid with a slipper.

The durable footwear is an efficient tool for killing insects and serves as a doorstop, a guardian against picking up parasites and bacteria through the soles of the feet, and a flotation device for toddlers when they are learning to swim. Cutout parts of a run-down sole are used by carpenters and painters as makeshift sanding blocks. In addition to all this, few families can afford toys, so kids play games with their tsinelas. One of the most popular is *tumbang-preso,* in which a group of children throw their slippers in attempts to topple an empty can, despite the efforts of the one who is chosen to stand guard over it.

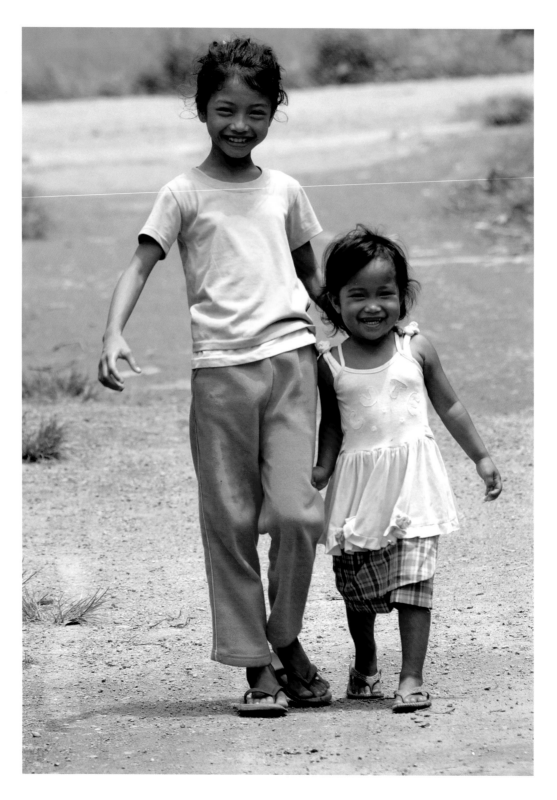

Mindanao: From Samai to Surallah

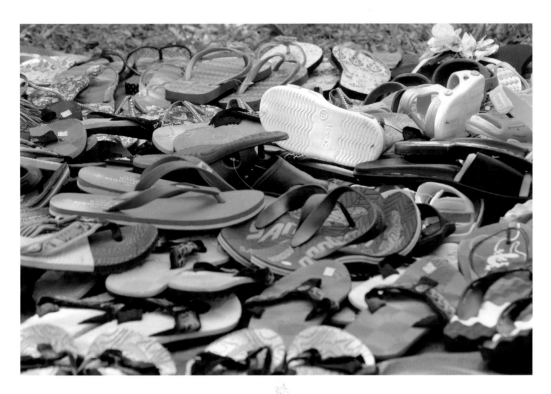

It is incredible to see how fast these kids can run without losing their dilapidated shoes. Even hiking long distances over rough terrain to get to school seems to be no problem at all for these little ones in their slippers.

It is a Filipino custom to remove footwear when entering a home, so on many doorsteps a small mountain of tsinelas are left in front of the entryway, creating diversions when people accidentally stumble over them or when somebody cannot find their own slippers in the pile. Tensions and emotions can get a bit high when finding that a dog has run away with a favorite shoe and has left it buried in the mud and chewed up beyond recognition. Replacement is easy, however, since tsinelas are sold everywhere, from street markets to shopping malls.

It appears as if the entire population of this peninsula is strongly attached to their reliable slippers. Certainly throwing them away and buying new ones is a last resort for many. Trying to repair them with iron wire, glue, duct tape, and a great amount of improvisation and ingenuity is always the first choice. When the trusty tsinelas are finally at the end of their life span, it is very hard to say goodbye to them and they are often tucked away as sentimental reminders of days gone by.

Koronadal City

Tsinelas are a way of life in the Philippines, since nearly everybody wears them. Business travelers, holidaymakers, and migrant workers alike take their cherished slippers wherever they go, for comfort and that familiar feeling of home. To outsiders these shoes may seem the most ordinary and unhealthy footwear ever, but successive generations from all over this island nation grew up with them and have worn them from the day that they learned how to walk. They are an indispensable detail of identity, with some of the outstanding characteristics of Filipino people similar to the features of the tsinela: simplicity, flexibility, modesty, and reliability.

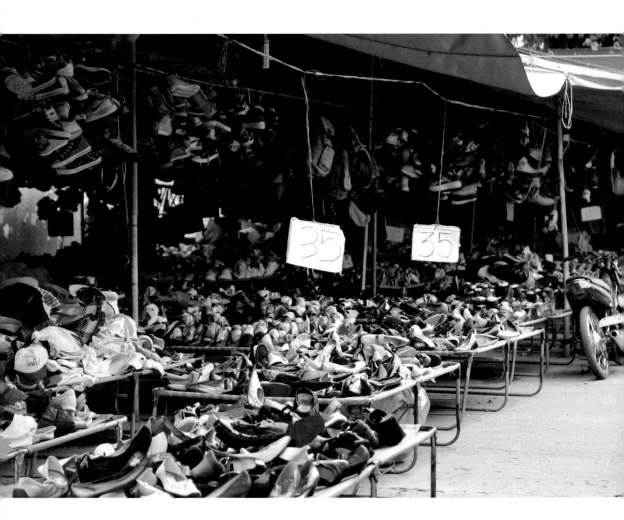

Mindanao: From Samai to Surallah

Ukay-Ukay

The public market is a hive of activity with a high-spirited atmosphere where shoppers come to find fish, meat, fruit, and vegetable sellers; hairdressers; and *ukay-ukay* stalls. Ukay-ukay is the Filipino adaptation of a flea market, born out of necessity more than thirty years ago and now the best bargain grand slam in the country, a shoestring enterprise that has grown into a lucrative fashion industry. Koronadal has a number of these open-air flea markets, along with sidewalk stalls and regular stores.

Ukay-ukay (for short, "UK") shopping involves burrowing into a pile of secondhand clothes. The word is derived from the Filipino word *halukay*, which means "digging" or "making a mess," and currently it is used for places that sell old clothes, bags, shoes, and other pre-owned goods at very low prices. When this poverty-stricken country is hit by a calamity, shiploads of secondhand or discounted garments and necessities from other countries in the world arrive as aid. The goods pile up and are exchanged to tradesmen who, in turn, sell them to the general public. The first resale stores were known as *wagwagan* because the dust had to be shaken (*wagwag*) from the merchandise. Although at first the relief-for-sale stores carried only used apparel, later on shopkeepers began to take in other items like toys and household goods. In parts of Mindanao even the most basic needs, especially clothing, are out of reach for the impoverished, so looking for good value is a daily occupation. For low-income families, ukay-ukay is the answer to their problems.

But recession has gained its foothold in today's economy. Ukay-ukay is not only for the less fortunate anymore; even the most stylish now scrounge into the piles of clothing, looking for that exquisite vintage piece for next to nothing. However, for the poor as well as the prosperous, poking into a pile of hand-me-down fashion trying to find that something to-die-for comes with a price. Vendors pour a disinfectant on their already musty-smelling merchandise that gives their stalls a nasty odor—much like the stench of a punctured mothball. Shoppers must be able to withstand this migraine-causing smell and practice a lot of patience while rummaging from stall to stall.

One is never alone in this search for the perfect item. For real bargain hunters, it's fun to go through heaps and racks of garments that are not always in the best of condition. For some it is the equivalent of treasure hunting, for many others it is a continuous quest for affordable clothing. Browsing through the ukay-ukay has not only financial advantages; sometimes there are garments that are hard to find anywhere else.

149

While fashion-minded individuals can shop for designer clothes with a rock-bottom bill, most of all the ukay-ukay benefits the poor and lower middle class, giving them the chance to bargain for cheap and presentable clothing that otherwise would end up as cleaning rags destined for a garbage site.

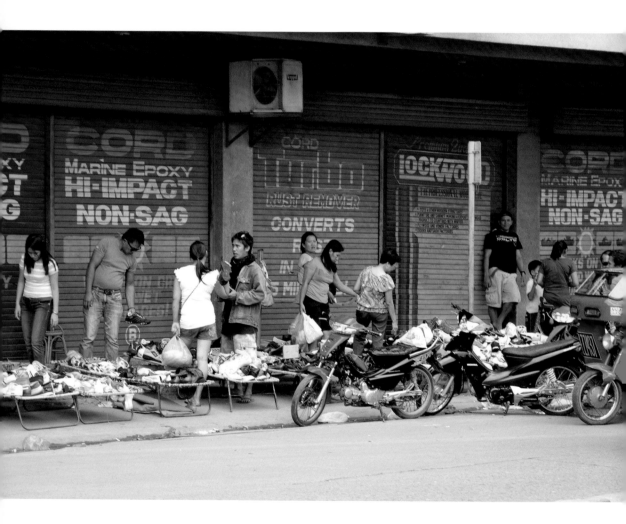

Mindanao: From Samai to Surallah

Polomolok, Durian Garden Restaurant

Mind Your Manners

Filipino culture has its own rules when it comes to basic household routines and table manners; most of these are based on profound courtesy, togetherness, and healthful living, while often anchored in religion and shrouded with country wisdom. The rules of general behavior are complex and it takes time to understand them.

When you are invited to have dinner with a Filipino family, sit down at the table with a gentle heart and a respectful mind. Enjoy the food, the company, and the hospitality, but keep in mind a few simple recommendations. Wear appropriate attire, preferably conservative in style; visitors are, in many instances, judged by the way they look and dress. Be attentive and friendly without being artificial, and show a genuine interest in the culture. Be cordial, take time to smile, and do not arrive empty handed. Bring some sweets or flowers as a token of appreciation for your hosts—making sure that your flowers are not chrysanthemums, orchids, or lilies, which are traditionally used for funerals.

If you give a billfold or purse as a gift, make certain to put some coins or bills inside it, because giving an empty wallet can cause bad luck and means the wallet will stay empty in the future. All gifts should be wrapped with festive paper and ribbons; this shows the amount of time, effort, and thought that was put into the gesture. Do recognize that gifts are not opened immediately when they are received.

When meeting the host, a firm handshake is the usual and most acceptable way of greeting, but don't give one that is bone crushing; this is seen as a sign of aggression. Expect a handshake in return that lasts longer than you may be used to receiving.

It is common for family and visitors to remove their shoes before entering the house; not doing so is considered rude and unhygienic. Don't worry; normally guests are given house slippers, if some are available. It is most likely a guest will be welcomed with the words "*Kumain ka na?*" ("Have you eaten yet?") instead of "How are you?" and will probably immediately receive a glass of water, which ensures that the guest has brought only good news.

Once you are inside, it is explicitly out of bounds to roam around without approval from the owner. Be very cautious about touching and moving objects: these are often placed so that bad spirits are kept out and the good ones are invited inside. When it is necessary to pass through a group of people, it's polite to bend forward a little, lower your head, and clasp your hands together in front of your body, which is both a token of respect and an unvoiced apology for your interruption. When having a conversation, it is normal to stand at arm's length from one another, but if you're talking to a stranger, the distance could be more than that. It is a major no-no to place your hands on your hips; this could be misunderstood as anger or arrogance.

Proper table manners will also affect the way you are perceived. Remember that as a guest, you are expected to wait to sit at the dinner table until your host invites you to take a seat, showing you which chair is yours. It is a custom to wash the hands thoroughly before and after every meal. Eating with the hands (*kamayan*) is not uncommon in rural areas; this way the food can be felt and smelled before tasting and it's believed that this method of eating makes the food taste a lot better. Nevertheless, avoid using your left hand for any kind of eating. Keep it at your side and do not place it on the table. Be careful not to eat food from the palm of your hand, do not put your fingers in your mouth, and do not scoop up the food as though your right hand is a backhoe. Religion plays an important role in family life and a prayer is said before the meal begins and on occasion after meals as well.

Glassware and cutlery must remain untouched until the prayer has been said. The host will lift his fork and invite all who are present at the table to eat, yet you should wait until the oldest person at the table has been served first. If you have an irresistible appetite for a second helping of the food, have some patience and wait until more is offered. When your glass is empty, usually the host will refill it; don't do it yourself, for this will cause your host to feel disgraced.

Because meals are served family-style, with all dishes shared, use only the utensils that come with the serving dishes to put food on your own plate. It is easy to understand that a spoon, a fork, or food that has come into contact with someone else's saliva is seen as repulsive; it is also believed that this will cause the food to get stale rapidly. A knife is seldom part of the table setting, so it is quite normal to cut your meat with the edge of the spoon or fork, easily done since most meat is served in small portions. In most families chopsticks are rarely used, unless the clan is of Chinese descent.

Be careful not to drop your silverware: when a spoon hits the floor, it is an implication that a female guest is soon to arrive; if it's a fork that falls, a male visitor can be expected. (However, Filipinos are very generous, so receiving additional visitors is no problem whatsoever. There is always more food on the table than the family could eat to allow for unexpected guests.) In the same way, be very careful while holding a glass; if it falls to the floor and breaks, it could mean serious trouble lies ahead or even that somebody in the family or a loved one will die soon.

Never decline food that has been offered; this could be interpreted as a refusal of hospitality. Eating heartily is the best way to give kudos to the lady of the house, but still try not to overload your plate with too much food. Taking the last portion, without asking for permission, from a central serving tray is unacceptable. If you do this, there is a possibility you will remain unmarried for the rest of your life. To avoid appearing greedy, always leave a small amount of food on the serving platter. Emptying it could insult your host; it also means you will go hungry for a lifetime. At no time stack dirty dishes one on top of the other; this could result in adultery. Please observe these rules of etiquette since death, loneliness, starvation, and infidelity are not things that anyone wants to deal with.

Food is an essential part of socializing and the presence of family and friends is highly valued, so lunch and dinner are, whenever possible, bonding time. No chair is left empty; often there are more than a few people seated at the table—but this number should never add up to thirteen, which means someone in the group could die very soon. Many people

at one dining table can lead to limited personal space, so never extend your arm too far to get something that is beyond your reach. Ask politely for it, and to keep from bumping your tablemates, don't extend your elbows to the side.

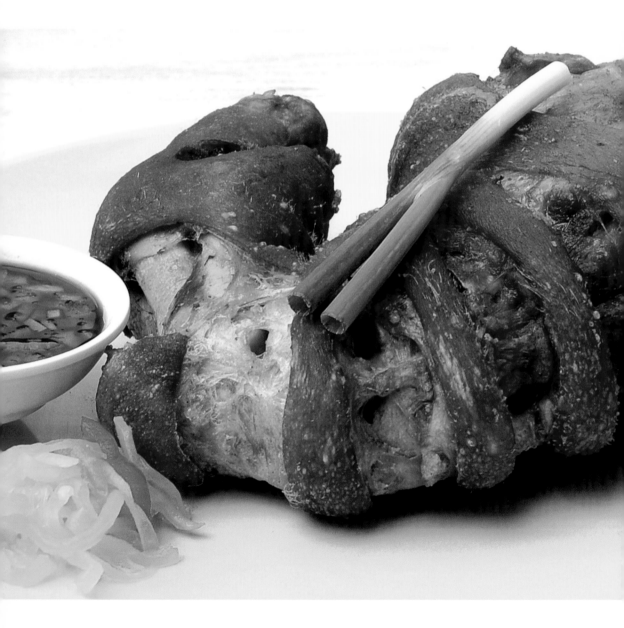

Keep your hands above the table at all times, and your elbows off the table while eating. Never pass food to someone else by using only your left hand but be sure to use both left and right to give and receive. Cupping your chin in your hands at the dinner table or placing your face between the palms of your hands is bad manners; this will drive away good luck and make you look indifferent. Never put your hands in your pockets either, which can indicate that you are feeling uncomfortable around other people. Your wallet should be kept in your pocket; placing bills or coins on top of the dining table will attract bad luck, as a prediction that your host's—and your own—entire income will be spent on food. Always sit up straight and keep all four legs of your dining chair on the floor; tipping your chair while eating is annoying.

A gentle burp during or after eating is allowed and will be thought of as a compliment, showing that you enjoyed the meal and there was enough to eat, but this should be done while covering your mouth with your hand or a napkin. However, belching, slurping, coughing, sneezing, smacking, moaning, blowing your nose, yawning, or any other body noises are frowned upon, and sighing while you eat can cause your own spirit to starve. Cover your mouth when it is not possible to control these natural inconveniences, and do not forget to say "Excuse me" when you have finished.

155

Because everybody's taste buds are different, some local dishes may not be your favorites. If the food that is prepared is not to your taste, do not show disappointment and set it aside, but try to eat a small portion and make an excuse rather than rejecting it straightaway. (Take into account that playing with your food can cause a stomachache.) Eat moderate portions and chew thoroughly. If someone chokes on a piece of food, there is a great chance that someone far away is talking about that person. If a fish bone gets stuck in your throat, don't tell anyone, try to pretend nothing has happened, turn your plate around three times, and the bone will disappear. If the bone is still in your mouth and not yet down your throat, remove it with your fingers, preferably without saying anything, and put it at the edge of your plate. And never forget that in the Philippines, picking your teeth with a toothpick in front of your tablemates is uncivilized.

Crispy Pate

Tapping your fingers on the table, humming, whistling, or singing is without question not accepted. Chewing should be done quietly and with the mouth closed. Sniffing the food from a short distance and talking with food in your mouth are regarded as vulgar. When you are finished eating, place your fork and spoon side by side on the plate, facing up, with your napkin on the table beside the plate. Don't leave the table until everyone else is done

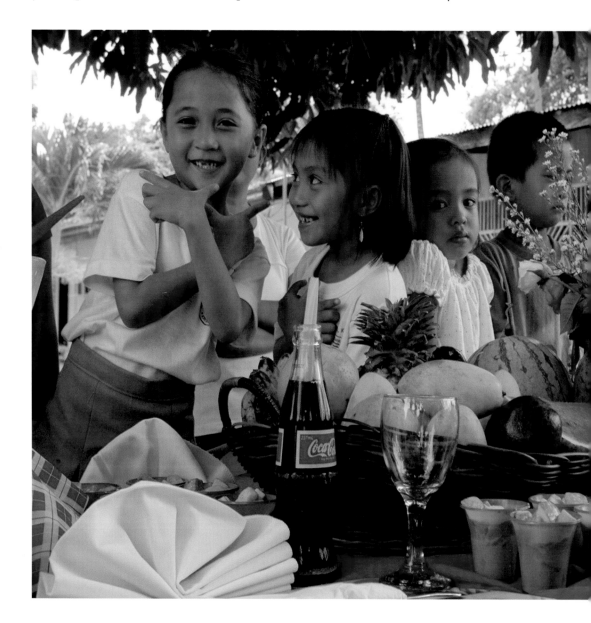

with their meal, although in large families it is permissible, since it allows another family member to take the vacant seat and join in. Still, when someone has to leave the table, the plates should likewise be rotated a full 360 degrees by those still eating; this will bring good fortune to the person who is leaving.

Finally, it is a sincere expression of kindness to give the departing guest a doggie bag (*pabaon*) with some leftover food inside; turning this down is rude and disrespectful. Accept the favor with thanks and bear in mind that it is called a doggie bag for a good reason.

Following these rules of etiquette requires constant attention but will keep you from social blunders and public embarrassment.

Nowadays these formal table rituals and manners may seem old-fashioned and stilted, but they are still, and will remain, an important part of the Philippine culture and tradition. (Whether dining in someone's home or in a restaurant, for the most part, the same rules apply.) Actually most Filipino table manners are not really that different than those in other countries.

157

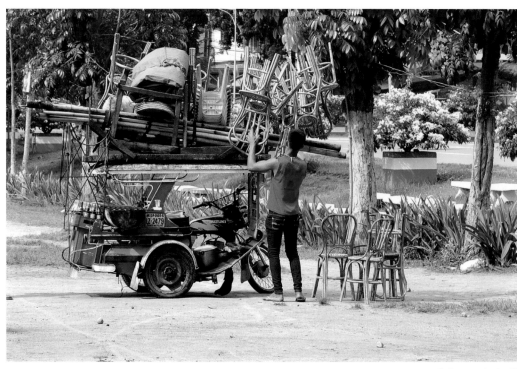

Mobile BBQ Stall

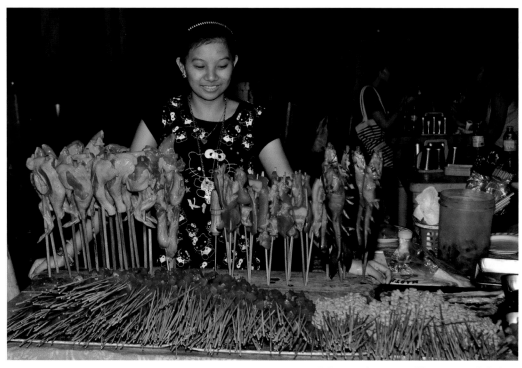

BBQ Vendor, B-walk Koronadal City

Mindanao: From Samai to Surallah

Street Food

Mindanao is famous for its street food and your trip will come up short if you don't sample the island's distinctive sidewalk cuisine. This is something like a handheld fast-food heaven, where freshly-cooked-before-your-eyes snacks are served on sticks, wrapped in paper, or put in a plastic bag. It gives everybody the pleasure of eating with their bare hands, digging in with their fingers and chewing on mess-making mouthfuls of goodies. Street food is inexpensive, convenient, fast, and easy, eaten anytime, anywhere, and with anyone.

Streets in Koronadal City and other places are filled with a bedazzling melange of gratifying goodness that is longed for by many Filipinos who live abroad. The stalls that can be found at almost every corner of the city streets offer a large choice of tasty food for those who need a quick bite. Chart-busters are *bibingka* (rice cakes), fish balls, squid balls, dumplings, fried bananas or sweet potatoes on a stick, and quail eggs dipped in a batter and deep-fried to a frizzle.

The B-Walk (*B* stands for barbecue) is a line of open-air food and barbecue stalls with small dining areas that are set up early in the evening, located only a short walk away from the market. Eating these goodies can be a real challenge; many first-time visitors avoid them for sanitary reasons or because they're afraid of eating such bizarre food.

Although the snacks may appear eerie and sometimes shocking, they taste better than they often look and many are tempted by the meaty, salty, sweet, and spicy choices. Filipinos are creative and nothing is wasted. Nearly every single bit of meat will be eaten, one way or another; even the least palatable ingredients are grilled, fried, or steamed.

Some ready-to-eat delicacies are given clever names, mostly based on their forms—such as a skewer of crispy chicken wings known as *PAL*, named after the Philippine Air Lines. *Isaw* is an outstanding choice, simple yet pleasing: grilled or deep-fried pig or chicken intestines on a wooden stick, served with sweet, sour sauce or dipped in vinegar with onions, peppers, and other spices (*kurat*). The innards are thoroughly cleaned, turned inside out, and boiled before they are grilled, and there's nothing that can beat this strange, twisted, smoky midnight snack. Because this looks like an intrauterine device, it is locally known as *IUD*.

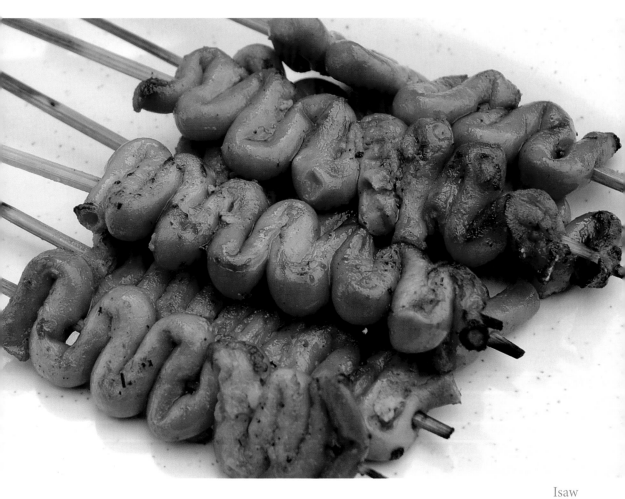

Isaw

Mindanao: From Samai to Surallah

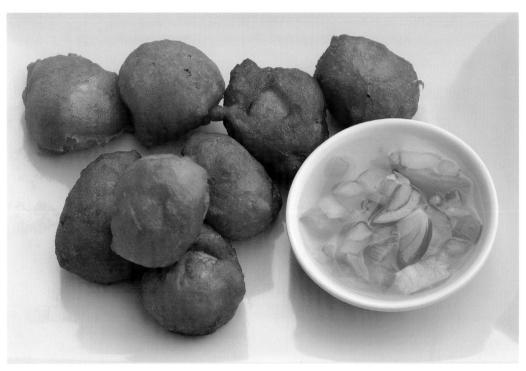

Tokneneng

Pork BBQ

Koronadal City

Mindanao: From Samai to Surallah

Balut

Balut, also dubbed "eggs with legs," is unmistakably one of the Philippines' most disreputable and at the same time one of its most popular treat. This is a cooked, fertilized duck egg, with a nearly developed, healthy, living embryo, between seventeen to twenty days in gestation and with recognizable features, almost ready to see daylight. This delicacy is eaten in the shell and is a high-protein snack, believed to be an aphrodisiac. Before the shell is peeled off, the broth surrounding the embryo can be sipped from the egg. After this the tender chick inside can be eaten. Balut is normally sold by street vendors out of metal buckets covered with a cloth to keep the eggs warm and is served with small packets of salt or spiced vinegar.

Another popular street food which is a must-try is *adidas*, or declawed chicken feet, marinated and grilled, or cooked adobo-style, with a strong, savory flavor. It's called adidas because the chicken feet are three-toed and the trendy sports sneakers have three stripes in their logo.

The *betamax* is another example of Filipino humor. Curdled chicken's or pig's blood that is shaped into cubes and grilled, the snack is called betamax because of its rectangular shape and black color that resembles the outdated Betamax videotape. It tastes like meat and is served with vinegar or another kind of sauce. The *helmet* is an appetizing adventure like no other and an all-time hot seller for street-food fanatics: a deep-fried or grilled chicken head, beak and feathers removed but with eyeballs, brains, and sometimes the comb intact, marinated in the same way as isaw. The skin is peeled off and eaten first, then the skull is broken and the brains are sucked out.

163

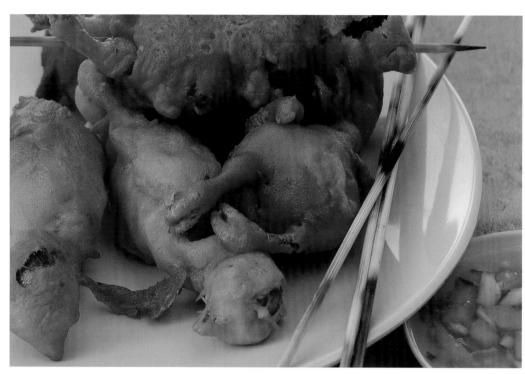

One Day Old

Lechon Baboy

Mindanao: From Samai to Surallah

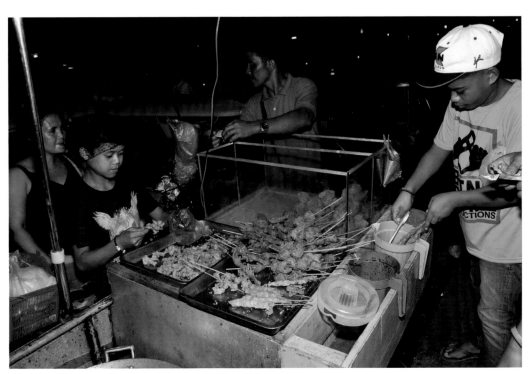

Koronadal City, BBQ Stall

A tiny meal called *one day old* is exactly what it says, baby chicks that are just about a single day old. The newly hatched male chicks are scorned by poultry farmers because they do not produce eggs so they are killed, coated in reddish-orange flour, and fried to perfection. Their tiny bones are still soft, so only their bowels are removed before they are eaten whole.

Roasted pig, or *lechon baboy,* is a highlight of fiestas and other celebrations. (*Lechon* is a Spanish word for "suckling pig," which can also be called *litson*.) No celebration would be complete without this symbol of the Philippine feast on the table, made in traditional style by stuffing the inside of the pig with a variety of herbs and vegetables, like onions, garlic, lemongrass, and ginger. Preparing this for consumption takes nearly a whole day; the body is soaked in hot water, shaved, and thoroughly cleaned. The piglet is then slowly roasted for hours over a charcoal fire, resulting in tender meat with a dark brown and crispy skin. It's usually served with an apple between its jaws, carved, and eaten with a liver-based sauce.

Mindanao: From Samai to Surallah

Helmet

A more common form of grub is the *walkman,* marinated pig's ears that are grilled on bamboo skewers. The ears are first cut into small pieces, boiled, and scraped clean; they're very popular, eaten with spiced vinegar and usually consumed with alcohol, most often a bottle of beer or rum. The name of this queer tidbit refers to Sony's outdated portable music players.

Dila or pickled barbecued pig's tongue is a good example of a less common snack that is normally grilled. This beguiling and extreme food is not exactly a feast for the eyes or the nose.

If you have plenty of backbone, if your belly is strong enough, if you're willing to forgo the usual fare of hamburger, pizza, or hot dogs, and if you dare to tackle the unfamiliar, try these local snacks. Gobbling up fried eyeballs, grilled brains, seared ears and tongue, roasted intestines, boiled duck fetus, dried blood, baby chicks, and other strange-looking animal parts is an inspiring way to discover the tastes of the city streets.

For culinary novices it probably will take some time and perseverance to get familiar with these gustatory adventures, but after a while their unusual aromas and flavors will become familiar and delicious. Although street-food snacks are the ultimate extreme-food challenge, they make the multifaceted Filipino cuisine stand out from others in Asia.

Filipinos love to eat and traditionally have at least two snacks in between meals. For them food is meant to be shared, and there are still a multitude of different curbside pickings waiting to be shared with you. Any of these tantalizing takeaway treats are definitely worth your best shot—try *tokneneng, pusit, penoy,* and *kwek-kwek.* Find out which one will tickle your taste buds and satisfy your appetite. Enjoy your street-food meal; it will be one to remember!

167

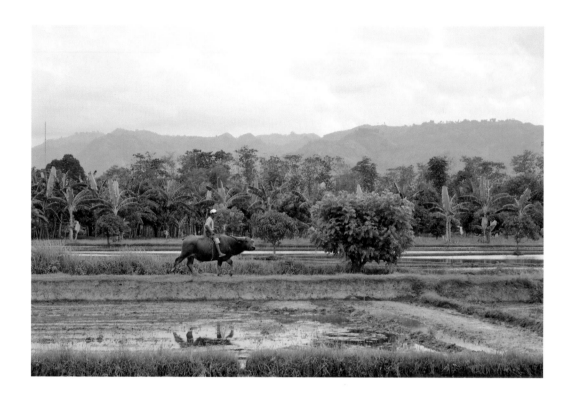

Mindanao: From Samai to Surallah

Rice Fields of the Allah Valley

The fertile land of the Allah Valley in the province of South Cotabato produces some of the tastiest vegetables and fruit in the country, but its richest gift is rice. In this valley, paddies stretch out like a tapestry that's been dyed with many shades of green.

In Mindanao rice is much more than food; it has historical and cultural values that are deeply woven into the Filipino civilization. No other food is used so widely in the Philippines; it is the core of almost every meal in every household. It's affordable; rich in nutrients, vitamins, and minerals; and is an important source of carbohydrates. It is served at breakfast, lunch, dinner, and often as *merienda* or snack. For most Filipinos a meal with no rice is no meal at all and a life without rice is absolutely unthinkable.

The Filipino language has many different words for rice, with *palay* (unmilled rice), *bigas* (milled rice), and *kanin* (cooked rice) among them. It can be steamed, fried, sweetened, used as stuffing, and baked in a cake (*bibingka*). It can even be made into strong liquor, *tapuy*, a native wine from fermented rice, often used in ceremonies. Other rice wines are produced in Mindanao (collectively knwn as *pangasi*), including *kulapo*, a reddish-colored wine with a strong odor and high alcohol content. There are rice dishes of Spanish origin, including *champorado*, paella, and *arroz caldo*, along with local dishes such as *sinangag* (garlic fried rice), *goto* (beef tripe) congee, and *puto* (steamed rice cake).

Rice is the mainstay of many rituals and traditions. One of the more well-known tribes in Mindanao, the T'boli, still practice the ritual *k'molot libol* (trial by ordeal.) If one of the tribe is accused of adultery or theft, the *datu* (village chief) fills a pot with water, grains of rice, and a stone. After the water comes to a boil, the accused can prove his or her innocence by removing the stone from the pot with a bare hand. If the hand is not burned, guiltlessness is confirmed. The Tiruray tribe, in the northwestern part of South Cotabato, holds a ceremonial feast four times a year, *Kanduli*, in which glutinous rice is shared by all, expressing the bonding of all individuals into the tribal community. The Tiruray tribe celebrates their hard labor in the rice paddies in a dance that is named *mag-asik* (sowing seeds). The Manobo tribe commemorates the rice planting in a dance known as *talapak*, named after a stick that is used to dig a hole where the grain or seeds are planted. The B'laan tribe showcases the different stages of upland rice planting in a four-part dance named *maral*: the *kaingin* shows the search for a plot of land that can be cleared for farming by burning away the vegetation, followed by the *almigo*, the clearing of the area; the *amla*, the planting of the rice; and the conclusion of the dance, the *kamto*, that shows the harvesting done by the women of the tribe.

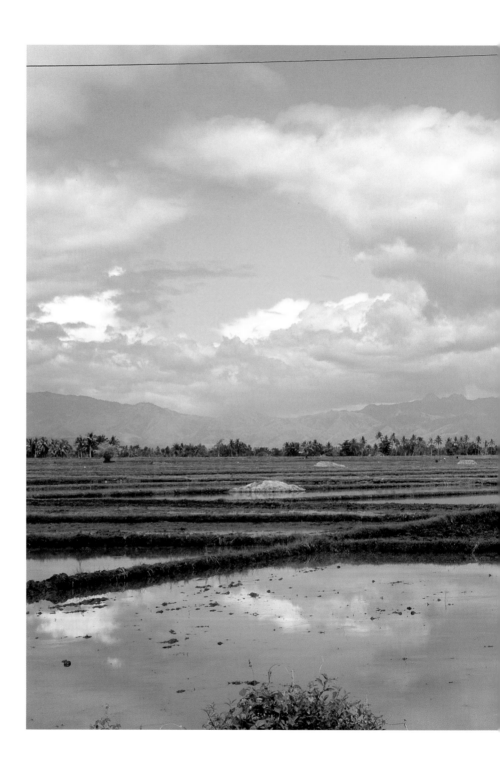

Mindanao: From Samai to Surallah

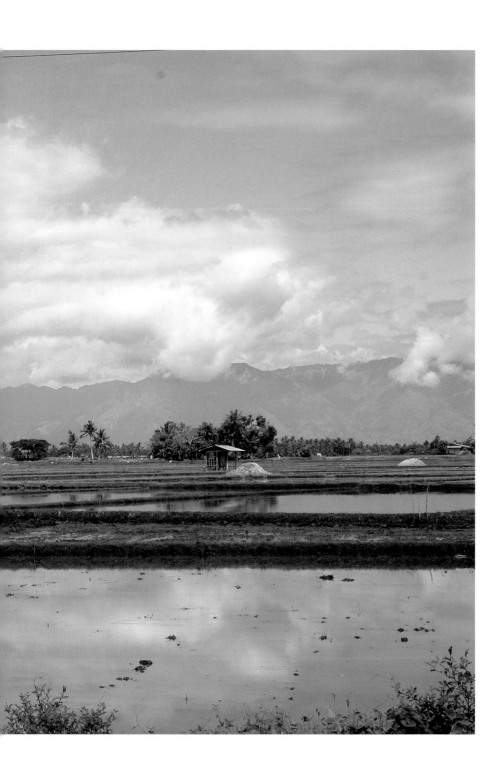

Koronadal City

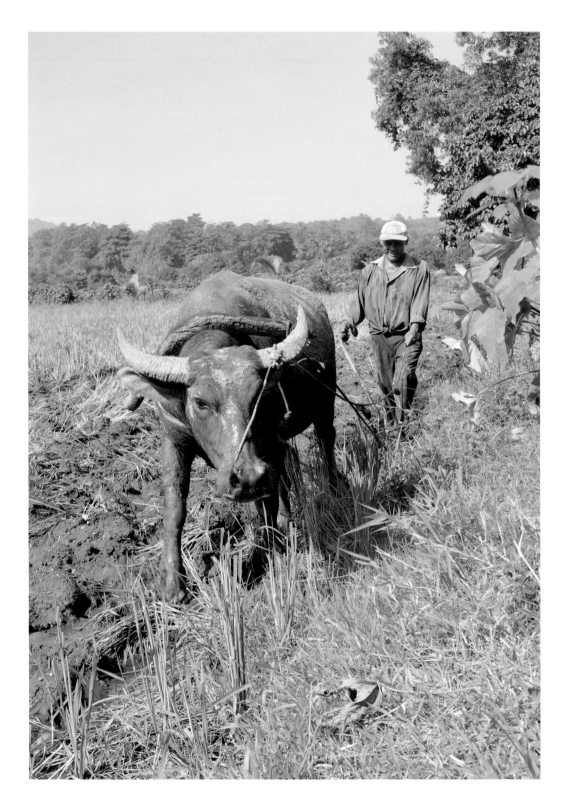

Mindanao: From Samai to Surallah

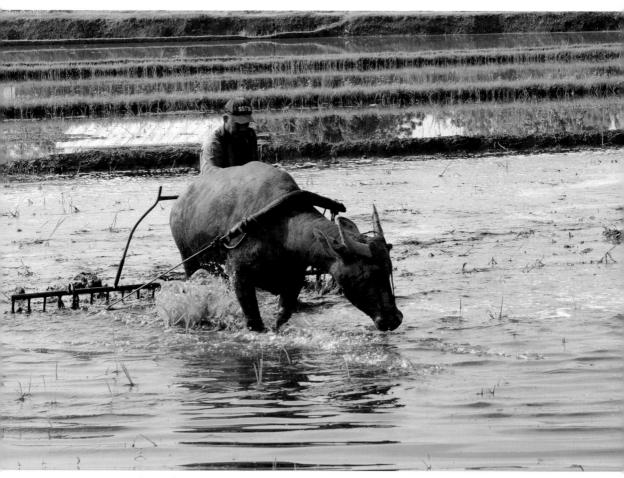

Rice Farmer and Carabao

Koronadal City

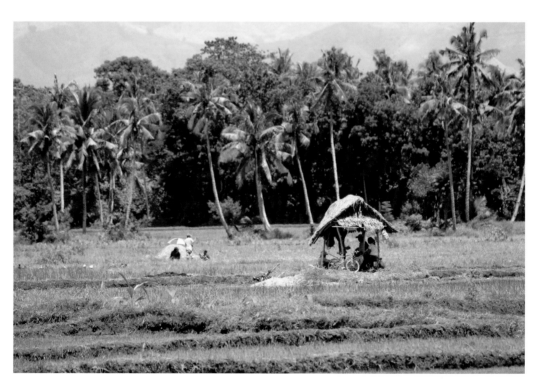

Mindanao: From Samai to Surallah

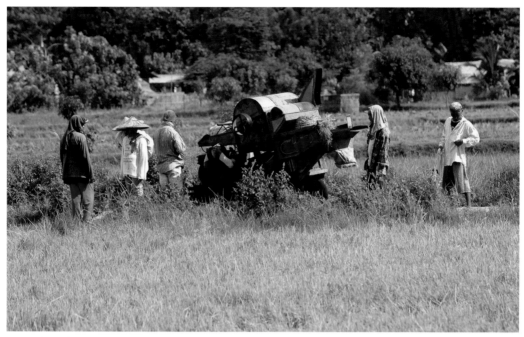
Rice Threshing

Tossing handfuls of rice at newlyweds is a familiar custom to many; in the Philippines it symbolizes a wish for many children, abundance, and prosperity. The bride and groom mark the solemnity of their sacred bond of marriage by exchanging a handful of rice during the ceremony, and the social status of their future family will be often be measured by the quantity of rice that they have stored.

Rice is widely produced in Luzon, Western Visayas, and both southern and central Mindanao. In the southern lowlands of Mindanao rice is mostly grown on small family farms. Planting and harvesting rice has become a way of life over the centuries; the right to plant rice is believed to be a privilege given by the gods and Mother Nature, and time is measured by the ripening of rice in the paddies.

Each planting of the rice field marks the start of a new season. The decision of when to plant the crops is often made according to the position of the sun, the monsoon rains, and the migration of birds. Before the rice can reach a plate, backbreaking work is done in the rice fields. Men and women, up to their knees in water, using their bare hands, simple tools, and water buffalo, prepare the paddies, plow and till the soil, and plant the rice seedlings in rows by hand.

The slow and tedious steps of a water buffalo or carabao are used to prepare the soil; the paddy is initially saturated with water from the irrigation canals and the carabao then tramples the planting area until it is soggy enough to plant the rice seedlings. The carabao is a multitasker that plows rice fields as well as pulls wagons. The sight of a plodding carabao hauling rice from the fields is a daily one in many villages. Most rice farmers own at least one carabao that is one of their most prized possessions.

Mindanao: From Samai to Surallah

When the rice turns golden yellow and its stems are straw colored, it is harvest time. Grains are harvested before they are fully mature, after about four months. The paddies are drained and the fields are allowed to dry. The next step is cutting the rice plants by hand with a sickle; the cut is made halfway up the stem, to prevent the spirit of the rice from being frightened away from the fields.

The harvested grains are taken to another location, threshed to separate the stalk and husk, dried, and bundled. Nowadays a threshing machine is used for this task but once in a while it's still done in the traditional manner of bashing bundles of rice stems on a stone. Then it is winnowed by shaking or tossing it on a rattan tray. The husk, chaff, and dust are blown away by the wind while the grain falls onto the mat; it is then dried in the sun and transported to the rice mill.

There the husk and the bran layers are completely removed, and, after cleaning and packing, the rice is ready to be sold to the public. The processing of rice creates local jobs and many valuable byproducts: rice husks can be used as bedding in poultry houses; rice stubble, broken rice, and rice straw are common ingredients in building and food products; rice bran is an additive for pet food. Other byproducts include spring roll wrappers made from rice flour, rice stick noodles, rice oil, rice vinegar, rice glue, and rice paper.

After the harvest is collected and milled, the rice paddies are taken over by local ducks, known as *itik*. These ducks are usually taken to the field in the morning to eat the leftover grains and are taken home in the afternoon. The itik is also known for balut; by selling their eggs, the itik tenders will earn an extra peso.

177

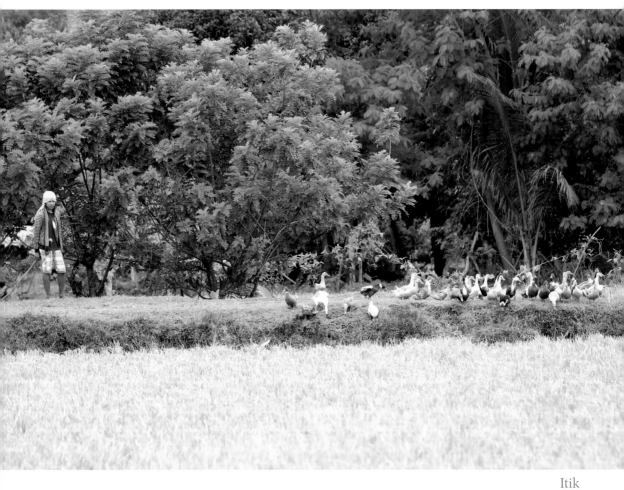

Itik

Mindanao: From Samai to Surallah

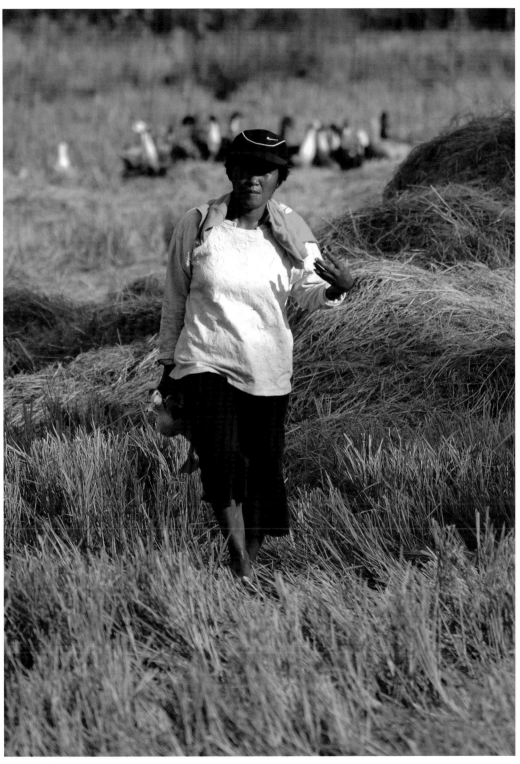

Itik Tender

Koronadal City

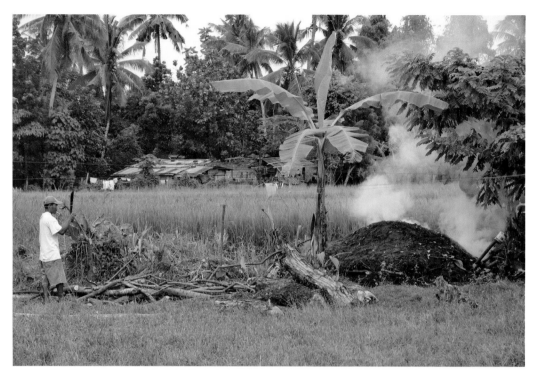

Burning Charcoal

Charcoal

Smoke plumes coming from the burning heaps made by charcoal makers can be seen everywhere across the southern countryside. Charcoal has been used as a traditional source of fuel in the Philippines since ancient times and most poor people living in the province still cook and grill their meals on locally produced charcoal that is made from wood. The timber is placed in pits, set on fire, and heated to a high temperature. After a couple of hours the blaze is completely covered with dirt so it will die down to a smolder. It will take days before the fire cool downs enough that the charcoal can be removed and used. The black charcoal is soft and easy to ignite. Locally produced charcoal (*uling*) is almost pure carbon, so it yields a large amount of heat, becoming hot enough even for iron smelting.

Butiki

Butiki and Other Indigenous Food Sources

The countryside has its own variety of native animals, bugs, and other creatures; the most common of them all is the *butiki* or lizard, alias the Philippine gecko, also known as the house lizard. These are busy hunters, always on the move to get their daily food supply, which is usually a careless mosquito that is eaten alive after a rapid and unexpected attack.

The butiki is a symbol of the Philippines and part of everyday life. People think that they bring good fortune to their host family and that killing them will bring bad luck. Every single Philippine home, big or small, wealthy or badly off, has at least a few of them, scurrying around on ceilings and crawling on walls, behind the closets and curtains, under the bed and next to the refrigerator. When coupling, they sometimes lose their balance and drop off the ceiling (their feet have a special adhesive that usually allows them to stick to surfaces). A butiki spends much of its time high up on ceilings and walls, but legend says that every evening at six o'clock, all butikis in the country kiss the ground, descending from their heights and making slight ticking noises that sound like quick kisses. It is believed that the butiki with its tiny ears can hear an ancient heartbeat and a never-ending lullaby coming from cracks in the earth.

Tokay Gecko

Rice Field Frog

Mindanao: From Samai to Surallah

There are many folktales about these little creatures. A butiki indoors will prevent a snake from entering the building. If a butiki falls on someone's head, it will start raining. If it makes its sound near a door, it means there will be a visitor very soon. If the sound comes from a window, mail will be received soon. If an umbrella is opened inside the house, a lizard will fall from the ceiling.

The bigger edition of this midnight crawler is the *tuko*, or the tokay gecko. Some people say that this gecko, when dried, grilled, or crispy fried, is as tasty as chicken. In folkloric practices they are boiled into a tea or ground into powder and used as medicine that is presumed to be a cure for asthma, impotence, and other diseases. (There is no scientific proof whatsoever that this is true.)

A distant relative of the tokay gecko is the monitor lizard or *bayawak*. The largest lizard found in the Philippines, mostly in Mindanao, Basilan, and Sulu, it can become as long as six and a half feet. Regarded as scrumptious food, they are caught, killed, dried, hung up in bundles at roadside stalls and markets, and sold for a high price. Its eggs *(itlog)* can be eaten after being boiled and are a bit salty. The mini-dragon itself is skinned, disemboweled, beheaded, chopped into small pieces, and cooked with coconut milk or sautéed in garlic and onion, ginger and laurel leaf with pepper, soy sauce, and vinegar. Even though the bayawak is a protected species in the Philippines, it is still hunted for its skin, and its meat is popular both in rural areas and in big-city restaurants.

Bugs, insects, snakes, frogs, bats, snails, and rats are some of the most fascinating and useful creatures, helping plants to reproduce, recycling natural material, and serving as a food source for other living things, including humans. Although they can be creepy looking, these creatures are often a main ingredient in Filipino cuisine and are thought of as tasty, crunchy bites.

Kamaru, or mole crickets, are often called rice field crickets because this is where they are usually found. A popular snack, when cooked every bit of these flying insects can be digested, but most eaters would rather remove the claws, legs, and wings. They can be stir-fried without oil or seasoning, but usually they are prepared as *adobong kamaru*; the cricket bodies are first boiled in vinegar and garlic and then sautéed in oil, onion, and chopped tomatoes until they are crispy on the outside and moist in the middle. They taste a bit like liver and are a favorite accompaniment to cold beer.

183

Dried and Fried Dilis Salad

Tipaklong, or grasshoppers, are a real nuisance for farmers; they can bring plague by eating up crops. Nevertheless, these arthropods make a great stir-fry when sautéed and sauced with vinegar, onions, and tomatoes. They are often eaten sun-dried with their wings and legs removed, or they are pulverized into flour. They can also be roasted on a barbecue and then cut into pieces or broiled whole with salt and seasonings. When prepared this way, they taste like shrimp.

Next there are the June bugs, which are collected along the riverbanks, usually after a summer rain. They can be eaten as larvae or when fully grown. If eaten as bugs, they have to be soaked in salt water overnight, and their legs and wings are removed. They can be roasted over charcoal, sautéed in soy sauce, fried, or heated on a stove top or microwave as if they were popcorn. This odd snack is called *salagubang.* It tastes like walnuts.

Forest Snail

Kuhol is the Filipino name for the apple snail or golden snail, which is made into *guinata-ang kuhol*, a much-favored canapé when sautéed with garlic, ginger, onions, pepper, and coconut cream.

Taklong or korakol are forest snails that live on trees and plants; they carry an oversized, dark brown, coiled shell on their backs and leave traces of orange slime wherever they crawl. This will not deter people from turning this gooey woodland dweller into an exquisite dish called *adobong taklong* (pickled forest snail). The snails are cut into small pieces and simmered with oil, onions, and garlic. Other tempting dishes made from them are *guinisang taklong* (sautéed forest snail) or *barbekyung taklong,* in which the snails are marinated in barbecue sauce, skewered on a bamboo stick, grilled over an open fire, and served with vegetables.

Snakes have long been part of the regional cuisine. When skinned and marinated in garlic, vinegar, soy sauce, and other seasonings, it is enjoyed as *adobong ahas* or snake adobo. Snakes really do taste like chicken when they are grilled or roasted. It is said that snake meat has medicinal value and is an aphrodisiac.

Mindanao: From Samai to Surallah

The Barrios

Small villages dot the provinces; they are called *barrios*, a Spanish word meaning "district" or "neighborhood." These communities are scattered throughout the province of South Cotabato, on mountain slopes and in between rice paddies. Most of them nestle at the end of winding roads, tucked away under leafy palm trees that give shade during the scorching midday sun. Life in an average barrio is simple, removed from the goings-on in the cities and unspoiled by the modern world. The pulse of time has remained unchanged; habits are governed by traditions and customs that have been shaped over centuries. The pace of life is slow, undemanding, and peaceful. Everybody knows everybody else; together they share the joys as well as the sorrows of their own lives and of those around them, getting along while appreciating the good things that Mother Nature has given them.

Families have a strong sense of commitment to their place of origin. Their roots are planted deeply in their own hamlet and they will not move to another quickly. Their barrio is their whole world. It is the place where they were born, played throughout childhood with family and friends, got married, and raised their own children, and it will be the place where they will grow old and eventually die. Many villagers are, in one way or another, related to one another. In a barrio, conventional family values remain a common rule and existence revolves around extended kinship. These warmhearted people also feel a strong obligation to stand by their neighbors and others who are in need. Strangers are treated as welcome guests and the host family will make every effort to please them; no matter what the time of day may be, there is always something to eat and drink, even if they themselves are enduring hardships.

Life in the barrio is not as romantic and sweet as it may seem. It's a harsh life with a continuous struggle to survive under difficult and primitive living conditions with only the basic amenities. Houses are for the most part constructed out of bamboo plants that surround the barrio, and roofs are made with rusty corrugated sheets that are covered with old rubber tires. Extended families share one house or settle close together on the same lot. Conventional principles in the barrio commonly espouse the value of large families: having many children is believed to bring joy and prosperity, and birth control remains largely out of reach.

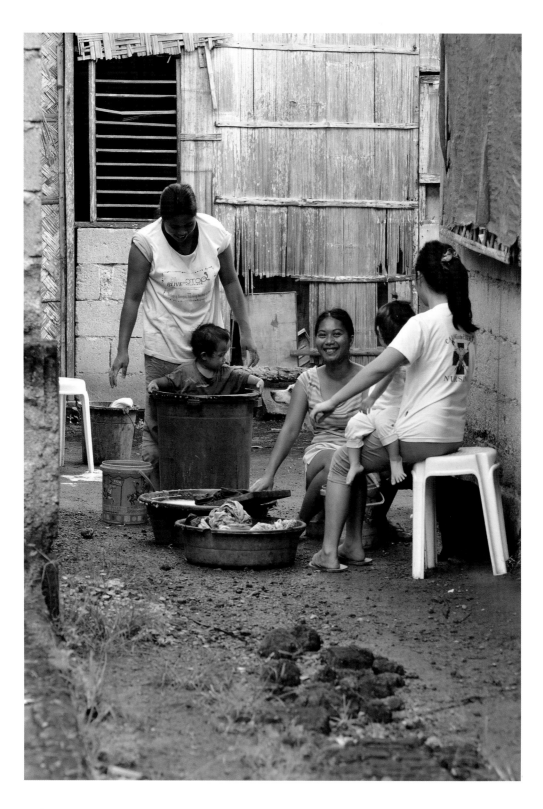

Mindanao: From Samai to Surallah

Proper sanitation is not at hand; a creaky, wooden shack with a hole in the ground serves as an outdoor privy. There is no running water. People rely on deep wells with simple hand pumps for the water needed for drinking, cooking, washing clothes, dishes, and bathing. Sometimes a number of households have to share one pump. Making the best of a bad situation, women use the pump as a place to get together, exchange the latest gossip, and discuss family matters while whining toddlers cling to their legs and the older children play nearby. Spider fighting, or *damang*, is a popular game for these children who have to make their own fun. Captured spiders are usually kept in used matchboxes, where each spider has its own space made of cardboard. The fight starts by placing two spiders at opposite ends of a stick and forcing them to go toward each other. When they meet, the battle begins. The spider that gets wrapped up in the web of its opponent is the loser and its owner has to give one of his spiders to the winner as a trophy.

Electricity is difficult to come by. Not all houses are connected, and in remote areas there is no power at all. Many villagers use oil lanterns and candles to light their homes. Nearly all the roads are in bad condition; during the rainy season they are flooded and sometimes impassable. Houses that are not built on stilts are flooded as well, destroying the few possessions people have and forcing them to seek temporary shelter.

189

Koronadal City

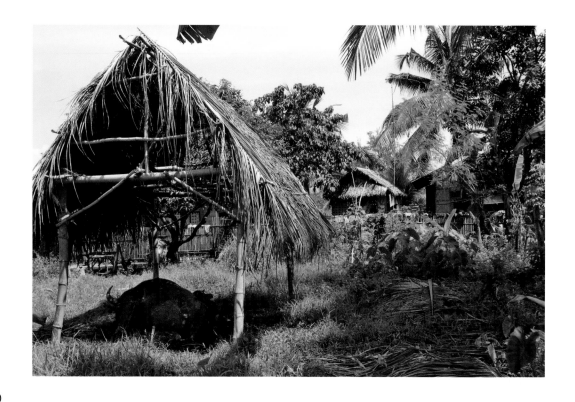

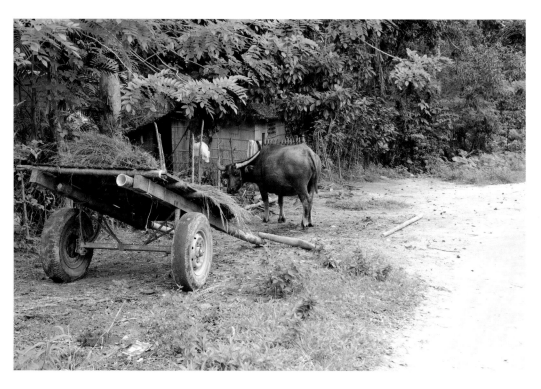

Mindanao: From Samai to Surallah

Spider fighting

Koronadal City

Life in the countryside follows the rhythms of the seasons, planting, and harvesting. People work as day laborers in the surrounding rice and corn fields or at a village rice mill. Some rely on growing vegetables or raising livestock and poultry to provide for their daily needs. A few will make their living as blacksmiths or carpenters; others sell homemade food on the side road, operate small sari-sari stores, or work as tricycle drivers to earn a few extra pesos. In many circumstances this will never be enough to provide the necessary education for their children; even though free primary and secondary schools are open to all, a large number of parents cannot afford the fees for books, meals, and school uniforms.

Their offspring often try to find work as housekeepers and babysitters, while others roam the streets selling small items in the hope of making enough money to eat and to help support their families. For these kids there will be little significant improvement in their living standards. Being caught in a vicious cycle of poverty, they have no choice but to stay in their barrio, get married at an early age, and start their own family, hoping and praying, just as their grandparents and parents did, that their children will have a better life.

Mindanao: From Samai to Surallah

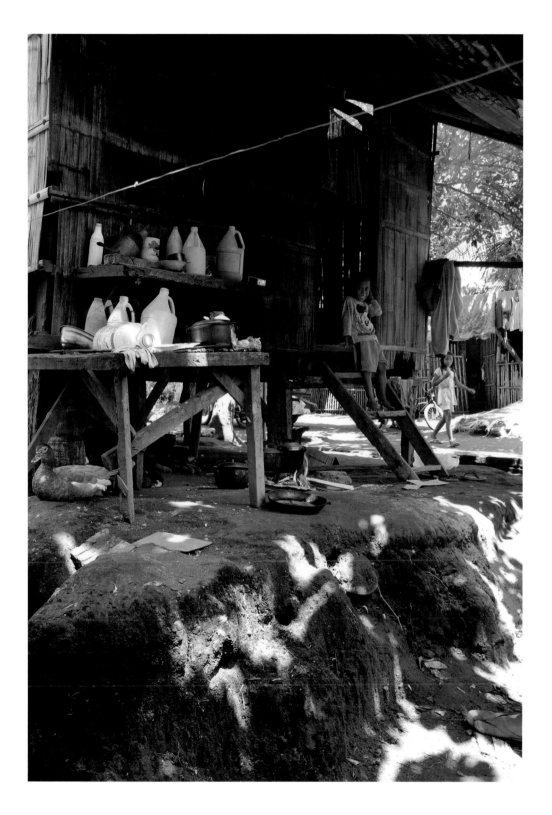

Koronadal City

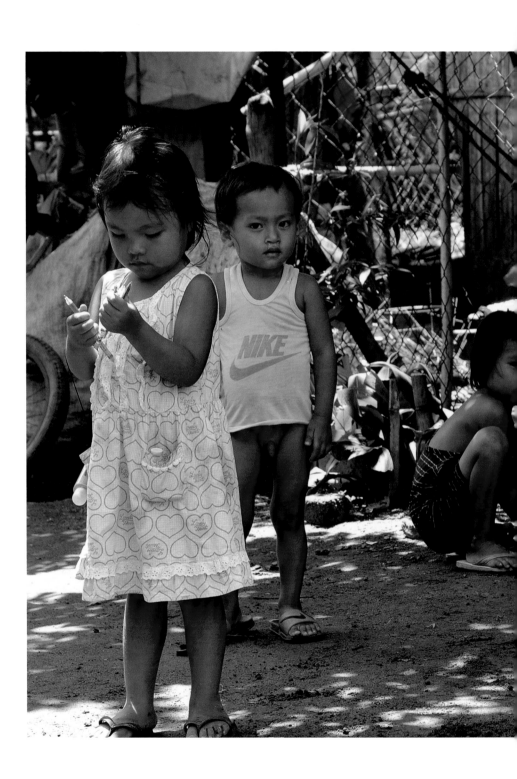

Mindanao: From Samai to Surallah

Children in Barrio

Koronadal City

Praying for better days is solidly embedded in the barrios; religion holds a central place with rituals and ceremonies that provide continuity and stability. Although predominantly Christian, provincial devotion is colored with many influences from different beliefs, firmly entrenched superstitions, and native wisdom that has withstood the passage of time. Witchcraft is still practiced and shamans are still called upon to persuade the spirit world to cure illness and avert evil.

A shaman is able to determine which spirit caused an illness or problem and what should be done to appease these supernatural beings. On many occasions this placation is carried out with animal sacrifices, usually chickens and pigs. The shaman also serves as a medium between the spirits (*diwatas*) and humans.

Most of the sacred rites take place to bring good health and fortune, the planting and bountiful harvest of crops, successful hunting and fishing, and arbitration in conflicts between barrio members or outsiders.

Where there is good, there is bad. Even wicked witches (*bruha*) have a reputation among the local population; their evil arts and mystical potions are called upon mainly to cast spells or place curses. This hexing is often used to bring sickness and death to opponents, to aid rejected lovers and jealous spouses, to punish theft, to solve marital problems, and as retaliation to adultery. A creepy part of this black magic is using insects like spiders, beetles, ants, and cockroaches to invade the body of a victim who eventually will suffer scorching pain. The illness caused by the vermin is resistant to any conventional medical treatment. Only the victim's death will make the creatures leave the body.

These spells are used not only to harm but also to express the sorcerer's might and authority. In Mindanao the occult coexists harmoniously with other religions. Good witches go to church, chant hymns, call upon the name of all kinds of saints, and whisper prayers. Black witches live in mountainous areas, are backed by demons, and are said to be associated with the devil. Although there is no objective evidence for any truth behind these practices or their results, there are a large number of living souls in the rural regions who absolutely have no doubt in their outcome or existence. Almost everybody in the provinces knows someone who has been bewitched or has some gruesome tale to tell.

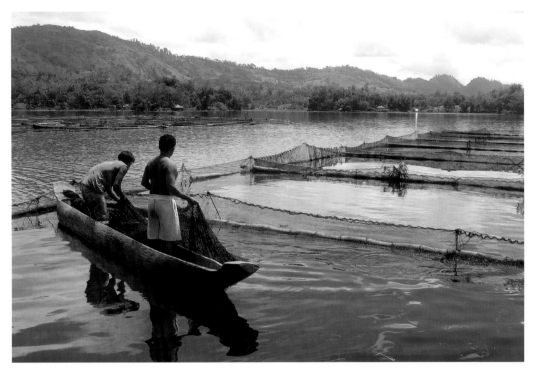
Lake Sebu

In the face of the ongoing hardship, deprivation, and tough times, still these people are satisfied and happy. The barrio spirit cannot be easily broken. It's a spirit that bends with the wind but survives storms, strong and flexible, with endurance that is similar to the bamboo trees that flourish everywhere. The down-to-earth attitude of the barrio displays a strong will and the avidity to have a good life, under any given conditions, coping with everlasting uncertainty and day-to-day problems.

As a show of gratitude for the small blessings in life, a barrio fiesta is held at least once a year. It's a time when everyone wears their best clothes and gives thanks to their local patron saint for good health and a bountiful harvest.

A barrio fiesta bonds everyone together and provides a sense of unity. It's celebrated with music and dances that illustrate the uncomplicated life in the countryside and the backbreaking work in the rice fields. For most men a barrio fiesta also means spending part of the money they have earned on a couple of bottles of rum, *tuba*, and beer, drinking and talking under the papaya trees, and singing along with a borrowed karaoke machine until the wee hours of the morning.

Koronadal City

When the fiesta comes to an end, the barrio is filled with silence. In the night air, the only sounds come from the wind blowing through the rice fields, the rush of water from nearby rivers, and every now and then the blare of a passing jeepney blowing its horn in the distance. At early dawn, when the sun begins to glow over the horizon, a pandemonium of twittering birds, playful children, crying babies, crowing roosters, barking dogs, croaking frogs, grunting pigs, and chirping lizards and crickets provide a welcome reminder for the folks to start their daily routine once more.

Allah River

The lingering smell of burning garbage; the scent of rice cooking on charcoal; the fragrant freshness of the morning dew; the sights of cigarette-smoking men wearing their cone-shaped, wide-brimmed hats woven from rattan or reeds (*salakot*), riding on the backs of colossal long-horned carabao to the rice paddies; and women hanging laundry to dry on makeshift lines, dressed in *malong*, the traditional tube skirt made of handwoven or machine-made multicolored cotton cloth and bearing a variety of geometric or *okir* designs: this all creates a mesmerizing impression of rural life. The way of life in a barrio provides a rare peek into the local history and old traditions based on family morals, mutual respect, and perpetual hope. People know life is short and they only get to live it once. Their key to fulfillment is the appreciation of what they have, while not longing for things that are unreachable. They remain contented with the situation they are in at any time. Barrio residents are often (incorrectly) named landless peasants, are (unfairly) thought of as lower class, and are decidedly treated as second-rate citizens. For these reasons they share a vigorous sense of pride and defiance toward the disapproval and exclusion that urban society places on them. But no matter what criticism and challenges they have to face, for them the barrio is the only life they have ever known.

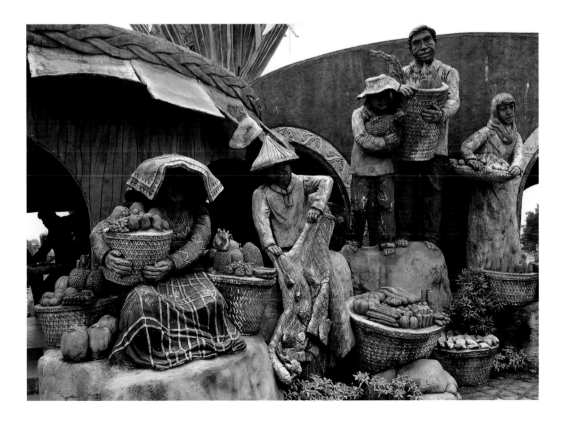

Koronadal City

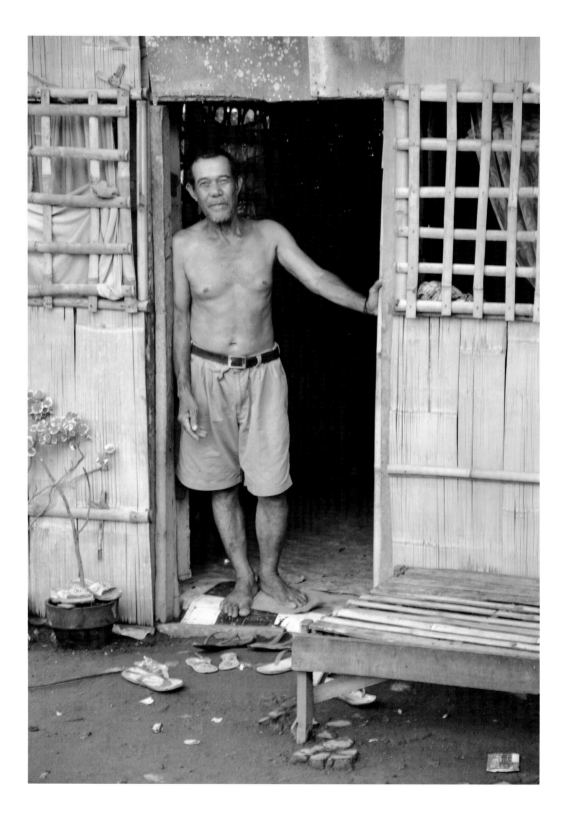

Mindanao: From Samai to Surallah

Bahala Na

How do people in the barrios maintain their hope and their love of life? They bond together in a communal spirit, help each other, and get on with their lives with the help of their motto: *Bahala na*. A Filipino phrase which can be translated as "come what may," it is believed to come from the word *Bathala*, the Tagalog word for God.

Deeply rooted in the Filipino way of life, the attitude of Bahala na is one that leaves almost everything to destiny, trusting in the providence of the Good Lord. It is more common among rural people, who have a strong dependence on spiritual guidance, convinced that the Almighty will take care of their daily needs and that the life they are living is simply meant to be.

Some urban Filipinos and Westerners often consider Bahala na a great cultural divide that separates urban and rural communities by nurturing a fatalistic and passive lifestyle. It is often regarded as an obstacle to doing business, an annoying interference in social interaction, and a source of irritation and disagreement. But if one is willing to let go of the (Western) direct way of thinking and is able to take an alternative and constructive approach, one will see that there is a lot more to it than meets the eye. This widespread *mañana* attitude doesn't mean that the Filipino people leave matters to fate but instead take their time in making decisions, being careful when doing things in daily life. It shows a strong will and an eagerness to have a good life, under any given conditions, coping with uncertainties and insoluble problems by embracing them. Filipinos are capable of going far beyond their personal limitations, just by doing the best they can, so God will take care of them. This "easy does it" philosophy is a virtue that finds its origin in the harsh lives and bleak poverty that most Mindanaoans have to endure; it gives people the ability to accept bad fortune, death, and other tragedies. Bahala na is a solemn trust in a superior power; it is the faith in God that shows the modesty and humility of the Filipino people.

Bahala na is not an expression of laziness and hesitation; it is not a disposition of hopelessness and unresponsiveness. It is a positive and down-to-earth attitude that signifies determination and strength, even in the most trying of times. It enables the Filipino people to take their leaps in the dark, no matter what kind of problems the future will bring, always ready and confident to struggle through adversity when it comes.

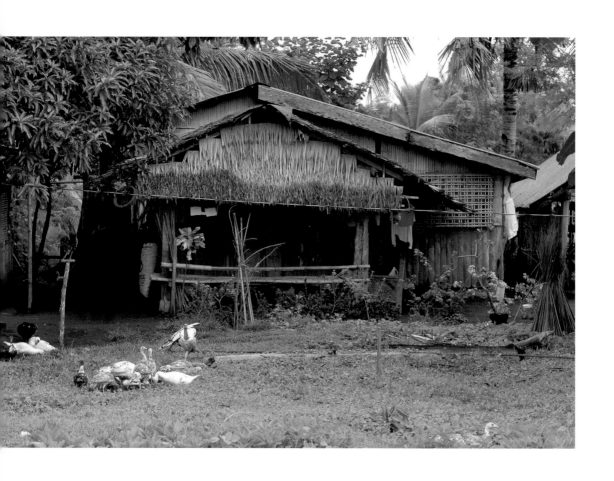

Mindanao: From Samai to Surallah

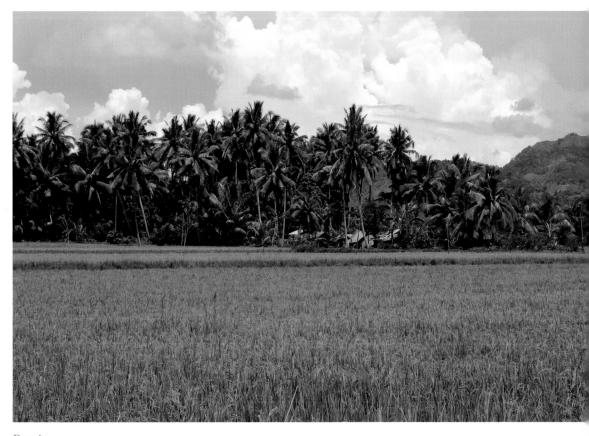

Barrio

Koronadal City

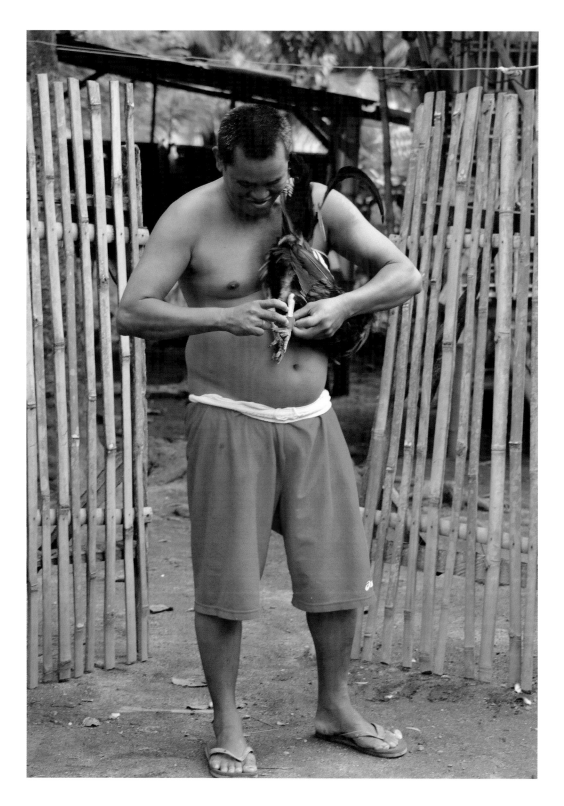

Mindanao: From Samai to Surallah

Sabong, the King of Sports

Whether in the provinces or in the cities, Filipinos share a passion for *sabong*, an organized fight between two roosters. After basketball, it is the second most popular sport in the country; many villagers own one or more fighting cocks, and plenty of tethered roosters can be seen alongside the road. Cockfighting has been around for centuries; it has become one of the most popular ways to gamble in the Philippines, with millions of pesos won and lost every Sunday throughout the nation. The participants and spectators are always excited about the upcoming fight. Gambling is ongoing during matches and heavy bets are often placed on the most revered fighter.

Every contest is judged by a referee, the *sentensyador*, whose ruling is definitive, without a chance for appeal. Another important figure is the person who holds the bets, often referred to as *Kristo*, a name derived from "Christ." He spreads his arms when taking bets and is supposed to be as honest as Jesus; trust is a sacred virtue in sabong. Fights (*pinta-kasi*) are held in a cockpit arena, a *sabungan*. The center of this square theater has a dirt floor that is littered with feathers, where roosters fight each other like Roman gladiators. The natural spurs of the roosters are sawed off and replaced with *taris*, two-inch-long, thin, razor-sharp blades or slashers that can inflict nasty wounds. The bloody match itself only lasts a few minutes and most fights are to the death, but in some cases the cocks may survive with severe injuries. The owner of the defeated bird cuts off the feet of his rooster, at the spot where the taris are attached, and gives them to the proud conqueror. However, even the winner may eventually reach the same fate as the loser: being cooked in a savory local dish appropriately named *talunan*, or defeated chicken.

Bitaw (or spar) is a less painful variation of sabong, a match to prepare the cock for a real sabong fight. Gloves or balls of leather are placed on the rooster's spurs to prevent the animals from injuring each other.

Except for some vendors there are no women inside the *gallera*, the arena where sabong takes place. It seems cockfighting is for men only; in some ways it is obvious that for most men the rooster is more or less an extension of themselves.

In the sabungan there is an enjoyable sporting atmosphere, tense with emotion and anticipation. The event is regarded as an equalizer, a place where men can mingle without thinking of class differences, which is relaxing for everybody. It is a form of recreation that relieves the stress of daily routines and for some it's a way to earning fast and easy money. For the onlookers and contestants, *sabungeros*, it is an exhilarating day out; cockfights can last till early in the evening. Sabong is practiced all over in rural communities. The roosters are bred to fight and are trained for aggression, strength, and endurance. It is an expensive enterprise; the owner of a rooster can spend thousands of pesos on training, vitamins, and additives to keep the bird in its best fighting form.

The competitions are a source of income for many traders, handlers, and game-fowl breeders. Inside and outside the gallera, vendors sell cold beverages, sweet cakes, cigarettes, and snacks. Sabong is a cottage industry and big business for various villages in Mindanao, with thousands of privately owned cock farms all over the island.

In the Philippines cockfighting is legal, regulated by the government with rules and permits. Matches take place every weekend and during fiestas, but illegal fights (*tupada* or *tigbakay*), are held almost daily in backyards, barns, vacant lots, and open fields. Cockfighting is always surrounded by criticism and remains a controversial issue: for some it means cruelty, for others it is amusement. Often called "the sport of kings" since wealth is made and squandered on these fighting roosters, it gives the needy an opportunity to dream about the day when their gamecock will win the match and pull them out of poverty. Luck is a major part of the game and country wisdom is always present: for instance, the owner of a gamecock will never allow other people to handle his prized fighter in the cockpit. It is said that if the rooster is managed by three or more people, it will lose the fight. Furthermore, participants are advised to avoid eating chicken at any time when their bird might see them.

Sabong

Koronadal City

Mindanao: From Samai to Surallah

Local Ghosts and Apparitions

Life in Mindanao is filled with superstitions and strange phenomena; stories of magic and psychic powers are woven into the culture. In remote, rural places, people still believe in the existence of supernatural beings, not just in local legends and folk stories, but in real life as well. Local beliefs are still practiced widely.

Foreign travelers may find it difficult to understand these folkloric traditions, but local people will show appreciation when strangers respect their behavior and habits. The philosophy that good and evil spirits inhabit the environment, such as the spirits of the rivers, seas, skies, and mountains, is recognized every day.

A bend in the road leading to Surallah, next to Barangay Matulas in Koronadal City, is believed to be the home of the elusive White Lady, or *Ang Babaeng Nakaputi*. Over the years strange and tragic traffic accidents have occurred on that bend in the road; some of them could be blamed on speeding or drunk driving, but the cause of many fatal accidents could not be explained and continues to stay a mystery. Legend tells that the White Lady can be seen at the side or in the middle of the road, hovering above the ground, her black hair flowing over a long, white nightgown. This spirit, which can be seen only by men, is believed to be the cause of many car accidents, particularly at nighttime. Sometimes the elusive White Lady will appear in a moving car or take the seat beside the driver, leading him to a dead end, a broken bridge, or a cliff.

Local motorists who have come across this wandering female apparition say they tried to swerve to avoid hitting the White Lady, bolstering the theory that the wayfaring spirit is the cause of the accidents. Many a driver blows his vehicle's horn repeatedly when nearing the Matulas bend, showing his respect by greeting the White Lady, in the hope of a safe passage.

There are many more evil and bloodthirsty creatures reputedly prowling this part of the country in search of their prey. Locals tell about the *aswang*, a ghoul characterized as a kind of vampire that hunts for children, unborn fetuses, or dying people. They say to watch out for the demon horse found in the countryside that is called *tikbalang*, who lies in wait for travelers and lures them from the highways into the surrounding forests.

Surallah Landmark

Mindanao: From Samai to Surallah

Lake Sebu

The Maharlika Highway does not come to an end in Koronadal City; it goes onward to Sultan Kudarat, but for another great opportunity to get to know Mother Nature up close, you should take a different route. About thirty miles from Koronadal is Lake Sebu, one of the prime ecotourism spots in South Cotabato. Before reaching this lovely spot, you will come to Surallah, a town near the Allah River, one of the tributaries of the second largest river in the Philippines, the Mindanao River. (*Surallah* means "south of Allah.")

When entering Surallah, you can't miss the main landmark. It's a sixty-foot obelisk-like statue of a two-stringed lute, called a *hegalong* by the people of the T'boli tribe. A corn husk, one of Surallah's town symbols, is at the center of the sculpture. There is a dome-shaped *kulintang* or gong; a woman dancing with an *abaniko* or folding fan; a dancer wearing the *malong;* a couple dancing and playing the gong at the top of a small waterfall; and a group playing the *kudyapi,* a two-stringed, fretted lute, and other traditional musical instruments. This group of sculptures was made by the artist Kublai Ponce Millan, who also made the statues in Toril and in Davao's People's Park.

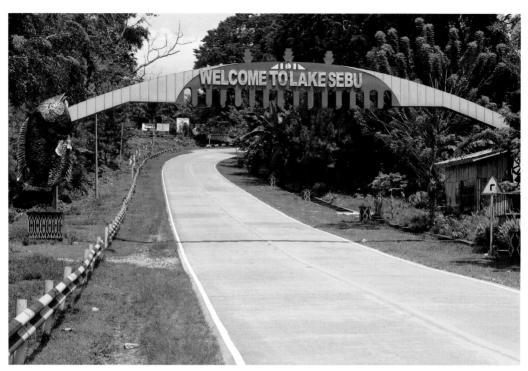

Lake Sebu Arch

Only a twelve-mile drive from this landmark is Lake Sebu, a beautiful inland sea, located in the southern Tiruray Highlands at an altitude of 984 feet. It is surrounded by rolling hills and forested mountains that are the ancestral domain of the T'boli, the Ubo, and the Tiruray tribes. The Ubo tribe live among the isolated mountains of southwestern Cotabato. They are known for their elaborate casting, ornate jewelry, and fine weaponry. Tribe members still believe that ancestral spirits inhabit their land, and they offer sacrifices to these unseen beings to gain permission to use the natural resources. The Tiruray also live in relative isolation and are loyal to their old beliefs and rituals. The life of the Tiruray is centered around fishing, farming, hunting, and basket weaving.

A few miles from the shores of Lake Sebu, an archway greets visitors, with a half-moon shape that has a hegalong on one side and a huge tilapia on the other. Both symbols are decorated with a T'nalak pattern at their base. The red-and-yellow archway, a symbol of the region's natural resources and musical traditions, is the gateway to one of the world's most unspoiled destinations.

Mindanao: From Samai to Surallah

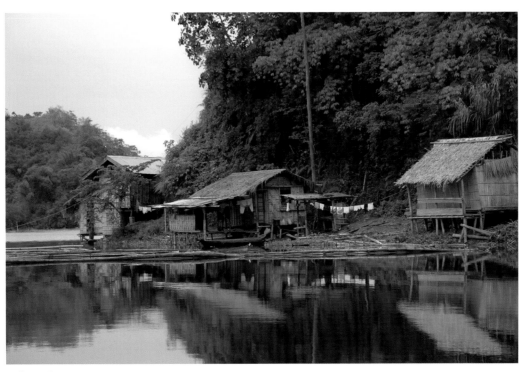

Lake Sebu

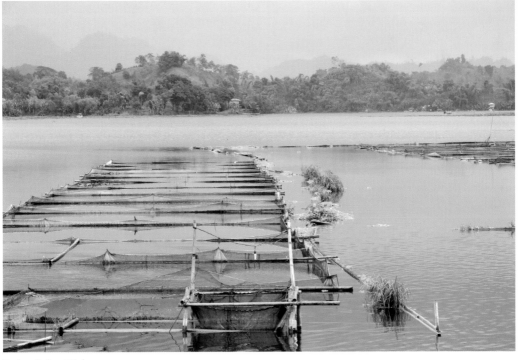

Lake Sebu Fishpens

Lake Sebu

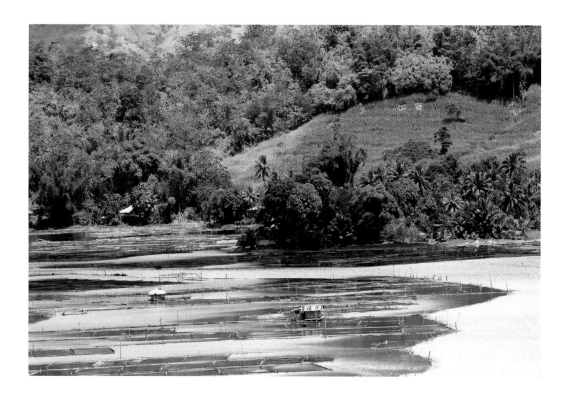

214

Lake Sebu is the largest of three adjoining mountain lakes and is one of the major sources of irrigation water for Sultan Kudarat and South Cotabato. Lake Selutan is the deepest of the three and is often called "the Sunrise Lake" for its dazzling view at daybreak. Lake Lahit is a free fishing zone; it is the smallest lake with the lowest elevation. These lakes are right in the middle of the Allah Valley Watershed Forest Reserve, which is used for fish farming, duck raising, and the harvesting of freshwater shrimp and snails.

Local tribesmen consider Lake Sebu a God-given food basket and a miraculous body of water that never goes dry. More than half of the land around the lake is agricultural. The lake also irrigates the fertile Allah Valley; the area surrounding Lake Sebu has many small streams, rivers, springs, and creeks. Fresh sweet-tasting tilapia and other local fish are grown in the many large fish cages that float in the lake.

The forest vegetation surrounding the lake and falls is thick and humid and visitors will find refreshing springs, natural caves, and exciting nature trails as they wander through the mossy woods. The Philippine eagle and tarsier live here, along with monkeys, wild boars, ducks, and deer. These animals are still hunted by tribesmen and their meat is considered a delicacy. Local specialties include *tapa* or *tapang baboy ramo* (marinated or smoked wild boar), *tapang usa* (dried, cured venison), and *kalderatang itik* (duck caldereta).

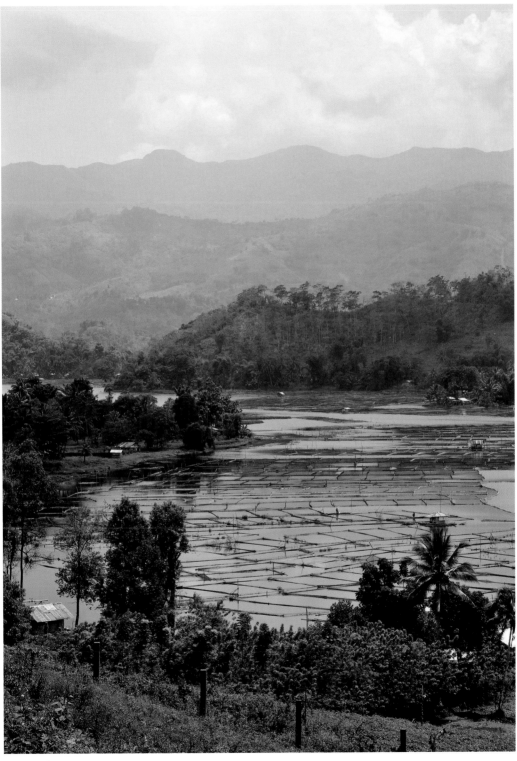

Lake Seletion

Lake Sebu

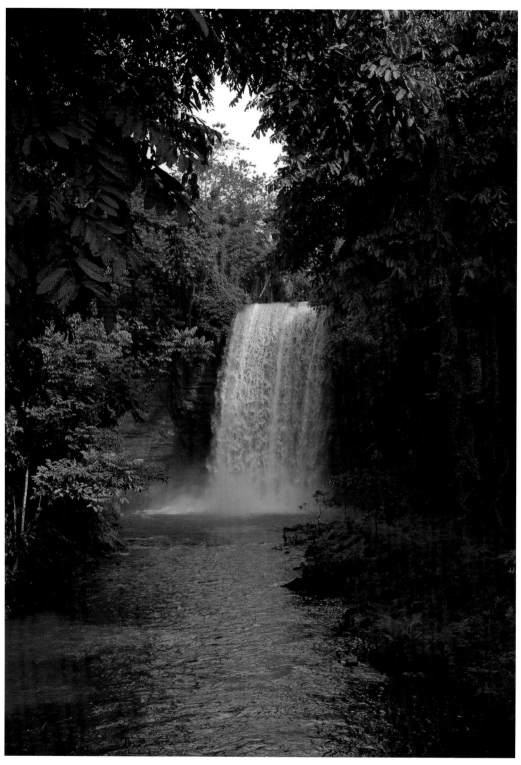

Seven Falls, *Hikong Alu*

Mindanao: From Samai to Surallah

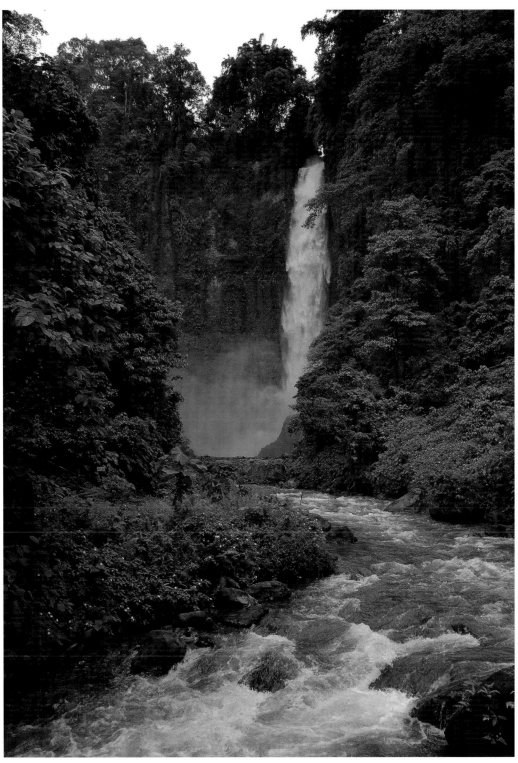

Seven Falls, *Hikong Bente*

Lake Sebu

Tulabong (Heron)

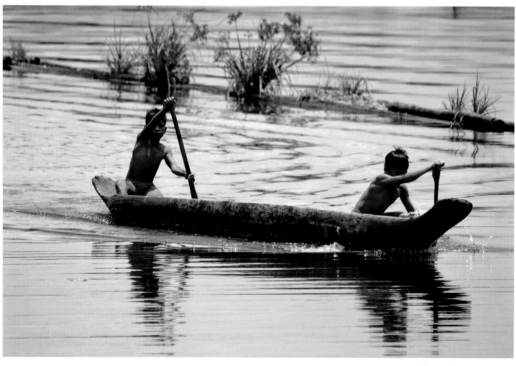

Lake Sebu, *Owong*

Mindanao: From Samai to Surallah

The lake and its surrounding forest are also a natural habitat to Philippine cockatoos, egrets, swallows, kingfishers, herons, kites, and the rare tigris butterfly. These rugged hills are a rest stop for migratory birds and a fine site for birdwatchers.

Lake Sebu is a fast-growing cultural center and a fabulous destination for ecotourism. The area is known for its Seven Waterfalls (or the Dongon Waterfalls) that lie close to Lake Sebu and are a popular spot for outdoor enthusiasts. This is the place to put your feet up and listen to the rolling sound of thunder from the rushing waters that plunge into the deep pools below. Above the falls, adrenaline junkies will have the time of their lives when gliding two thousand feet down the highest zip line in the Philippines, soaring over a canopy of blooming treetops and the glitter of sparkling streams.

The Dongon Waterfalls are a splendid illustration of the power of nature. The water that flows from the edges of the hills has, over the ages, carved these scenic masterpieces in a brilliant display of natural colors. The T'boli tribe has given each of the seven waterfalls a name. The first is called *Hikong Alu*, meaning "passage." Fall number two is named *Hikong Bente*, or "immeasurable." Number three, with its winding shape, is dubbed *Hikong B'lebed*, or "coiled" or "zigzag." Four is *Hikong Lowig*, which means "booth." Five is known as *Hikong Kefo-I*, or "wildflower." Number six is known as *Hikong Ukol*, which means "short," and the last fall is *Hikong Tonok*, or "soil." Only the *Hikong Alu* and the *Hikong Bente* are easily accessible; the other five are reached only by climbing steep hills that are covered in thick jungles.

Mindanao: From Samai to Surallah

Lake Holon

One of the most idyllic lakes in Mindanao is Lake Holon, named "Deep Water" by the T'boli. It is nestled deep in the highlands, in the crater of Mount Melibengoy, one of eight dormant volcanoes in Mindanao, which is believed to have erupted only three times over the past three thousand years. Lake Holon is the source of the five large rivers running through this region. Because the secluded inland sea is surrounded by mountains and forests, it is still relatively undiscovered as a tourist destination. Located 4,750 feet above sea level, Lake Holon is a sacred place for the T'boli tribe, and has been declared a sanctuary and a nature preserve.

Mount Melibengoy (which In T'boli means "the mountain that peeks") has also been dubbed Mount Parker, after the American general Frank Parker, who allegedly discovered the crater in the 1930s. Lake Holon takes its name from the word for "portal to heaven," a name that comes from an old legend. In bygone days a T'boli witch predicted that the end of the world was near and led part of the tribe deep into the mountain forests, to the shores of this lake. Telling her followers that they would live forever if they jumped into the waters, she and her disciples plunged to their deaths—or so it's thought, since they haven't been seen or heard from since. Most tribe members believe the group perished and went straight to heaven; others claim that, in the early morning light, their cries can still be heard from the depths of the lake.

The waters of Lake Holon flow into the Luhan River, a tributary of the mighty but flood-prone Allah River. The Allah is one of the biggest rivers in the area and a major source of irrigation, providing water for the rice and corn fields that keep riverine residents alive.

T'boli dancer with a *Kudyapi*

Mindanao: From Samai to Surallah

The T'boli Tribe

The T'boli tribe is the largest tribe in the region. Their culture is inspired by the environment and they have a high regard for nature, as is demonstrated by their simple way of living, their craftsmanship, and their dances that mimic the actions of animals such as monkeys and birds. The T'boli still live much the same way as their ancestors lived centuries ago.

The T'boli distinguish themselves from other tribal groups by their colorful attire with its fine embroidery and complicated beadwork, intricate jewelry, and beautiful brass ornaments. The T'boli tribe has a variety of musical instruments, but their music and singing are not meant only for entertainment. Their tribal songs are a living contact with their ancestors and a source of ancient wisdom.

The kulintang is an ancient form of music played by striking the tops of seven to eight horizontally laid metal kettlegongs with two wooden beaters or sticks that are each about a foot long. Kulintang music is a time-honored tradition that represents the highest form of gong music and is usually performed at festivals, parades, weddings, religious rituals, and healing ceremonies. It is forbidden to perform kulintang music during funerals or during the times of planting and harvest.

223

Other musical instruments played by the tribe are bamboo tubes, wooden guitarlike instruments, mouth harps, and drums, all of which are made from natural materials that grow in the forests around the lakes.

The T'boli believe that everything has a spirit that must be respected if good fortune is to come their way. Bad spirits can cause illness and misfortune.

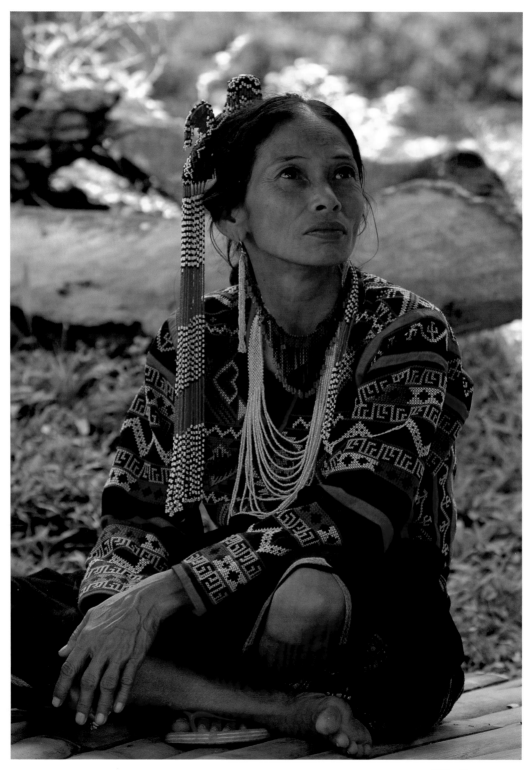

T'boli woman

Mindanao: From Samai to Surallah

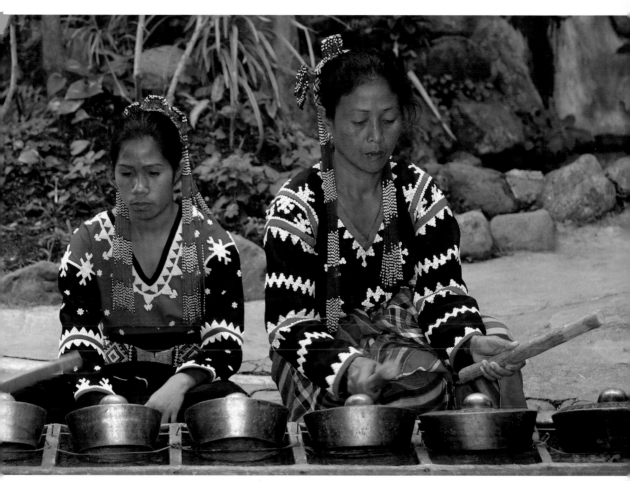

Kulintang

Lake Holon

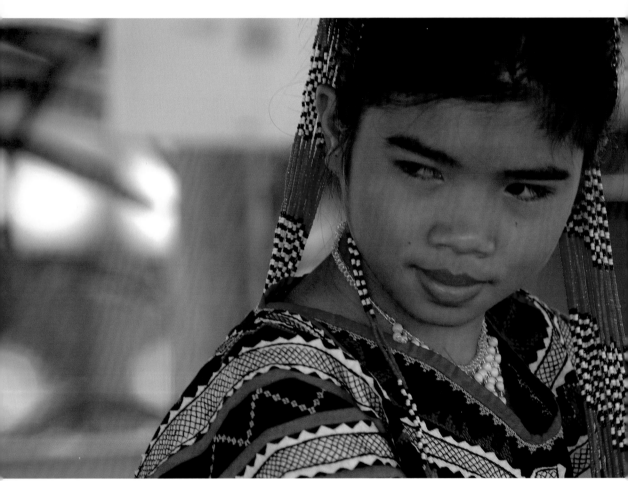

T'boli girl

Mindanao: From Samai to Surallah

The Helubong Festival is the main festival of the T'boli and B'laan tribal people of Lake Sebu. *Helubong* is a T'boli word meaning "never-ending joy." Every second week in November, the T'boli people dress up in native attire and demonstrate their arts, songs, dances, rituals, and games, like the *hegidu kuda* traditional horse fight in which two unmanned stallions do battle. The Helubong Festival is a spectacle where rural wisdom comes alive, a seven-day journey through the past, present, and future of this region, its community, and its folklore.

The T'nalak, the T'boli sacred cloth made from abaca, is the best-known T'boli craft. A traditional tribal textile, it is exchanged during marriage ceremonies and is used as a coverlet during births. *T'nalak* refers to the way the abaca cloth is woven by the women of the T'boli tribe, which is thought to symbolize the unity and strength of all the tribes in the province.

The T'boli women are called "dream weavers." Legend has it that the T'nalak weaving was taught to them in a dream by the goddess Fu Dalu. The tribe believes all of its weavers still learn this sacred ritual, based on tribal designs and patterns, through their dreams. These particular patterns are made with centuries-old practices and are passed down from generation to generation.

This type of T'boli textile is history held in the hands of its makers, and their creations show the tribe's collective imagination and beliefs. The weaving is a painstaking art; it can take up to several months to finish, depending on the length and the intricacy of the pattern. It requires not only patience but also a lot of creativity. The T'boli women design the weaving without the use of drawn patterns or guides, relying on their mental images of the designs. Men are not allowed to touch the abaca fiber and other materials used in the weaving process, and the weaver must not mate with her husband while she is working on the cloth, for this act could cause the fiber to break and destroy the design. After the weaving is finished, the fiber is dyed with black pigment extracted from the leaves of the kenalum tree and the red from the roots of the loco tree. In the past few years the T'nalak weaving has become the signature product of the province of South Cotabato.

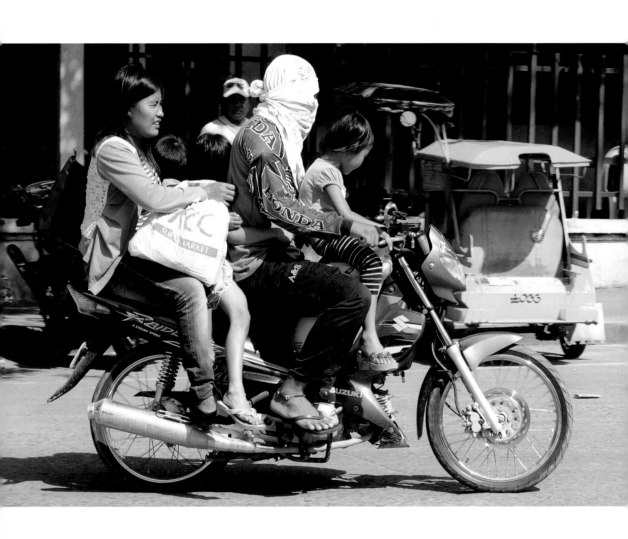

Mindanao: From Samai to Surallah

Habal-Habal

The roads that lead to the lakes and waterfalls of South Cotabato Province are steep, unpaved, full of mud and potholes, and slippery during the rainy season. Traveling through this remote area often means moving along narrow and bumpy trails to locations that cannot be reached by car, tricycle, or jeepney. This inaccessibility makes parts of Mindanao among the most untouristed regions in the southern Philippines. But since the resourcefulness of the Mindanaoans will evermore find a way to get where they want to go, the need to reach distant villages and far-flung farmland gave birth to the *habal-habal* or *iskaylab*. This is a motorcycle without a sidecar that can carry seven people at a time, and sometimes, depending on their sizes, even more. Its sitting capacity is extended by constructing additional seats at the rear and building wooden or metal racks on both sides of the motorbike; if needed, an extra seat can be created on top of the gas tank.

A habal-habal is frequently called the poor man's motorcycle taxi and while some people regard them as a traffic nuisance, others see them as a convenience and a necessity. It's generally regarded as the most practical and rapid form of public transportation in out-of-the-way corners of interior Mindanao. Various goods, including sacks of rice and vegetables, cartons stacked with groceries, and even crates filled with chickens and shackled goats, are strapped onto the most unlikely places.

Habal is a position that resembles two animals mating, and the driver and passengers are seated in the same intimate manner, all facing front. The expression *iskaylab* (skylab) is probably an abbreviation of the phrase *Sakay na, lab,* meaning "Get on, love."

A trip on a skylab is great fun and a blood-tingling adventure which is not for the faint-hearted. All riders sit with nothing to hold onto except the seat or the cargo. Clinging to fellow travelers is not an option since everyone is squeezed together like canned sardines.

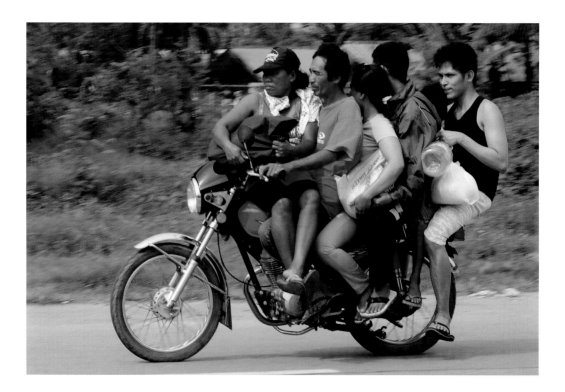

The ride isn't a smooth one and it's difficult to maintain balance. Having blind faith in the driver is essential; there must be an ability to surrender mind, body, and soul to a complete stranger and trust that this daredevil will safely negotiate unsafe paths, rough, steep terrain, and dirt roads. Getting stuck behind a jeepney or truck while not being able to pass it because of the curved roads; frisky stray dogs; a wandering carabao; slowly moving bull or horse carts; swerving bicycle riders; *palay* (rice harvest) that is left in the middle of the road to dry; and drivers who are on the wrong side of the road are only a few hurdles that have to be taken along the way. There might be some minor setbacks like a flat tire or mechanical failure; bad weather could delay the trip; and unpredictable local driving habits and the lack of any regard for traffic rules and signs demonstrated by other vehicles can cause some unexpected, precarious situations and tense moments.

It can also be a dangerous trip because a motor bicycle is prone to accidents. It's not easy to keep control when carrying multiple passengers or a heavy load. When forced to go at slow speeds, the driver must perform a delicate balancing act just to make sure the machine won't turn over. There will probably be no helmets available for passengers, who understand they are riding at their own risk. This kind of transport is, in some parts of the country, still illegal and unregulated. The only things a wannabe habal-habal driver needs are a rebuilt motorbike and a valid driver's license, although some don't even have a permit.

Mindanao: From Samai to Surallah

Habal-Habal waiting point

Working as a for-hire driver provides a regular income, since people always have the urge to travel. Because of the hazards involved and the lack of other forms of transportation, habal-habal drivers will ask for a slightly higher fare than a tricycle operator. Usually they charge a fixed rate, depending on how far they have to go, the weight of the load they have to carry, and the weather.

Many drivers look like bandits, with their dark sunglasses, a bandanna or a simple baseball cap worn to protect their head from the burning sun, and a piece of cloth to cover their nose and mouth from dust and the exhaust coming from other vehicles. But don't judge by appearances. Once the bone-jarring journey has come to an end, your habal-habal driver will be counted as one of your best friends.

Mindanao is graced with multifold beautiful places that are difficult to reach. When they're most needed, habal-habal drivers are there, waiting patiently to offer their services so you can enjoy the scenic landscape at close hand. Try to embrace the extreme and ask the driver to be your personal tour guide. He can show you the eco-rich sites known only to locals and make your day trip an experience of a lifetime.

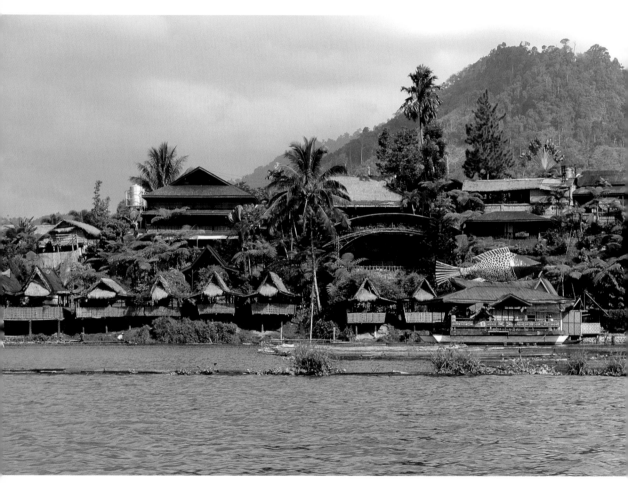

Punta Isla Lake Resort

Mindanao: From Samai to Surallah

Resort Recommendations

There are good resorts around Lake Sebu, with guided boat tours, recreational facilities, and hotel accommodation. A few of them are the Traankini Resort, Estares Resort, Mountain Log Resort, Dongon Hills & Falls Resort, and the Punta Isla Lake Resort. The restaurants at most of these resorts specialize in the local cuisine, which mainly consists of tilapia dishes. The fish is cultivated in net-enclosed bamboo fish pens and taken out only when ordered by a customer, so the freshness of the catch is guaranteed.

Located on the hillside of Lake Sebu, in the midst of the green belt, the Punta Isla Lake Resort is a wonderful place to end your journey. The resort is one of the most scenic spots in the region, a place where life blends with nature. The lake is filled with drifting water lilies and pink lotus flowers that only bloom just after sunrise. Dug-out tree trunks, called *owong,* are used as boats by the fishermen who tend the tilapia fish pens. Owong are carved by hand and are widely used for fishing and travel between the islands of the lake.

The resort's floating restaurant serves a wide array of the local cuisine, with almost all the food eaten from a rattan plate that is covered with a banana leaf. There are many different tilapia dishes to choose from: *paksiw na tilapia* (fish cooked in vinegar and garlic), *tilapia fuyong* (with omelette), *tocino* (sweetened and cured), *tilapia kilawin* or *kinilaw* (marinated raw fish), sizzling tilapia, and the resort's specialty, *tilapia chicharon* (crunchy tilapia skin).

233

Once the sun sets, take some time to rest in the palm-thatched open-air pavilions that line the lakeshore. Savor the pleasure of being outdoors, feel the droplets of evening mist, and enjoy the gentle touch of a cool breeze in a mesmerizing world of water and mountains. Look back and reflect on your two-hundred-mile journey from Samal to Surallah, driving along Mindanao's Maharlika Highway and experiencing the many enchanting places, outdoor pleasures, culinary delights, and hospitable communities along the way. Who could imagine this modern highway would bring you so close to the natural beauty, indigenous culture, and the delightful people of Mindanao?

Lake Sebu, Punta Isla Lake Resort

Mindanao: From Samai to Surallah

Lake Sebu: Lotus Flowers

Lake Holon

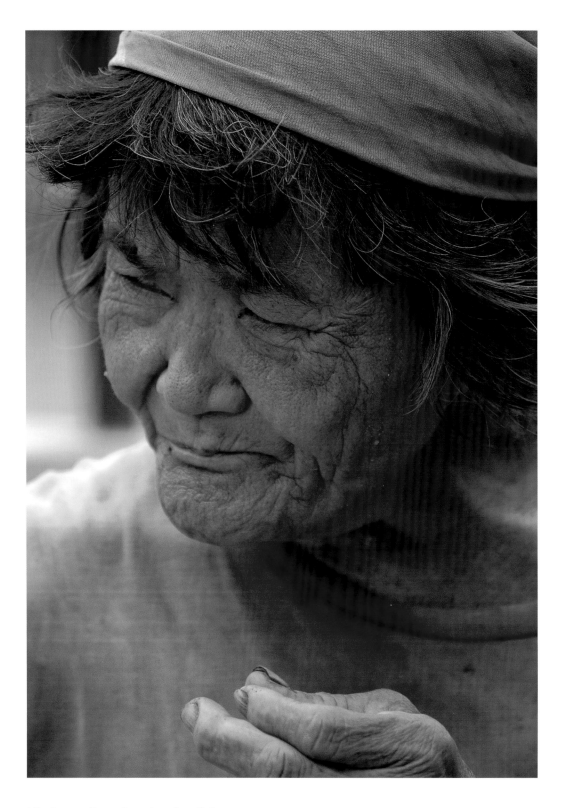

Mindanao: From Samai to Surallah

Photography Tips

Mindanao has a tropical climate with a considerable amount of rainfall, heat, and humidity; unexpected downpours, moisture, high temperatures, and sand can affect your camera's performance. For making the most of the many photo opportunities that this island has to offer, it is essential to protect vulnerable and valuable equipment from weather conditions. The right gear, practical tips, and a few simple precautions can help to make your photographic excursions problem free, without permanent breakage or much wear and tear on camera bodies and lenses.

Tourists can only bring cameras and electronic equipment through Philippine customs if they are intended for personal use. Hand-carry your camera bag to ensure that the gear is safe and secure; to avoid the risk of breakage, it is best to detach the lens from the body of the camera.

Keep your camera, lenses, and other material in weatherproof, well-padded backpacks that will allow some ventilation, and put a few silica gel packets inside the bag to absorb most of the moisture that can cause mold and fungus to grow inside the lenses and the body of the camera. Many camera bodies are weather resistant, but some rubber gaskets are not waterproof, increasing the risk of apparatus failure if exposed to too much moisture.

If the camera is cold and brought into a warm and damp environment, condensation can appear on the front of the lens, but in most cases this will disappear within a couple of minutes. It's important to keep the lens clean, check it before starting to shoot, and always wipe away any visible haze immediately with a lens-cleaning cloth.

The waterfalls and rain forests on the island are mostly located at high altitudes with conditions that produce rain, drizzle, or fog. Rain sleeves and jackets for cameras, lenses, and

other flash devices will keep your equipment dry and protected. Don't change lenses in the open air and be sure your hands are clean and dry before changing memory cards and batteries. The negative effects of high humidity can be reduced if sensitive items are stored in Ziploc bags.

On the beaches of Mindanao strong sea winds can blow sand granules into the lens of the camera, causing a lot of damage. It's best to remove these grains with a lens blower brush and a microfiber tissue. A lens pen will come in handy for sweeping dust and smudges off lenses and filters.

The scorching sun can overheat the circuitry within the camera and cause severe deterioration over time. Don't leave your camera equipment out in fierce sunlight too long and do not use the camera while the body is still warm.

A good-quality coated UV filter will not only block ultraviolet light, but also will serve as protection when left on the lens at all times. Taking photographs in the mornings and evenings will allow you to avoid harsh light and unflattering shadows; these times will provide a suitable light to work with and are the best for shooting natural scenery.

The varied landscape of Mindanao comes in all forms; mountains, plains, forests, swamps, lakes, rivers, and seacoasts, all with an extreme assortment of textures, colors, and patterns that can require the use of different lenses and filters to fully capture its mesmerizing beauty. Power outages are prevalent in Mindanao and the high temperatures can reduce battery life, so keep all batteries charged and carry some extras for the flash units before going out. A battery grip is a great accessory; not only does it allow you to use more than one battery at a time but also provides the possibility to plug in AA batteries, preventing the threat of power loss. It will give you a much better hold on the camera, making it easier to handle, and it provides full vertical shooting control.

Clean the battery contacts in the camera and charger regularly, since many charging problems are caused by dirty contacts. Disable the flash when it is not needed. If you do not turn the camera off after each and every picture, you will significantly extend the value of a power pack. Because of the ever-changing weather that can cause low-light conditions, a good lightweight mini-tripod, monopod, or flexible pod can be essential; it will steady the camera and guarantee sharp pictures. It also gives you the ability to monitor and compose a scene in much greater detail.

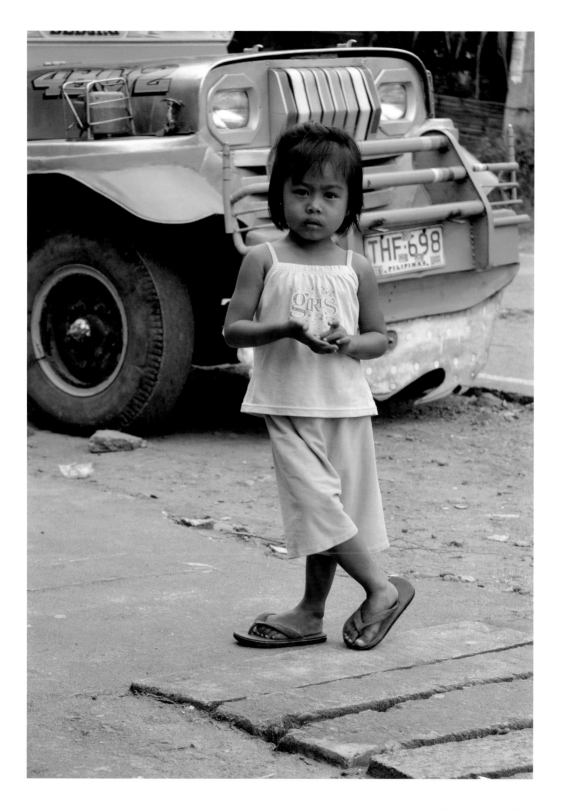

Photography Tips

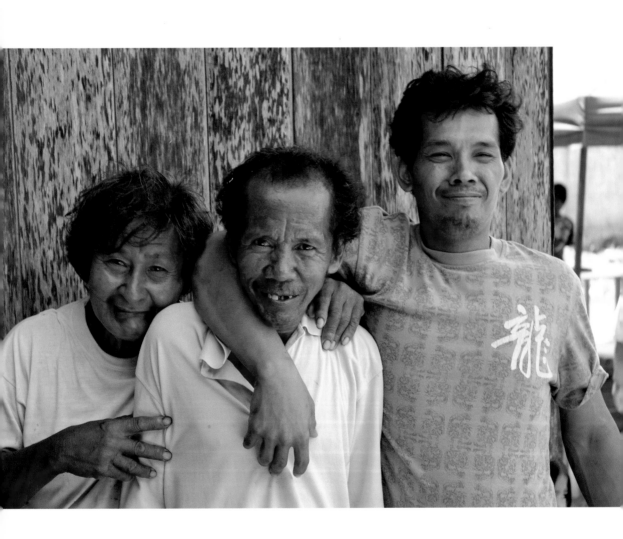

Mindanao: From Samai to Surallah

About the Author

Ronald de Jong is a freelance travel photographer and writer, based in Mindanao, the Philippines. His photographs and articles have been published in various magazines and other periodicals around the world. He loves photography and has a deep passion for the Philippines, a country with an amazing array of photographic wonders.

Through his photography he wants to uncover the way he sees the fascinating island of Mindanao. His versatility and ability to respect and understand the local culture and people helps him preserve memories, share experiences and illustrate the essence of the ever-present natural beauty of the Philippines and its rich cultural heritage.

Because of his independent character, imaginative mind, and free spirit Ronald seldom takes assignments. Instead he wants to concentrate on composing inspiring images that will show unforgettable moments and enchanting scenery, creating stock images and writing. Ronald has traversed several parts of Mindanao extensively in pursuit of his passion, looking for and finding beauty in everyday surroundings and capturing a wide palette of places and faces.

His work has an unique, balanced blend between travel photography, candid shots and photojournalism. None of Ronald's photographs have been digitally manipulated, his aim is to keep the images true to their origin. It is this straightforward and no-nonsense approach that makes each of his images a remarkable reflection of reality.

http://aliawanenterprises.tripod.com

❧ *Also by ThingsAsian Press* ❧

Travel Literature

Light and Silence
Growing Up in My Mother's Alaska

By Janet Brown
Photographs from the author's private collection
2015, 5 1/2 x 8 1/2 inches; 144 pages;
paperback; color & b/w images
ISBN: 978-1-934159-56-9
$12.95

Almost Home
The Asian Search of a Geographic Trollop

By Janet Brown
Photographs by Janet Brown
2013, 5 1/2 x 8 1/2 inches; 210 pages;
paperback; color images
ISBN: 978-1-934159-55-2
$12.95

Defiled on the Ayeyarwaddy

By Ma Thanegi
Photographs by Ma Thanegi
2010, 5 1/2 x 8 1/2 inches; 256 pages;
paperback; color images
ISBN: 978-1-934159-24-8
$12.95

Nor Iron Bars a Cage

By Ma Thanegi
2013, 5 1/2 x 8 1/2 inches; 176 pages;
paperback
ISBN: 978-1-934159-50-7
$12.95

Tone Deaf in Bangkok
(and other places)

By Janet Brown
Photographs by Nana Chen
2009, 5 1/2 x 8 1/2 inches; 160 pages;
paperback; color images
ISBN: 978-1-934159-12-5
$12.95

Liberace's Filipino Cousin

By David R. Brubaker
2016, 5 1/2 x 8 1/2 inches; 160 pages;
paperback; color images
ISBN: 978-1-934159-65-1
$12.95

Eternal Harvest
The Legacy of American Bombs in Laos

By Karen J. Coates
Photographs by Jerry Redfern
2013, 5 1/2 x 8 1/2 inches; 380 pages;
paperback; 218 images
ISBN: 978-1-934159-49-1
$12.95

This Way More Better
Stories and Photos from Asia's Back Roads

By Karen J. Coates
Photographs by Jerry Redfern
2013, 5 1/2 x 8 1/2 inches; 288 pages;
paperback; color images
ISBN: 978-1-934159-48-4
$12.95

Vignettes of Japan

By Celeste Heiter
Photographs by Robert George
2003, 5 1/2 x 8 1/2 inches; 180 pages;
paperback; color images
ISBN: 978-0-971594-02-9
$12.95

Ganbatte Means Go for It!
...Get Hired in Japan

By Celeste Heiter
2016, 5 1/2 x 8 1/2 inches; 240 pages;
paperback; color images
ISBN: 978-1-934159-45-3
$14.95

Taiwan Tattoo

By Brian M. Day
2015, 5 1/2 x 8 1/2 inches; 216 pages;
paperback; color images
ISBN: 978-1-934159-64-4
$12.95

Vignettes of Taiwan
Short Stories, Essays & Random
Meditations About Taiwan

By Joshua Samuel Brown
2006, 5 1/2 x 8 1/2 inches; 160 pages;
paperback; color images
ISBN: 978-0-971594-08-1
$12.95

To Asia With Love

Edited & with contributions by Kim Fay
Photography by Julie Fay
2004, 5 1/2 x 8 1/2 inches; 248 pages;
paperback; color images
ISBN: 978-0-971594-03-6
$18.00

To Cambodia With Love

Edited & with contributions by
Andy Brouwer
Photographs by Twefic El-Sawy
2011, 5 1/2 x 8 1/2 inches; 240 pages;
paperback; color & b/w images
ISBN: 978-1-934159-08-8
$21.95

To Japan With Love

Edited & with contributions by
Celeste Heiter
Photographs by Robert George
2009, 5 1/2 x 8 1/2 inches; 280 pages;
paperback; color & b/w images
ISBN: 978-1-934159-05-7
$21.95

To Myanmar With Love

Edited & with contributions by
Morgan Edwardson
Photographs by Steve Goodman
2009, 5 1/2 x 8 1/2 inches; 296 pages;
paperback; color & b/w images
ISBN: 978-1-934159-06-4
$24.95

To Nepal With Love

Edited by Kim Fay and Cristi Hegranes
Photographs by Kraig Lieb
2013, 5 1/2 x 8 1/2 inches; 216 pages;
paperback; color & b/w images
ISBN: 978-1-934159-09-5
$21.95

To North India With Love

Edited & with contributions by
Nabanita Dutt
Photographs by Nana Chen
2011, 5 1/2 x 8 1/2 inches; 288 pages;
paperback; color & b/w images
ISBN: 978-1-934159-07-1
$21.95

To Thailand With Love

Edited & with contributions by
Nabanita Dutt
Photographs by Marc Schultz
2013, 5 1/2 x 8 1/2 inches; 328 pages;
paperback; color & b/w images
ISBN: 978-1-934159-11-8
$21.95

To Vietnam With Love

Edited & with contributions by Kim Fay
Photographs by Julie Fay Ashborn
2008, 5 1/2 x 8 1/2 inches; 304 pages;
paperback; color & b/w images
ISBN: 978-1-934159-04-0
$24.95

Lost&Found Bangkok

Ediited by Janet McKelpin and Janet Brown
Photographs by Nana Chen, Don Gilliland,
Rodney Moore, Rattapon Teanchai,
Likit Q Kittisakdinan
2011, 7 1/8 x 9 1/2 inches; 240 pages ;
paperback; color photos
ISBN: 978-1-934159-21-7
$19.95

Lost&Found Beijing

Authored by Elizabeth Briel
Edited by Janet McKelpin
Photographs by Elizabeth Briel, Stefen Chow,
Fang YiFei, Liu Laoshi & Marc A. Smith
2017, 7 1/8 x 9 1/2 inches; 176 pages;
paperback; color images
ISBN: 978-1-934159-68-2
$19.95

Lost&Found Hong Kong

Ediited by Janet McKelpin
Photographs by Hank Leung, Albert Wen,
Blair Dunton, Elizabeth Briel, Li Sui Pong
2009, 7 1/8 x 9 1/2 inches; 288 pages ;
paperback; color photos
ISBN: 978-1-934159-17-0
$19.95

Lost&Found Hanoi

Authored by Elizabeth Rush
Edited by Janet McKelpin
Photographs by Aaron Joel Santos,
Elizabeth Rush,
Nguyen Thanh Hai (Maika Elan),
Nguyen The Son, Mattew Dakin
2014, 7 1/8 x 9 1/2 inches; 240 pages;
paperback; color photos
ISBN: 978-1-934159-54-5
$19.95

THINGSASIAN PRESS

Experience Asia Through the Eyes of Travelers

"To know the road ahead, ask those coming back."
(CHINESE PROVERB)

East meets West at ThingsAsian Press, where the secrets of
Asia are revealed by the travelers who know them best. Writers
who have lived and worked in Asia. Writers with stories to tell
about basking on the beaches of Thailand, teaching English
conversation in the exclusive salons of Tokyo, trekking in
Bhutan, haggling with antique vendors in the back alleys of
Shanghai, eating spicy noodles on the streets of Jakarta,
photographing the children of Nepal, cycling the length of
Vietnam's Highway One, traveling through Laos on the mighty
Mekong, and falling in love on the island of Kyushu.

Inspired by the many expert, adventurous and independent
contributors who helped us build **ThingsAsian.com**, our
publications are intended for both active travelers and those
who journey vicariously, on the wings of words.

ThingsAsian Press specializes in travel stories, photo journals,
cultural anthologies, destination guides and children's books.
We are dedicated to assisting readers in exploring the cultures
of Asia through the eyes of experienced travelers.

www.thingsasianpress.com